SELL
COMICLINK.COM

WHERE YOU GET TOP DOLLAR
THE PREMIUM REAL-TIME EXCHANGE
THE PREFERRED AUCTION VENUE

MW00582853

MAXIMIZE YOUR RETURN

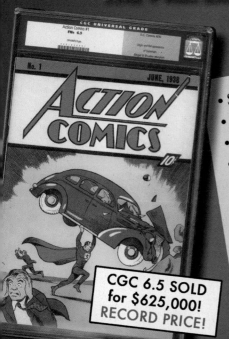

- Sell at Auction or on the Exchange
- Regularly Establishing Record Prices
- Longest Online Presence of any Comic Service
- Our Client Base & Experience are Unmatched
- Buyers are Waiting for Your High-Quality Items
- Pricing Experts can Maximize Value
- Grading Experts can Grade Your Comics
- Customer Service is Always Accessible
- Proven Track Record of Prompt Payment
- Cash Advance and Purchase Options Available

CGC 6.5 SOLD
for $625,000!
RECORD PRICE!

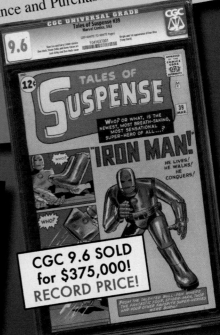

CGC 9.6 SOLD
for $375,000!
RECORD PRICE!

ComicLink makes the sales process easy!
Contact us to find out how to get the most money
quickly for your vintage comics and art.

ComicLink
AUCTIONS & EXCHANGE
www.comiclink.com
617-517-0062
buysell@comiclink.com

WWW.HAKES.COM

Since 1967

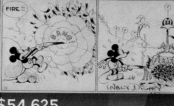

AMERICANA & HAKES COLLECTIBLES

SOLD: $54,625

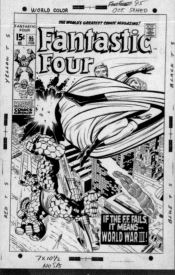

★CONSIGN NOW

SOLD: $95,155 SOLD: $25,370 SOLD: $75,000

We Are America's First and Foremost Pop Culture Auction House

No One Has Done It Longer, No One Does It Better

*Let Us Showcase Your Original Art -
We Will Present Your Items In The Best Way Possible*

*We Do Limit The Amount Of Art We Offer In Each
Auction So Every Piece Realizes Its Full Potential*

World Record Prices Set In Every Auction

SOLD: $5,621

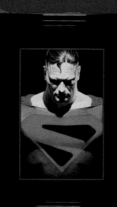

SOLD: $5,051

SOLD: $10,120

SOLD: $10,209

SOLD: $15,181

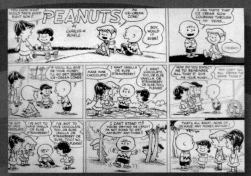

SOLD: $41,264

SOLD: $9,740

★ CONSIGN NOW ★
WWW.HAKES.COM

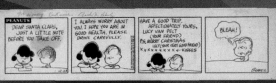

SOLD: $21,275

SOLD: $3,478

SOLD: $26,565

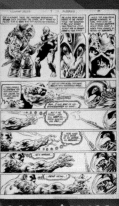

SOLD: $11,132

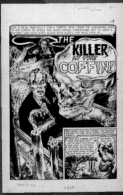

SOLD: $18,658

★ ORIGINAL ART WANTED ★ PROVEN RESULTS ★

SOLD: $11,500

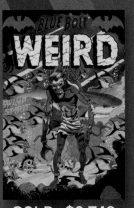

SOLD: $9,740

SOLD: $3,452

SOLD: $2,932

SOLD: $8,222

If interested in consigning contact:
Kelly McClain at mkelly@hakes.com or call 866.404.9800 ext: 1636 or
Alex Winter at walex@hakes.com or call 866.404.9800 ext: 1632
Hake's Americana & Collectibles
PO Box 12001 - York, PA 17402
Toll Free: (866)404-9800

A Division Of
GEPPI'S ENTERTAINMENT AUCTIONS

With Great ART Comes Great Responsibility

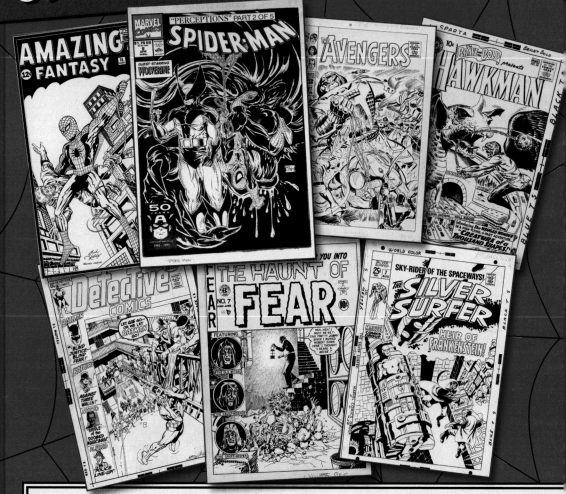

ORIGINAL COMIC BOOK ARTWORK HAS BEEN MY PASSION EVER SINCE I BOUGHT MY VERY FIRST ORIGINAL ART PAGE FROM *AMAZING SPIDER-MAN* #46 IN 1989 FOR $110.00. I NOW HAVE WELL OVER 8000 PICTURED PIECES OF ORIGINAL COMIC BOOK AND COMIC STRIP ART FOR SALE ON MY WEBSITE. IT'S ALSO A PLACE TO DISPLAY AND SHARE MY EXTENSIVE SPIDER-MAN ORIGINAL COMIC BOOK ART COLLECTION.

I BUY, SELL AND TRADE ORIGINAL COMIC BOOK AND COMIC STRIP ARTWORK FROM THE 1930S TO THE PRESENT, AND I'M ALWAYS LOOKING FOR MORE. LET ME KNOW YOUR WANTS OR WHAT YOU HAVE FOR SALE, AND I'M SURE WE CAN WORK SOMETHING OUT!

Mike Burkey (YOUR FRIENDLY NEIGHBORHOOD ART DEALER)

www.Romitaman.com

THE OVERSTREET®
GUIDE
TO COLLECTING
COMIC & ANIMATION ART

BY ROBERT M. OVERSTREET

WRITTEN BY J.C. VAUGHN

WITH WELDON ADAMS, ROBERT BEERBOHM, SCOTT BRADEN,
BRUCE CANWELL, ART CLOOS, MARK HUESMAN, ROB HUGHES,
MICHAEL KRONENBERG, JOE MANNARINO, ROBERT M. OVERSTREET,
S.C. RINGGENBERG, KEN SCARBORO, MARK SQUIREK, AND RON STARK

DESIGN & LAYOUT BY MARK HUESMAN

WITH MARK "LEFTY" HAYNES, ROB HUGHES,
MICHAEL KRONENBERG AND MARK WHEATLEY

PHOTOS BY
DAN GALLO, TOM GORDON III, JOE JUSKO, AND KEN SCARBORO

OVERSTREET ADVISORS FOR THIS EDITION
WELDON ADAMS, ROBERT BEERBOHM, PETER BILELIS, STEVE BOROCK,
SHAWN CAFFREY, MICHAEL CARBONARO, ART CLOOS, FRANK CWIKLIK,
MICHAEL EURY, TOM FISH, STEPHEN FISHLER, DAN GALLO,
STEVE GEPPI, DOUGLAS GILLOCK, TOM GORDON III, ROB HUGHES,
NICK KATRADIS, MICHAEL KRONENBERG, PAUL LITCH, JOE MANNARINO,
NADIA MANNARINO, HARRY MATETSKY, PETER MEROLO, JOSH NATHANSON,
S.C. RINGGENBERG, BARRY SANDOVAL, BRIAN SCHUTZER, TODD SHEFFER,
ANTHONY SNYDER, MARK SQUIREK, MAGGIE THOMPSON, JOE VETERI,
ALEX WINTER, AND VINCENT ZURZOLO

FOR A FULL LIST OF OVERSTREET ADVISORS, PLEASE SEE THE CURRENT EDITION
OF THE OVERSTREET COMIC BOOK PRICE GUIDE.

SPECIAL THANKS
WELDON ADAMS, STEVE BOROCK, NICK KATRADIS, JOE & NADIA MANNARINO,
ROBERT MILLER, AND ROB REYNOLDS, AND TO COMICCONNECT.COM,
COMICLINK.COM, HAKE'S AMERICANA & COLLECTIBLES,
HERITAGE AUCTIONS, AND S/R LABS

COVER BY JOE JUSKO

EDITED BY J.C. VAUGHN & MARK HUESMAN

ADDITIONAL EDITING AND PROOFING BY
LEONARD (JOHN) CLARK

ACCOUNTING SERVICES BY
TOM GAREY, KATHY WEAVER, BRETT CANBY,
ANGELA PHILLIPS-MILLS AND JEN RUGGLES

GEMSTONE PUBLISHING

STEPHEN A. GEPPI
PRESIDENT &
CHIEF EXECUTIVE OFFICER

ROBERT M. OVERSTREET
PUBLISHER

J.C. VAUGHN
VICE-PRESIDENT
OF PUBLISHING

MARK HUESMAN
CREATIVE DIRECTOR &
PRODUCTION COORDINATOR

THE OVERSTREET GUIDE TO COLLECTING COMIC & ANIMATION ART. Copyright © 2013 by Gemstone Publishing, Inc. except as noted. All rights reserved. Printed in Canada. No part of this book may be used or reproduced in any manner whatsoever without written permission except in the case of brief quotations embodied in critical articles and reviews. For information, write to Gemstone Publishing, 10150 York Road, Suite 300, Hunt Valley, MD 21030 or email feedback@gemstonepub.com.

All characters and all images ©2013 respective copyright holders. All rights reserved.

All rights reserved. **THE OVERSTREET GUIDE TO COLLECTING COMIC & ANIMATION ART (1st Edition)** is an original publication of Gemstone Publishing, Inc. This edition has never before appeared in any form.

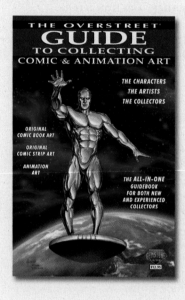

Cover by Joe Jusko.
The Silver Surfer ©2013 Marvel Characters, Inc.
Used by permission.
All rights reserved.

Overstreet® is a Registered Trademark of Gemstone Publishing, Inc.

ISBN: 978-1-60360-153-5

Printed in Canada

10 9 8 7 6 5 4 3 2 1

First Printing: October 2013

www.gemstonepub.com

GEMSTONE
PUBLISHING

AVAILABLE NOW:

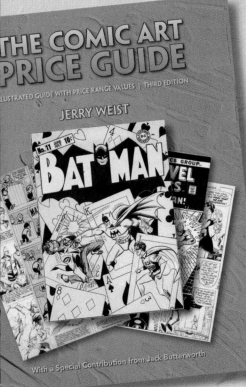

THE COMIC ART PRICE GUIDE

Illustrated Guide with Price Range Values, Third Edition

By JERRY WEIST with a special contribution from Jack Butterworth.

Softcover, 574 pages,
black & white
and color, 8.5 x 11

The Comic Art Price Guide: Illustrated Guide with Price Range Values, Third Edition, by Jerry Weist, is the most authoritative guide to original artwork for comic strips, comic book art, science fiction, pulp, and fantasy art. As comic art values soared over recent years, hundreds of collectors encouraged Jerry Weist to update his indispensable reference work. Now the work is done, with The Comic Art Price Guide being the culmination of Jerry's vision for this third edition. With more than 500 pages of art reproductions, price range values and artist bios, this is a must for all collectors of original comic art.

CONTENTS INCLUDE:

- The Comic Art Price Guide Philosophy
- Understanding Price Ranges
- Guide to Newspaper Strip Art Values
- Guide to Original Comic Art Values
- Guide to Science Fiction and Pulp Art Values
- The Lloyd Jacquet Estate discovery of original art

$29.95

WITH FREE SHIPPING
WITHIN THE U.S.
ORDER NOW AT
HA.COM/WEIST

Annual Sales Exceed $800 Million | 800,000+ Online Bidder-Members

3500 Maple Ave. | Dallas, TX 75219 | 877-HERITAGE (437-4824) | bid@HA.com

DALLAS | NEW YORK | BEVERLY HILLS | SAN FRANCISCO | HOUSTON | PARIS | GENEVA

THE WORLD'S LARGEST COLLECTIBLES AUCTIONEER

HERITAGE HA.com
AUCTIONS

 HA.com/FBComics HA.com/Twitter

TX & NY Auctioneer license: Samuel Foose 11727 & 0952360. Heritage Auction Galleries CA Bond #RSB2004175; CA Auctioneer Bond: Carolyn Mani #RSB2005661. Buyer's Premium 12%-25%. See HA.com for details. HERITAGE Reg. U.S. Pat & TM Off.

29536

THE BEST COMICS ART OF ALL-TIME

THE LIBRARY OF AMERICAN COMICS

"THE LIBRARY OF AMERICAN COMICS HAS BECOME THE GOLD STANDARD FOR ARCHIVAL COMIC STRIP REPRINTS."
— *Scoop*

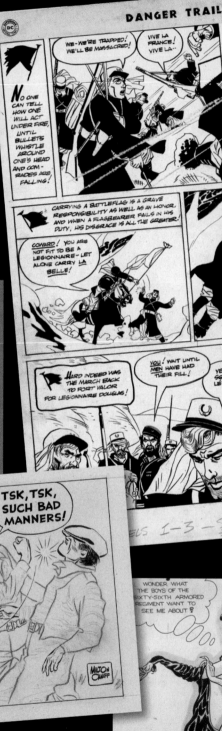

Danger Trail © DC Comics, Inc., Crawford TM and © Chuck Jones Enterprises, Terry and the Pirates and Little Orphan Annie ® and © Tribune News and Features. Ad © Library of American Comics LLC

LibraryofAmericanComics.com

TABLE OF CONTENTS

SAVE THE DATE!

FREE COMIC BOOK DAY

1st SATURDAY IN MAY!

www.freecomicbookday.com

WWW.NICKKATRADIS.COM

DO YOU LOVE ORIGINAL COMIC ART? I DO!

Hello, my name is Nick Katradis. If you love comic art as much as I do, and you are considering selling any of your comic art, please contact me. I am a lifelong collector of comics and I am one of the most serious collectors of comic art, specifically from the Bronze Age.

I want to purchase comic art from DC, Marvel or Charlton. I collect mostly Bronze Age art from 1968 to 1979. But I will purchase Silver Age and Golden Age art, too. I also collect Bronze Age Romance art, from DC, Marvel, and Charlton, from 1968 to 1976.

I collect comic art by Sal Buscema, Jim Aparo, Gil Kane, Gene Colan, Nick Cardy, John Romita, Jack Kirby, John Buscema, Steve Ditko, Irv Novick, Rich Buckler, Curt Swan, Herb Trimpe, Dick Giordano, Dick Dillin, Don Heck, George Tuska, Mike Sekowsky, Jim Mooney, Ross Andru, Marie Severin, etc.

If you are interested in selling your comic art to a fellow collector, or if you would like to purchase any of my comics or comic art on my website, please contact me and we can discuss a possible sale or trade.

Overstreet Advisor • Visit My Sites!

www.NickKatradis.com

CAF Gallery:
http://www.comicartfans.com/
GalleryDetail.asp?GCat=3575

Facebook:
https://www.facebook.com/pages/
nickkatradiscom/175576422556096

ndde@aol.com • (917) 815-0777

THE VALUE OF YOUR COMIC COLLECTIBLES!

COMIC ART APPRAISAL LLC

www.comicartappraisal.com

Appraisals for: Fair Market Value, Insurance, Donation, Estate, Equitable Distribution, Legal, Archives, Collections, Libraries.

Comic Art Appraisal LLC

Has been the foremost source for formal appraisals for comic books, original comic art, illustration art, original newspaper strip art and animation art for over 25 years. Collectors, dealers, financial institutions, museums, attorneys, galleries and the IRS have availed themselves of our services for establishing values for comic books, original comic art, original newspaper art and animation art. We have appraised over 1,000,000 individual items.

Free Initial Evaluation Of Your Collectibles

Over 25 years Of Experience

Members Of American Appraisers Association
Members American Institute Of Conservation

FANTASTIC FOUR #100
JACK KIRBY PENCILS
JOE SINNOTT INKS
1970 15 X10

Value Factors And Point Breakdown Comic Book Original Art

Potential Points	12	10	5	10	10	10	12	20	8	10	100
Factors	Condition	Configuration	Confirmation	Content	Context	Continuity	Creativity	Creator	Cross-over	Cyclical Interest	Total
FF #100 Cover	3	10	5	10	8	10	12	20	8	9	95

Free Evaluation!
Do not sell without knowing what your collectibles are worth.

Inquiries: Joe Mannarino or Nadia Mannarino
(201) 652 -1305
http://www.comicartappraisal.com

DAN GALLO

Overstreet Advisor and Co-Promoter of Comic Art Con

SPECIALIZING IN CGC-GRADED BOOKS AND ORIGINAL COMIC BOOK ART

Buying entire collections,
(the bigger the better),
Individual Books,
CGC-Graded or Raw,
Gold, Silver, & Bronze Age,
Plus Original Art.
-- Will Travel --

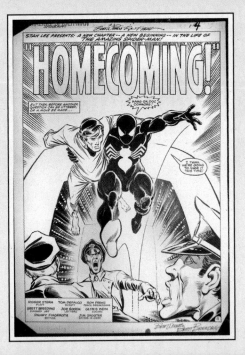

Dan Gallo
Westchester County, NY

(954) 547-9063
dgallo1291@aol.com
eBay ID: dgallo1291

$500,000 PAID FOR ORIGINAL ART

**COLLECTOR PAYING TOP DOLLAR FOR "ANY AND ALL" ORIGINAL COMIC BOOK AND COMIC STRIP ARTWORK FROM THE 1930S TO THE PRESENT! COVERS, PIN-UPS, PAGES, IT DOESN'T MATTER!
1 PAGE OR ENTIRE COLLECTIONS SOUGHT!
CALL OR EMAIL ME ANYTIME!**

330-221-5665
mikeburkey@aol.com

OR SEND YOUR LIST TO
MIKE BURKEY
P.O. BOX 455 • RAVENNA, OH 44266
CASH IS WAITING, SO HURRY!!!

ROMITAMAN
ORIGINAL COMIC ART

IF YOU LOVE COMIC BOOKS, THEN YOU "MUST" CHECK OUT THE LARGEST INTERNET WEBSITE IN THE WORLD DEVOTED TO BUYING, SELLING AND TRADING ORIGINAL COMIC BOOK ART AND COMIC STRIP ART! WE ARE YOUR BEST ARTWORK INTERNET SOURCE!

CHECK OUT OVER 8,000+ "PICTURED" PIECES OF COMIC BOOK AND COMIC STRIP ART FOR SALE OR TRADE. ALSO CHECK OUT THE WORLD'S "LARGEST" SPIDER-MAN ORIGINAL ART GALLERY!

I BUY/SELL/ TRADE "ALL" COMIC BOOK/ STRIP ARTWORK FROM THE 1930S TO THE PRESENT. SO LET ME KNOW YOUR WANTS, OR WHAT YOU HAVE FOR SALE!

www.romitaman.com

INTRODUCTION

By Robert M. Overstreet

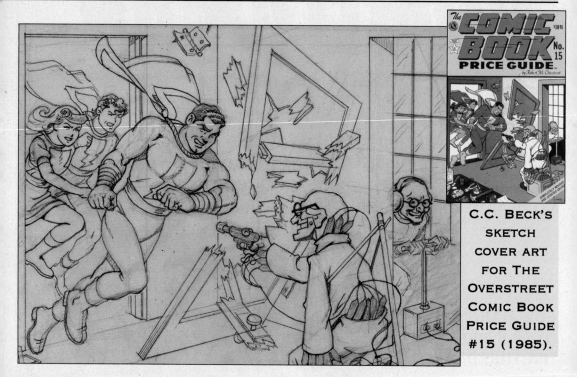

C.C. Beck's sketch cover art for The Overstreet Comic Book Price Guide #15 (1985).

There are many ways to collect original comic book, comic strip and animation art, and while these fields may be under-documented compared to comic books themselves or any number of other pop culture niches, that certainly doesn't speak against the viability of collecting in these areas. In fact, at present the original art market is commanding a tremendous amount of attention.

There are some very strong reasons for this:

First, each piece is inherently one of a kind.

Second, we have entered an era in which the acceptance of pop culture by the culture as a whole has never been greater.

Third, and subsequent to my second point, we have achieved a large degree of recognition of these component pieces of a larger work standing on their own as art, too.

All of this makes for a very interesting environment in which to collect or deal in these pop culture treasures.

In the pages of this book, you'll hear from the experts in each of these areas, and they'll offer their insights on how they got started, what they've seen in the marketplace, and how they've seen the business evolve. From what they say, we believe you'll be able to piece together your own unique, informed approach to collecting comic book, comic strip and/or animation art.

The first thing we always say though, whether in art or comic books or any other specialty, is collect what you love. Whether you're spending tens of dollars or $10,000, don't let anyone talk you into anything you wouldn't want to keep in your collection. While the market – particularly in original comic book art – is very liquid at the moment, the best bet to a path with as few regrets as possible is to collect what you love.

And as you'll always hear us say in each of our publications, get informed. Don't be afraid of diverse and sometimes conflicting opinions. Eventually you'll have to sort things out for yourself, but the key to

understanding any field of endeavor is to get informed. There are many great resources out there in the art fields – most of them in the form of experienced collectors and dealers – and you'll find that a high percentage of them are willing to share their knowledge with you.

Another important element to understand is that while there are many record prices being paid – and we'll talk about a number of them in this volume – there are many pieces in each of these niches that are priced so that even the most unseasoned beginner can pick up some truly enjoyable pages, strips or cels. Again, when you start with something you love, it's hard to go wrong.

WEIRD FANTASY #8

That, of course, is not to say that the record prices haven't commanded attention. In fact, it's been a tremendously interesting part of the field. You'll see plenty of the record-setters in this book as well.

Comic book original art of both covers and story pages have continued to set records showing increased demand all through 2012. Heritage Auctions set the record in 2012 with the sale of Todd McFarlane's cover art for *Amazing Spider-Man* #328 which sold for $657,250. His cover art for *Amazing Spider-Man* #325 went for $83,650 and his cover art for *Spider-Man* #1 (1990) brought $358,500, while a great Kirby/Sinnott panel page featuring the Silver Surfer from *Fantastic Four* #55 went for $155,350. The original cover to *Flash* #137 sold for $167,300 and the cover to *Brave & the Bold* #34 went for $89,625. A Frazetta paperback cover

painting, "The Solar Invasion," brought $262,900.

A few EC covers and stories sold, too. Among the covers, *Crime SuspenStories* #16 ($62,737.50), *Tales From the Crypt* #32 ($31,070), *Weird Fantasy* #8 ($80,662), and *Weird Fantasy* #16 cover ($50,787.50). Among the interior pages, a Graham Ingels seven-page story, "Partnership Dissolved," from *Crime SuspenStories* #8 went for $16,730, while his "Poetic Justice" eight-page story from *Haunt of Fear* #12 sold for $20,315. A six-page story by Wally Wood for *Weird Fantasy* #11, "The 10th At Noon," sold for $26,290, and a seven-page story by Jack Davis for *Haunt of Fear* #13, "Wolf Bait," went for $26,290.

Even with the majority of comic art priced in much more accessible fashion, the original comic book art market continues to be intriguing to observe. We now have conventions dedicated specifically to original art – Comic Art Con is the first, but we doubt it will be the last of its kind – and the market seems to be thriving. While there are certain very, very rare comic books, original comic art does have a distinct appeal in that each piece is a one-of-a-kind creation. And you'll hear from Comic Art Con's founders in this volume as well.

Happy Collecting!

[signature]

Robert M. Overstreet
Publisher

SPIDER-MAN #1

COLLECTING ORIGINAL COMIC ART

The past few years have seen no end of record prices being paid for original comic book and comic strip art. There have been high profile sales through All Star Auctions, ComicConnect.com, ComicLink.com, Hake's Americana & Collectibles, Heritage Auctions and many other auction venues, as well through private transactions.

If you're just starting out, however, some of those prices may seem pretty daunting. Well, they're actually *very* daunting even to many seasoned collectors. That's okay, because for every major sale like that there are hundreds or even thousands of deals made at much more accessible prices.

First, let's look at just a snapshot of some of the high level sales Heritage experienced from 2010 to 2012:

Todd McFarlane's original cover art for 1990's *Amazing Spider-Man* #328 sold for $657,250, the highest price ever realized for a piece of original comic art, at Heritage Auctions July 26-28, 2012 event in Beverly Hills, California.

That same sale saw McFarlane's cover for *Amazing Spider-Man* #317 sell for $143,400, his *Marvel Tales* #235 cover go for $56,762.50, and two of his interior pages from *Amazing Spider-Man* #319, Page 1 and Page 19, realize $28,680 each.

Frank Miller and Klaus Janson's original art for *Batman: The Dark Knight Returns* #3 Page 10 became the previous single most valuable piece of American comic art to ever sell when it brought $448,125 as part of Heritage's May 5, 2011 auction.

Prior to that, Miller's original cover for *Daredevil* #188 sold for $101,575 at Heritage on Friday, May 21, 2010.

In recent years, there have been record prices paid for the works of many different creators spanning a multitude of genres. *Peanuts* Sunday pages and dailies by Charles Schulz and many other comic strip originals attract plenty of attention and high prices as well.

It might be surprising then, to hear Steve Borock, Senior Consignment Director of Heritage, say that prospective comic art collectors should concentrate on collecting what they love, not what they think is going to sell for a record price… but that's precisely what he does.

"Is it even a question? Collect what you love," Borock said.

He said that doesn't mean what you love can't be worth big money, but that if you're going to have to live with it and look at it and risk losing money on it, it better be something you can enjoy.

There are very few other rules for collecting, he said.

Know your budget. Only buy what you can afford. That may seem pretty basic, but emotions are powerful forces

and can compel us to reach beyond our means. Specifically, don't purchase a piece of comic art for which the expense will only force you to turn around and sell it in short order.

Know whether the piece you are considering has a personal appeal to you or is one that has appeal to everyone. This can have a major effect if you are unexpectedly forced to sell the art. Obviously the broader the appeal, the more demand for the piece it would be reasonable to expect.

"Ask yourself 'Will I at least be able to get some of the money back when I go to sell it?'" Borock said.

He also pointed out that there are at least as many niches in collecting original comic art as there are in comic books. You can collect favorite heroes, favorite villains, first appearances, last appearances, genre themes, publishers and in many other ways.

You can also, of course, collect by creator.

And in addition to McFarlane and Miller there are many to choose from. Try Neal Adams, Murphy Anderson, Jim Aparo, Sergio Aragonés, Matt Baker, Carl Barks, John Buscema, Dave Cockrum, Palmer Cox, Jack Davis, Dan DeCarlo, Steve Ditko, Will Eisner, Bill Everett, Frank Frazetta, Jean Giraud (Moebius), Larry Hama, Carmine Infantino, Jack Kirby, Joe Kubert, Harvey Kurtzman, Jim Lee, Russ Manning, Winsor McCay, Mike Mignola, Mart Nodell, George Pérez, Mac Raboy, Jerry Robinson, Marshall Rogers, John Romita, Sr., John Romita, Jr., Don Rosa, Kurt Schaffenberger, John Severin, Marie Severin, Joe Shuster, Bill Sienkiewicz, Joe Simon, Walter Simonson, Jim Steranko, Dave Stevens, Curt Swan, Alex Toth, Michael Turner, Mike Wieringo, Al Williamson or Wally Wood, for instance (Of course they are all Overstreet Hall of Fame artists and there are only a few known examples of work by some of them).

But don't limit your choices by who's in our hall of fame or *any* hall of fame. It keeps coming back to what *you* like personally and what you can afford. After that, there are many different approaches.

Noted comic art collector Nick Katradis shared his.

"When purchasing original comic art, before we take into consideration our own nostalgic connection which attracts us to the page, or whether it's the artist and/or inker who we prefer, there are several structural qualities to look for," Katradis said.

"One wants to look for a page where the main character appears in as many panels as we can find. One should look for pages where the villain is present also, if possible. Other qualities are, if a page has a double panel or features a larger than normal panel; that is also quite desirable," he said.

"More qualities to look for are when an important thing happens on the page, which affects the continuity of the story and/or is of long term importance to the character (first appearance, death, change in costume, etc.)," he said.

"Lastly, the condition of the page is also important. One has to make sure there are not too many defects (too much white-out, cut-outs, glue residue, ink stains/smudges, browning of the paper, etc). All these things can affect eye appeal and affect the overall desirability of the page, and its value in the future if one chooses to sell it," he said.

When getting started in any field, it's wise to familiarize yourself with the various companies doing the selling. Find out what sells in which market venues for how much. Despite the attention we paid at the beginning of this article, some pieces there go for surprisingly reasonable rates. Either way, in our information-is-king world, it's best to be informed, no matter what your specialty.

Most of these same considerations also come into play when you are selling a piece.

"Artwork is unique and so personal that it often takes quite a while to find the right buyer" said Rob Hughes of Archangels. "I also look for artwork that is affordable to the majority of the market. The higher the price any item is, the less potential buyers you'll have."

EXPLORE THE BIGGER PICTURE OF THE WORLD OF COMICS!

"A wonderful info-packed gift idea for long-time fans and those new to the comics hobby!"
-- Joe Field, Flying Colors Comics

"The go-to name in comics values has created the go-to book for comics collecting."
-- Benn Ray, Atomic Books

"How To Collect Comics should be the title as it covers literally every aspect of learning the ins and outs of collecting comic books. I wish I had one of these when I first started out."
-- Vincent Zurzolo, Metropolis Collectibles & ComicConnect

"Wow! What a comprehensive look at the hobby in such a compact edition!"
-- Mike McKenzie, Alternate Worlds

"It's the perfect look at comics both for the beginner and, almost even more, for the experienced collector. It's a great gift for anyone who wants to introduce their friends and family to our crazy world."
-- Fred Pierce, Valiant Entertainment

THE OVERSTREET® GUIDE TO COLLECTING COMICS

THE CHARACTERS
THE CREATORS
THE COLLECTORS

GEMSTONE PUBLISHING
$19.95

THE ALL-IN-ONE GUIDEBOOK TO THE WORLD OF COMIC COLLECTING

Spider-Man ©2013 Marvel Characters, Inc. Overstreet® is Registered Trademark of Gemstone Publishing, Inc. All rights reserved.

It's like Comic Book Collecting 102 in a single book!

336 PAGES • FULL COLOR • SOFT COVER • $19.95

AT BETTER COMIC SHOPS NOW!

GEMSTONE PUBLISHING

WWW.GEMSTONEPUB.COM

COMIC SHOP LOCATOR SERVICE
comicshoplocator.com
888-COMIC-BOOK

A Brief Market Overview

By Joe Mannarino

The Market

The original art used to produce comic books, newspaper strips, science fiction, fantasy and related material has become incredibly collectible. Although the market did not exist prior to 40 years ago, collecting original art, as it is routinely called, is a natural progression for many readers and collectors of the narrative art form. The first modern comic books date to 1933. Comic book collecting began in the mid-sixties and blossomed in the early seventies. Fandom flourished with the publication of numerous fanzines and dedicated conventions.

The field is well documented within the pages of numerous publications and in particular *The Overstreet Comic Book Price Guide.* The collecting of comic books, and related material promoted research into the origins of the medium. Soon the influence of newspaper comic strip features, science fiction, fantasy, pulp magazines became clear. Invariably this lead to identifying the professionals responsible.

Beginning in 1895 with the *Yellow Kid,* by R.F. Outcault, to the present day, narrative art's popularity has not waned. This art form is considered one of the most pervasive forms of entertainment in America this century. However, it would be approximately 60 years before any kind of organized activity centered around collecting and preserving "comic art" would take place. "Comic art" or as it is commonly referred to, is sought by collectors around the world. It is one of the truly unique American popular culture items and as such is enjoying significant popularity. A vast array of institutions within the United States and abroad currently contain significant collections of sequential art, including: The Library of Congress, numerous universities and colleges as well as major museums.

The Process

The typical process for the creation of narrative art normally involves the following: A script is written by a writer which in many cases can also be the artist. The artist is commissioned to interpret the script using sequential panels. The first step is to pencil each panel. In most cases the pencilled pages are then carefully outlined and toned with india ink. This step is necessary as the color which may appear in the printed product will be applied by the printer directly on negatives within the inked lines of demarcation. The original art remains black and white. Inked pages are then lettered with the dialogue and submitted to an editor for review.

Editor's note: The script-to-final-page process was described and displayed in The Overstreet Guide To Collecting Comics, *also available at comic book shops, book stores, and from Gemstone Publishing.*

Assessing Value Of
Comic Character Original Art

Comic Art Appraisal Rating (CAAR)
100 Point Value System

By Joe Mannarino

©2013 Joe Mannarino

The **Comic Art Appraisal Rating** reflects the various key factors that affect value in the comic art market through a 100 point standard. The following "rules" apply to the Original Comic Book Art Market.

The rating reflects the factors that one would use in determining the relative value in the current market place.

Although it is a 100 point scale and there are 10 factors they do not bear equal weight of 10 points each, rather the numerical points next to the factors indicate the highest potential number of points for each value factor.

The ratings are relative to their classification of period within the comic book timeline as described in *The Overstreet Comic Book Price Guide*. e.g. Golden Age to Golden Age, Silver Age to Silver Age, Bronze to Bronze, Modern to Modern, etc.

The ratings are relative to their classification as to format in regards to front cover to front cover, chapter splash to chapter splash and interior page to interior page, sketches to sketches, concepts to concepts, roughs to roughs.

The terms supply and demand have purposely been excluded. These terms tend to artificially simplify and inhibit the process of assigning an accurate rating. The goal is to quantify the factors that create demand or desirability.

Rarity

Non-professionals, non-enthusiasts or amateurs often look first to the age and rarity of an item and feel that value should be greatly influenced by these factors. In fact, age may have little if anything to do with the value of an item. Many items from the 60's and 70's are worth considerably more than items from the 30's and 40's or even the turn of the century. Rarity only comes into play when an item also reflects other listed factors. Unfortunately, when age and rarity of items without any other factors are evaluated, it may be old, it may be rare but for lack of value factors there may be little interest. One must keep in mind, that over the history of the medium, thousands of books have been created by hundreds of publishers and professionals. Many titles lasted a few or even a single issue never gaining any popularity, this art may be rare or hard to find but may have little value. However, the value of a noted artist's work, which is also rare, will enhance the value.

The sum of the points assigned to these value factors result in a relative score that should be used when discussing the comparative merits in terms of value of a page of original comic book art. The process should be viewed as a filter, a lens if you will, whose focus can blur or sharpen as conditions, tastes and interests change as such, the categories and associated points are subject to revision in the future.

The more factors that apply, the greater the value. The list of Value Factors with associated rating points, in alphabetical order are:

Condition	5 points
Configuration	10 Points
Confirmation	5 Points
Content	10 Points
Context	10 Points
Continuity	10 Points
Creativity	12 Points
Creator	20 Points
Cross-over	8 Points
Cyclical Interest	10 Points

Condition

A general state of poor conservation significantly decreases the value of a collectible item. Mass-produced items are greatly effected, originals to a lesser extent. Missing any portion of the actual art (as opposed to the substrate) decreases value. The presence of paste-overs for corrections, white-out and glue stains on a page of art as well as tears can decrease value. The only exception to this rule is cover and title page (also known as the splash page) art of a publication. With rare exception, the logo, copyright information and credits as well as some word balloons are photographic copies; known as stats. Stats were routinely glued to the page of art with rubber cement which quickly yellows with age. Collectors recognize this as being a necessary part of the process used to create the book and accept these faults with little impact to price.

Original comic art may be professionally cleaned and restored to correct condition issues. This is known as restoration, archival repair or conservation. A qualified professional should always be used and should be able to provide a report of work performed. Restoration may include, cleaning, diminishing or eliminating defects such as: glue staining, tears, yellowing, white-out, dirt and in some situations the replacement of a missing piece. As of today, unlike printed comic books, cleaning and light restoration does not significantly add or detract from the value of the art. Redrawing of art, adding to the substrate, coloring of art does reduce its value.

Configuration

• Physical dimensions of art and panels.
• Overall dimensions of art.
• Dimensions of and arrangement of individual panels.
• Hand colored by the artist especially in a field where this is not common
• Published vs. unpublished
• Panel layout – Optimum being entire page one large panel

Confirmation

• Authenticity
• Provenance - Provides a direct lineage documenting proof of authenticity and ownership.
• Pedigree - The market normally applies a premium to items with a documented, notable lineage. The more notable the lineage or collection the greater the premium.
• Inscription - With rare exception, at the present time, a signature or inscription on a work of original comic book art does not increase the value.

Content

Refers to the actual content that appears within the page of art, this can be a hero, villain, girlfriend, boyfriend etc. Think of it more as "Who" as opposed to "how" the work was executed.
• The appearance by any principal character, the more significant the character the greater the number of points
• The appearance of a popular villain
• Appearance of a popular character
• Beautiful women
• Character in costume, popular pose or

attire
• Size of subject
• The depiction of something controversial such as; death, bondage, intense horror, needles, scantily clad women, swastika etc.
• Patriotic themes
• Adventure as opposed to humor
• The genre for which the creator(s) are best known for or recognized.

Context
Refers to the historical significance of either the item itself or the subject depicted.
• The first appearance by any principal character, the more significant the character the greater the value
• The origin of a character
• Retelling of the origin of a character
• First issue of a title
• The very first publication by a publisher. As well as the significance of the title, (was it sold or adapted by another company).
• Groundbreaking either in art, content or storyline.
• Trendsetting
• Popular storyline
• Portrays a historical moment or figure.
• Involved in a historical event such as a court case, investigation (Senate Committee on the Judiciary. Comic Books and Juvenile Delinquency)

Continuity
The longer a title, publication, publisher or character appears, the greater the interest tends to remain. This includes cross-over licensing such as toys, movies, television, radio, advertising, food packaging, books and institutional interest within academic circles. The longer the duration of popularity, the more exposure leading to greater and consistent appeal.

Creativity
Defined as the aesthetic of the art, (relating to the sense of the beautiful and to heightened sensory perception in general) as well as technical mastery. Think of it as the "how".
• Action as opposed to static
• Prime (sought-after) period for the artist
• Proper proportions
• Effective and accurate foreshortening
• Anatomical correctness
• Ability to change the reader's vantage point
• Perspective
• Control of values
• Design or layout of panels or page
• High contrasts (dark background)
• Size of characters
• Subject facing forward
• Quality of inking
• Modeling (the expression or indication of solid or three dimensional form)
• Composition
• Mass
• In the case of a collaborative effort (penciller/inker) the preservation of the penciller's original vision.
• Use of wash
• Use of color
• Innovative techniques including breakthroughs
• Uncommon medium for the milieu.

Creator(s)
The reputation, standing and talent of the individuals involved in the creative process are paramount in determining the value of an item, in particular original art. Obviously, the factors utilized in determining values for fine art and antiques apply. However, consideration must include the fact that in the majority of situations, comic, cartoon or illustrative fields were collaborative efforts and as such an individual item normally does not represent the sole "vision" of a single creator. In addition, the work of art may not represent the "final published" product. In most cases the penciller, inker and writer combinations must all be taken into consideration when assigning value points.

Rarity of the artist's art is a factor.

A comprehensive list has been created that will assign a point value to each artist/inker combination. Some artists will have several points assigned to them based on having worked in more than one distinct category during their careers.

Cross-over

Both into and out of their normal niches. Any feature, depiction and sometimes even mention of popular, niche individuals or properties may add value as a larger audience will have interest. This will naturally increase appeal as collectors from other areas also pursue these items.

This relates to current interest. For instance, Little Orphan Annie may have been one of the most popular characters/features in the history of the medium. Newspapers, books, radio, premiums, product licensing including toys and apparel as well as Broadway shows, songs and movies. However in the past decade there has been little cross-over beyond the newspaper feature and reprints. In this case, little if any points would be given for past appeal and perhaps 1 or 2 for today.

Celebrities, world leaders, politicians, popular movies, TV, Disney characters, novels, Robots, Atomic war, westerns, planes, rockets etc.

The appearance of a popular character (hero or villain) crossing-over from another title will increase the value of an item.

Cross-over appeal - The character(s) depicted in the art is so influential and prevalent that they translate into many mediums out of their primary niche. This includes: toys, movies, television, radio, advertising, food packaging, books as well as institutional interest within academic circles. Prime examples would be Superman, Batman, Spider-Man, Mickey Mouse, Donald Duck etc. These characters would receive points in this category based on their universal appeal.

Artist cross-over- often times an artist, writer, inker or other professional will cross-over into a different field this can include fine art, illustration, movies, television, fantasy, sci-fi etc. Steranko, Frazetta are prime examples.

Cyclical Interest

In all fields of collectibles, cyclical interest can lead to spikes in value within a particular segment. Spikes are usually temporary but in some instances remain on-going. Factors include:

A collector(s) entering a field and impacting pricing by offering uncharacteristic prices for a very narrow range of items.

Institutional interest such as an exhibit or academic event.

A happening such as a character or titles' anniversary, a movie or TV adaptation may increase (usually temporarily) interest leading to speculation.

In addition, within each collectibles market there are definite segments; in comic book art they may be sectioned by "age" Golden Age, Silver Age, Bronze Age, or by publisher, Timely, Marvel, DC, Image, Centaur, Fawcett etc.

Characters and story lines enter in and out of favor as do artists and titles. In determining a value rating, this cyclical interest should be taken into consideration.

Freshness to the market as defined by the number of times an item has been offered as well as the length of time between offerings.

A high cyclical rating should encourage further inquires into the basis of the rating.

Condition 5 - Excellent condition.

Configuration 10 - One large image, twice up art.

Confirmation 5 - Full points, authentic, obtained directly from Frazetta family and sold on behalf of artist. Documentation included.

Content 10 - Pluses: Main character prominent and in action on the cover. Beautiful women on cover for which Frazetta is noted.

Context 10 - Pluses: Origin and first appearance of Thun'da, appears on cover.

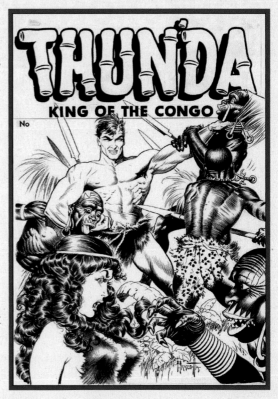

Continuity 2 - While a "clone" of Tarzan the character has had no lasting appeal. One issue only. A short-lived movie serial followed but disappeared.

Creativity 12 - Effective layout and composition, beautiful inking also by Frazetta, controversial subject matter.

Creator 20 - Within category of Golden Age/Silver Age Frazetta at very top of value scale. Frazetta is somewhat unique in that he also inked much of his own work.

Cross-over 4 - Frazetta as the artist receives full cross-over points as he went on to became a leader in Sci-fi/fantasy field. Character was one shot, little or no cross-over appeal beyond the fact that Frazetta created and drew it.

Cyclical Interest 8 - Full points for artist, minus 2 points for the character.

TOTAL: 86 Points

IS THE INVESTMENT IN YOUR COLLECTION WORTH ANY LESS?

The average person will spend 5% of their car's original value every year on car insurance. Your car devalues over time; your collection does not. For this same amount you can protect your collection for years to come.

With E. Gerber's Mylites 4 line of Archival products, your collection will receive the ultimate level of safety and security. This second generation of Gerber's original Archives line provides the same great 4 mil protection, sense of security and world-renowned quality you get from Gerber's original Archives line, but upgraded to include a sealable flap to allow for ultimate protection.

You work hard to build your collection; you should use the collection protection that works hardest for you. Go with the brand used by governments worldwide and the U.S. Library of Congress to insure the safety and protection of the documents that form the very foundation of our country.

E. GERBER – THE #1 NAME IN ARCHIVAL PROTECTION

FOR MORE INFORMATION CALL 1-800-79-MYLAR OR VISIT EGERBER.COM

WHAT MAKES US THE BEST?

FREE 3 DAY UPS SHIPPING!
WITH ORDERS OVER $150
(CONTINENTAL U.S. ONLY)

ALL ORDERS SHIP WITHIN 24 HOURS!

FREE GIFT WITH ORDERS OVER $250!

INTERNATIONAL ORDERS WELCOME!
(THEY'RE OUR SPECIALTY!)

WE ARE ALWAYS BUYING!

WHETHER YOU HAVE ONE BOOK TO SELL OR TEN THOUSAND...

CONTACT US TODAY TO DISCUSS IT - BUYING@BESTINCOMICS.COM

WE CAN TRAVEL TO YOU - AS QUICK AS 24 HOURS!

WE WILL PAY YOU CASH FOR YOUR GRADED COMIC BOOKS,

COMPLETE COLLECTIONS AND BETTER UNGRADED COMICS!

CALL OR EMAIL US TODAY!

BESTINCOMICS.COM

PHONE: 1-866-461-0637 / EMAIL: SERVICE@BESTINCOMICS.COM

COLLECTING BY CREATOR

Art by Alex Toth

One of the most obvious – and yet sometimes one of the most rewarding – ways to collect original comic book art or original comic strip art is to collect by creator. Whether it's a creator who is a personal friend, a hot new talent who has just come on the scene, or an art hero of bygone days, there are many ways to approach collecting the work of a particular artist.

Whether you're talking about the steady output of a long career such as Charles Schulz on *Peanuts*, the diverse output of an inspiring talent like Alex Toth, or dynamic superheroes from a fan-friendly creator such as George Pérez, there are different approaches you can take. Here are just a few:

- **Representative Samples:** Collect pages spanning the creator's career (or tenure at one company).

- **Complete Issue:** Collect the original art for an entire issue of the creator's work.

- **Signature Character:** Collect different examples of the artist's work on his or her signature character.

You can also collect just their covers, just their splash pages, great moments, significant story points, origins and first appearances, and virtually any other sub-set you can apply to comic art collecting as a whole. You can even make it the dominant focus of your collection.

Take for example, Mike Burkey, who bought his first piece of comic book artwork in October 1989, his first day out of the Army after a four-year hitch.

"I saw an ad in the *Comics Buyers Guide* and I decided to buy a battle page from *Amazing Spider-Man* #46 for $110," he said. "I had no idea what it would look like or the size, but that day I opened up that package, I just started looking at the line work by the great John Romita. Seeing Stan Lee's story notes in pencil on the sides of the art board explaining to John Romita how the storyline was to be, when I saw this art that very first time a little light bulb went off in my head and I told myself that this art was going to be very valuable one day to a lot of people," he said.

A month after that, he called the seller, who still had two more pages for the issue, and he purchased them as well. The process opened the door to a new chapter in his life.

He's known online as "Romitaman" for good reason. Not only does he possess a huge collection of John Romita, Sr.'s work on the wall-crawler, pages from his collection have been featured in John Romita's *Amazing Spider-Man: Artist's Edition* from IDW Publishing, and after 23 years he ultimately acquired all 20 interior art pages from *Amazing Spider-Man* #46.

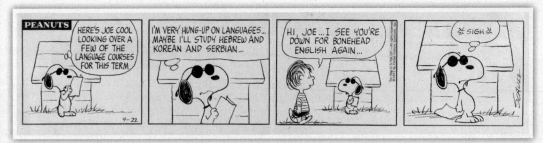

Art by Charles Schulz

Of course even with the most revered artists in comics, sometimes the demand for a particular page can come down the combination of pencil artist and inker, and for many folks it can be one of the most important considerations.

"The differences are so great that the prices paid for a particular inker can vary by thousands of dollars. There is a 'desirable' inker over any artist's pencils. To a certain degree, the collector's own taste makes the difference. But in most circumstances, the marketplace determines who is the most 'desirable or 'valuable' inker over any pencils," said collector Nick Katradis.

And there have been a lot of great teams to consider: Jack Kirby and Joe Sinnott, Ross Andru and Mike Esposito, John Byrne and Terry Austin, Frank Miller and Klaus Janson, Mike Zeck and John Beatty, Steve Rude and Gary Martin, Jim Lee and Scott Williams, and so many others.

"An iconic team like Jack Kirby and Joe Sinnott greatly affects the desirability and value of each piece. There are several art teams that are highly sought after and thus, when the demand is strong and each piece is unique, you know what happens to the price – it goes up!" said collector, dealer and Comic Art Con promoter Joe Veteri.

"It's a huge difference in who inks it. It can be night and day to the point that you question who penciled the art after the inks were done," said Alex Winter, General Manager of Hake's Americana & Collectibles.

"How well those penciler-inker teams mesh, and how their combined styles work with the material, is important. From your examples,

Sinnott was appropriate for Kirby's Fantastic Four, and [Mike] Royer nicely delineated Kirby's *Fourth World*. I'd hesitate more over an inker whose results were poor or mixed: Vince Colletta over Kirby on, say, *New Gods* might give me pause, but Colletta's inking of Kirby on *Thor* seemed appropriate for the material," said Michael Eury, editor of *Back Issue*.

The inking of Jack Kirby's work alone is the subject of many volumes and much debate, and the subjective arguments are just part of the allure of collecting by creator.

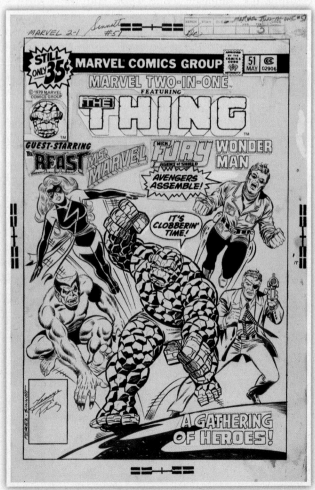

Art by George Pérez & Joe Sinnott

COLLECTING BY CREATOR: JACK KIRBY

Perhaps no other figure contributed as much to the notions of comic book storytelling – even what stories could be told – as artist Jack Kirby.

"A creative dynamo given human form, for many Jack Kirby defined with his work the very idea of what comic books should be. In his art and stories, the obvious brash doses of daring design and explosive action were infused with something more unexpected in the eras in which he worked: an equally bold excitement for the cerebral, philosophical and spiritual," reads his entry in The Overstreet Hall of Fame. "Whether working with partners such as Joe Simon (with whom he co-created Captain America, the Fighting American, Boys Ranch, and many would say the romance comics genre) and Stan Lee (co-creating the Fantastic Four, Thor, and the Silver Surfer, among others), or on his own (DC's "Fourth World" titles such *The New Gods*, *Mister Miracle*, *The Forever People*, or his creator-owned *Captain Victory* and *Silver Star*), Kirby worked as much in metaphor as he did in pencil.

"The number of creators and fans he influenced will never be known," said Alex Winter, General Manager of Hake's Americana & Collectibles, "but based on those who testify openly about his work's impact on them, it's easy to imagine that it's a staggering percentage."

Many of those fans include today's top creators, as well as collectors and dealers, and when discussions of Jack "King" Kirby come up, many of them quickly splinter off into debates of who was the best inker for him. Was it Joe Sinnott? Was it Vince Colletta? Was it Mike Royer? Was it someone else?

If you venture the question, be prepared for a spirited debate.

"Some people like some artists when they are inked by inker A and other like inker B. You should buy what you like but do your research first and learn which teams are more respected. I've been involved in debates on who Kirby's best inker was and people definitely have strong opinions," said Vincent Zurzolo of Metropolis Collectibles. "Next time you see me at a con ask me mine."

Thanks to the efforts of Kirby's colleagues such as writer Mark Evanier and fans such as John Morrow, founder of *The Jack Kirby Collector*, the King's work in comics is probably the most well documented of any artist to work in the medium.

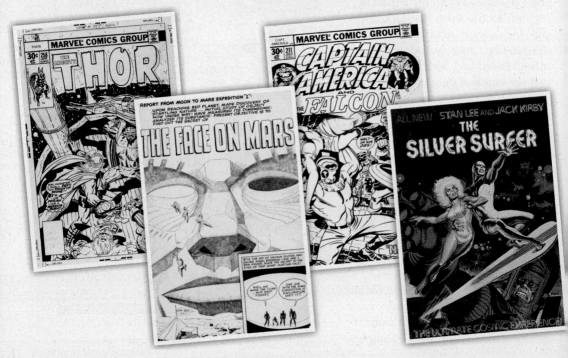

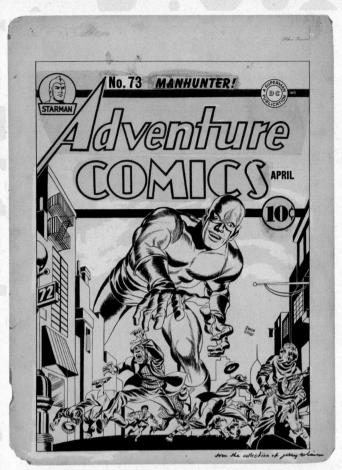

Adventure Comics #73, cover by Joe Simon and Jack Kirby (1942).

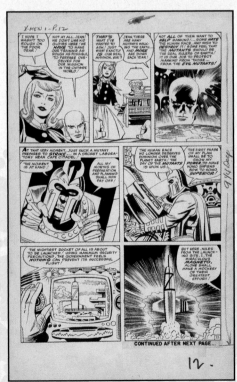

X-Men #1, page 11 by Jack Kirby and
Paul Reinman (1963). Debut of Magneto.

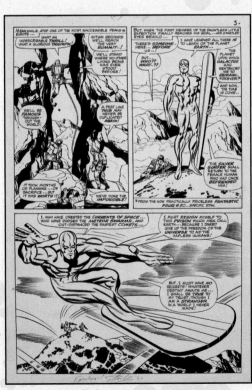

Fantastic Four #55, page 3
by Jack Kirby and Joe Sinnott (1966)

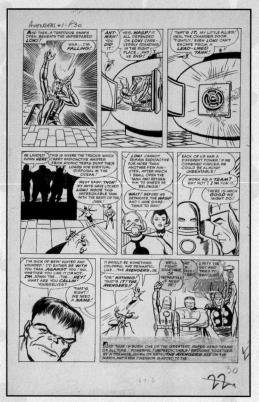

Avengers #1, page 22 by Jack Kirby
and Dick Ayers (1963).
The Avengers are named.

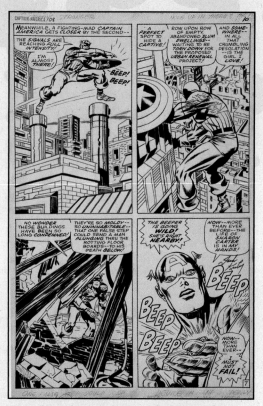

Captain America #108, page 7 by
Jack Kirby and Syd Shores (1968).

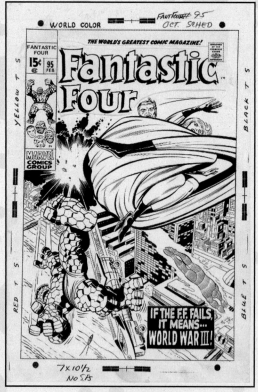

Fantastic Four #95,
cover by Jack Kirby (1970).

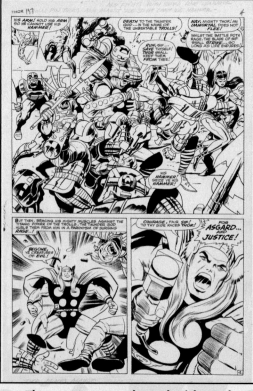

Thor #137, page 4 by Jack Kirby and
Vince Colletta (1967).

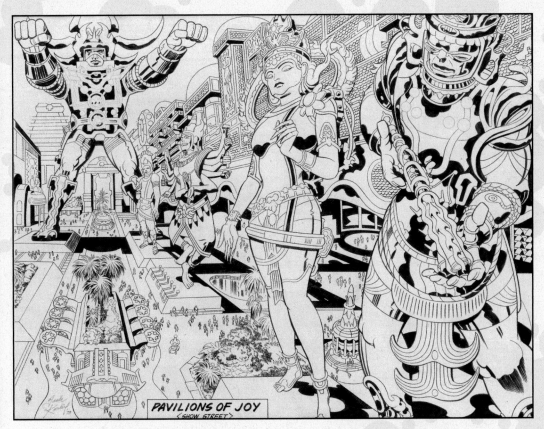

Lord of Light/Argo Pavilions of Joy (Show Street) by Jack Kirby (1978).
Sold for $16,730 by Heritage Auctions in August 2013.

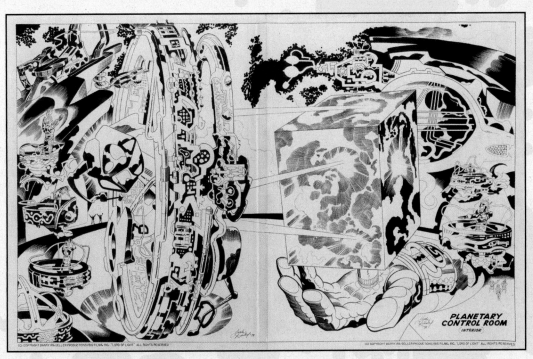

Lord of Light/Argo Planetary Control Room (Interior) by Jack Kirby (1978).
Sold for $23,900 by Heritage Auctions in August 2013.

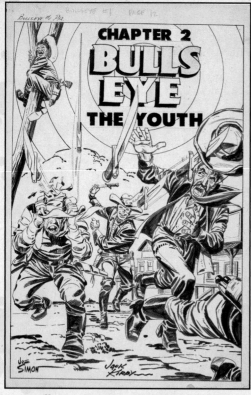

Bulls-Eye #1, page 12 by Jack Kirby
and Joe Simon (1954).

Love Romances #96, page 1
by Jack Kirby (1961).

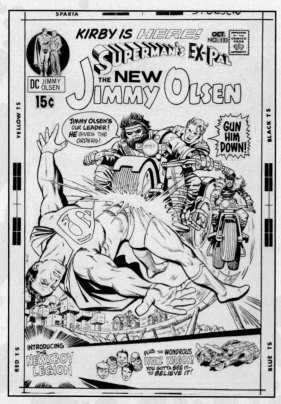

Superman's Pal Jimmy Olsen #133, cover by
Jack Kirby and Vince Colletta,
Superman by Al Plastino (1970).

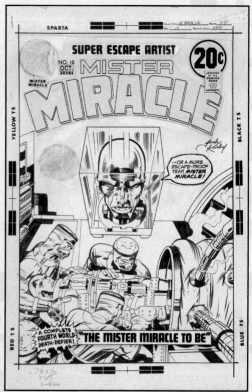

Mister Miracle #10, cover
by Jack Kirby and Mike Royer (1972).

BOOK YOUR WEDDINGS, CORPORATE EVENTS, HOLIDAY PARTIES, BIRTHDAY PARTIES AND MEETINGS AT GEPPI'S ENTERTAINMENT MUSEUM!

LOCATED IN HISTORIC CAMDEN STATION AT BALTIMORE'S PREMIER DESTINATION OF CAMDEN YARDS.

Geppi's Entertainment Museum is a tribute to the characters, toys and collectibles of our past and present. Our main gallery can accommodate up to 400 for an amazing cocktail party. Our third floor is the perfect spot for an intimate sit down dinner.

To Make Your Party a Night to Remember: Contact Danielle Geppi-Patras
Facilities Coordinator • Phone: 410-625-7089 • FAX: 410-625-7090

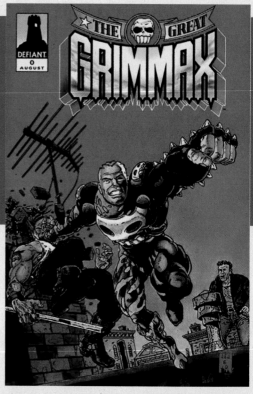

J.G. Jones and the creation of Grimmax #0

In 1993, Jim Shooter launched the comic book company DEFIANT, taking a new direction with the science-infused, imaginative storytelling he had demonstrated in "The Korvac Saga" in the pages of *The Avengers* at Marvel, in *Star Brand* in Marvel's New Universe, and in "Alpha and Omega" in *Solar, Man of the Atom* at VALIANT.

Along with VALIANT alumni JayJay Jackson and David Lapham, Shooter recruited industry veterans such as Chris Claremont, Len Wein, Steve Dikto, Dave Cockrum, and Alan Weiss for the company's projects. He also enlisted numerous newcomers such as Georges Jeanty (*Buffy The Vampire Slayer*), Adam Pollina (*X-Force*), and J.G. Jones (*Before Watchmen: Comedian*).

Jones was clearly a stand-out.

Following his work at DEFIANT, Jones again teamed with Shooter for *Fatale* at Broadway, and then in short succession worked with writers Tony Bedard, Chris Golden and Tom Sniegoski on several *Shi* projects at Crusade, with Brian Augustin on *Painkiller Jane/Darkchylde* at Event, and on *Black Widow* and *Marvel Boy* at Marvel before landing graphic novel *Wonder Woman: The Hiketeia* at DC Comics. Once at DC, he produced a significant amount of work. His most recent effort on comic book interiors came on DC's 2012-2013 *Before Watchmen: Comedian* mini-series with Brian Azzarello.

In 2003, he and writer Mark Millar launched the six-issue mini-series *Wanted* at Top Cow Productions. It was made into the 2008 movie of the same name starring Angelina Jolie.

Once his career took off, Jones became known as an excellent cover artist. With the notable characteristics of energy, vitality, power and great composition, his covers are known for catching – and holding – the eyes of comic buyers, and his originals command serious attention from original art collectors.

Among other achievements, he provided the covers for all 52 issues of DC's weekly limited series *52*, as well as a series of landmark covers for Brian K. Vaughn's *Y: The Last Man* #1-17 at DC's Vertigo imprint. While the majority of his cover output has been for DC, he has also

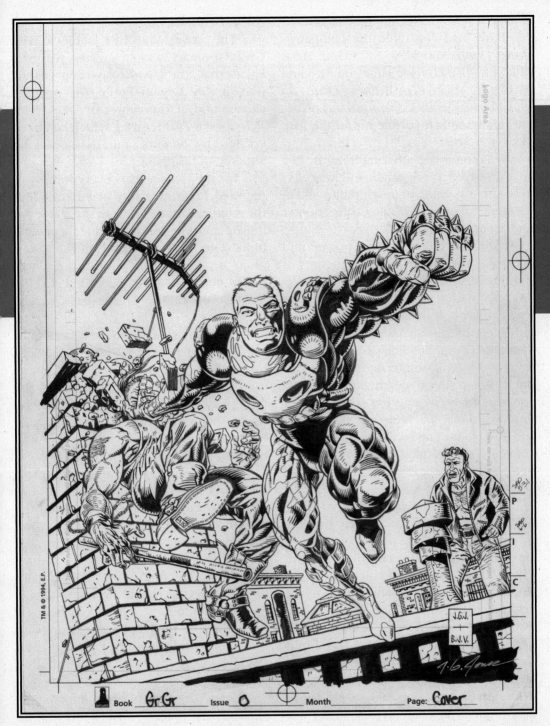

illustrated covers for Black Bull, BOOM! Studios, CPM Manga, Crusade, Dark Horse Comics, Dynamite, Marvel, Image Comics, Speakeasy, and Wildstorm Productions.

His cover for *Grimmax* #0 holds a distinction like none of the others, though. According to Jones, it may have been the first time he was ever commissioned to provide a cover of a comic for which he did not illustrate the interior.

Grimmax #0 (billed on the cover logo as *The Great Grimmax* #0) was an original, eight-page comic by Defiant issued in the polybag of *Hero Illustrated* #15. With a story by Ed Polgardy (now a film producer) and Shooter, a script by Shooter, pencils by former Legion of Super-Heroes and X-Men artist Dave Cockrum, inks by Jose Delbo, colors by Su McTeigue and edits by Debbie Fix, it was designed to

kick off a series featuring the character.

Jones had illustrated the company's *Dark Dominion* #7-9, following Steve Ditko on #0, editor Joe James on #1-3 and #5, Charlie Adlard (*The Walking Dead*) on #4, and Louis Small, Jr. (*Vampirella*) on #6, but this was his first time out of the gate as a cover artist.

"J. G. Jones was amazing from the get-go. He started at outstanding. It was easy to see he was going to develop into one of the great ones, and he has," Jim Shooter told *Scoop*.

"This cover rocks. The power and dynamism in the foreground figures is startling. It's a milestone. It has great significance with regard to J.G.'s brilliant and rising career. It brings to mind those unforgettable, early-career covers by Frank Miller and Bill Sienkiewicz."

"I was an absolute neophyte at this point, still trying to learn how to make comics. Jim, JayJay, and Joe spent a lot of time with me, teaching me storytelling and all of the nuances of working in comics. I had no idea what I was doing, but I was game to try anything," Jones said.

"I was very disappointed that DEFIANT closed its doors before the big Schism crossover storyline came out. It was to cross all of the storylines in all of the DEFIANT books into one big narrative, and I had already drawn much of the first giant, oversized issue, which never saw print. I think that my art was finally improving, at that point, and I was implementing the lessons that Jim and the crew had been trying to hammer into my peanut-sized brain," he said. "It was all so new to me then; I had no idea what I was doing. I'm glad that I had amazing guides to teach me the craft of comics."

"We were crazy about J.G. back then. He quickly became like one of the family. We not only thought he was talented, we felt he had the kind of all around creator potential that he would have already achieved if not for being held back," said JayJay Jackson. "J.G. is a perfect storm of talent and ideas."

ABOUT GRIMMAX

The cover and title subject "The Great Grimmax" was the greatest player of Splatterball, the favorite sporting distraction on the Org of Plasm, the organic, alien world at the center of DEFIANT's *Warriors of Plasm* series, which had been created by Shooter and developed by Shooter and Lapham.

In the sense that everything was recycled, Plasm was very eco-friendly. But the culture placed little or no value on individuality or individual life, so conditions were frequently harsh and almost as often deadly. On this world, there was some personal fame accorded to the greatest of all the Splatterball players, Grimmax.

"Like any sport, Splatterball needed a star player and the revolution needed an inspirational icon. The Great Grimmax is not Spartacus, who was one of the oppressed, nor is he Jonathan E, who loved his sport and unintentionally became an icon of individuality because of his prowess," Shooter said.

"I wanted a man who arrived at his reverence for life by thinking things through. His accomplishments on the field made him realize he was unique, and therefore, were not others? In several scenes, he expresses respect and admiration for opponents," he said. "Eventually, he arrives at the radical, heretical conviction that he doesn't want to kill them. Or anything else. How did I come up with him? I just thought things through. And David Lapham provided a visualization that's, well, killer," Shooter said.

Grimmax #0 depicted the incredible Splatterball player with a newfound respect for life transported to Earth, where he attempts to fit in and live his life by his newly adopted principles.

The original cover art for Grimmax #0 was held privately by one collector since approximately 1996, when it was purchased from the artist, until June 10, 2013, when it was sold by ComicConnect.com for $270.

Over 30 Years Of Experience!

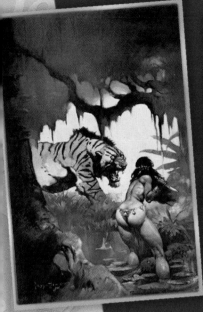

ALL STAR AUCTIONS

The most trusted name
in comic collectibles
world-wide!

www.allstarauctions.net

Free Evaluation

**Auction Your
Collectibles**

Sell for $CASH

**Realize 88% of YOUR
TOTAL selling price!
Consign to one of our
convention events.**

**Only certified
appraisers in the
industry!**

**Let us help you
realize the highest
prices possible.**

The #1
Service
**DEDICATED
EXCLUSIVELY**
to Comics, Original Art,
Animation
& More!

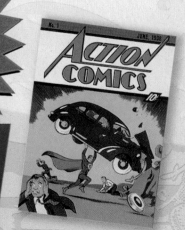

www.allstarauctions.net
allstar@allstarauctions.net
1-201-652-1305

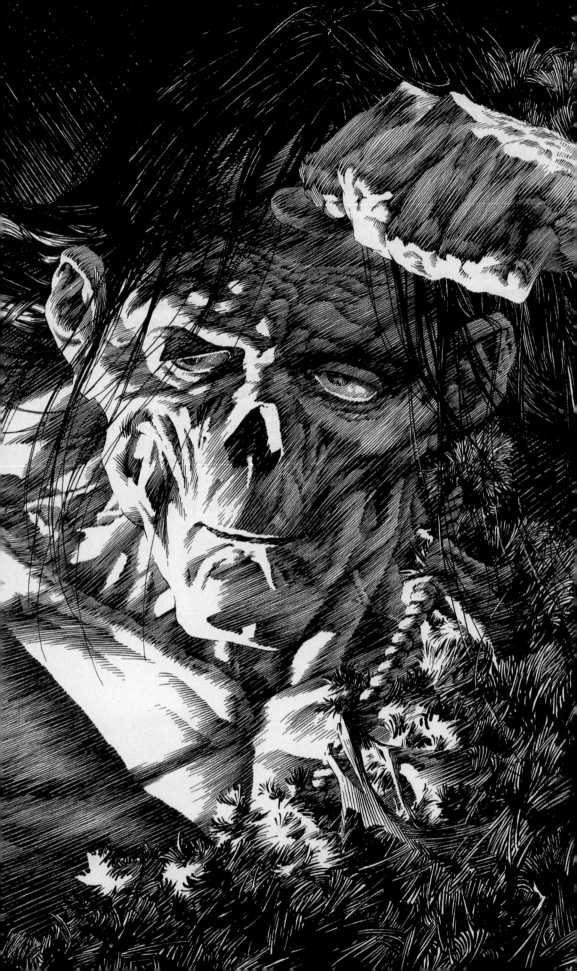

WRIGHTSON
MASTER OF THE MACABRE

The following interview appeared in *Comic Book Marketplace* #105 (August 2003). While some of its contents are slightly dated now, it remains a compelling discussion with one of the most influential artists in comics.

Interview by Michael Kronenberg

In the shadow of the Golden Age of horror movies, EC Comics, and the paperback covers of Frank Frazetta, the seeds of inspiration started to grow in Bernie Wrightson. From his home in Baltimore, Md., he moved to New York City and found success at DC Comics, producing beautiful and horrific work for such titles as House of Mystery and House of Secrets. Soon afterward, Wrightson and writer Len Wein redefined the monster comic book with their groundbreaking run on Swamp Thing.

After a successful stint at adapting such literary luminaries as Lovecraft and Poe for Creepy and Eerie magazines, Bernie tackled his lifelong obsession with Mary Shelley's Frankenstein. Following the successful release of several portfolios of his Frankenstein illustrations and years of hard work, this beautiful tome combining Shelley's words and Wrightson's astonishing drawings was released in 1983 by Marvel.

From the mid to late seventies Wrightson, along with stand-out artists Jeff Jones, Barry Smith and Michael Kaluta moved into a shared working space and formed "The Studio." There, Wrightson produced a series of beautiful paintings, with subjects ranging from Poe and Conan to Dinosaurs and serial killers.

In the eighties and nineties Wrightson returned to the comics field with such projects as Batman: The Cult and Batman/Aliens for DC, Captain Sternn for Heavy Metal, and The Punisher: War Journal for Marvel. At the same time Wrightson began his work in movies. Contributing to both Ghostbusters films, Galaxy Quest, and Spider-Man, among others.

Overstreet: How did Frazetta's explosion on the scene in the early '60s influence you to become an artist and how did that influence your style?

Bernie Wrightson: Oh my gosh. Probably as long as I can remember…something I learned, like monsters and things. When I saw Frazetta's stuff it was like somebody pulled a veil from over my eyes. I saw the stuff and I said, "This is how to do it. This is just the way to draw." I'd been influenced before by comic books, EC comics, when I was a kid—Graham Ingels, Jack Davis, Johnny Craig, Al Williamson, and all those guys. I didn't even know their names when I saw their work, but I guess all that stuff kind of came together. Early on I tried copying Frazetta to the best of my ability, which wasn't very well. But over time I guess I just mixed that with all the other influences and came up with my own methods and the style that I have.

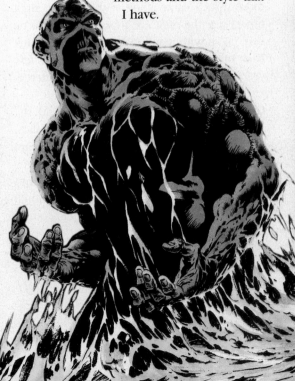

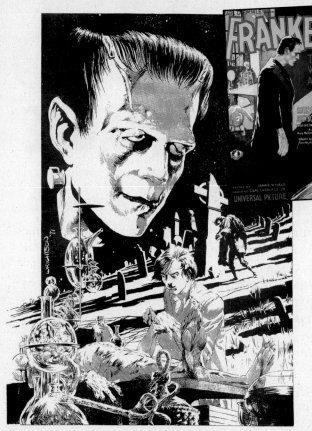

An early Frankenstein drawing by Bernie, showing the influence of the 1931 film starring Boris Karloff.
INSET: The six-sheet to the James Whale classic.

these things called fillers, and they were two or three pages of whatever they needed to fill out the comic book. Because at the time their ad space was restricted to a certain number of pages and they had to make the rest up with content. It's not like it is now where it seems like half the comic book is advertising.

Overstreet: Can you tell us about the *Frankenstein* book and the portfolios? You seem obsessed with the subject.

Wrightson: Well, I guess I've always been obsessed with Frankenstein. I saw the original 1931 Boris Karloff *Frankenstein* on TV when I was a kid. Again, that was like being in the right place at the right time. It really took hold of my mind and I became very fascinated with the movie and eventually reading the book when I was 10 or 12 years old. I don't think I even got through it the first time; I tried, but it was just so different from what I was expecting. It was a bear to get through—it is really not a terribly well written book. Trying to wade through it was a real

Overstreet: Which is uniquely your own.

Wrightson: I guess it is. I have to really strongly credit my influences. I wouldn't be doing this now if it weren't for them. Frazetta, well, all those guys. I came along at the precise right time; I was the right age to see that and to be very taken with it and excited about it. I think back on it, if that had come along just a few years later it probably wouldn't have mattered.

Overstreet: Your first successes were in the fanzines and in privately produced portfolios. When did you decide to go into mainstream comics?

Wrightson: I did a few things for fanzines, but I actually started working for professional comics pretty early. I started working in comics in 1968, but I don't think anything was published until 1969.

Overstreet: Who was the first to publish you?

Wrightson: Oh, it was DC. I did stuff for the *House of Mystery*. At the time they were doing

Cover to Shelley and Wrightson's *Frankenstein*, published by Marvel (1983).

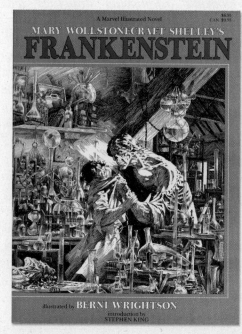

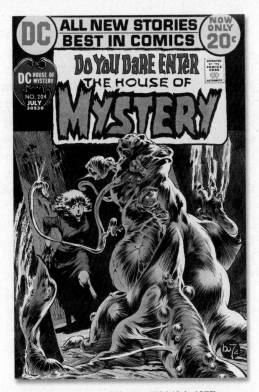

Cover to *House of Mystery* #204 (July 1972).

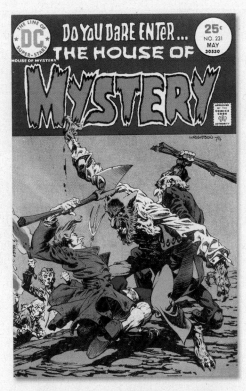

Cover to *House of Mystery* #231 (May 1974).

chore. It was a few years before I actually picked it up again and read it and actually finished. I felt that the book wasn't as good as the movie, so I put it away and forgot about it. Eventually I picked it up again and read it for the third or fourth time. Each time I read it I found something more, there was another layer there, that this is actually a really good story, it's really saying something. The writing is kind of clunky and old fashioned, but that's just the surface or how it's presented. The ideas behind the book were just really striking. For a long time I thought about adapting the book as a comic book—what we call graphic novels now—but that never really seemed to go anywhere. At some point I thought rather than adapt this story and diminish it by trying to hammer it around to fit some other medium, why not just illustrate the novel itself. That's where it started. I couldn't give you a real time line on that because I know I had this stewing in the back of my mind for a few years before I actually started to do it.

Overstreet: You put out the portfolios quite a bit of time before the book was released, and I assume trying to get the book published is a story in itself.

Wrightson: Well, my first thought was that I wanted to self-publish. It was never an option to me to go to a publisher with this and say, "Okay, look, I want to do this very opulently illustrated edition of *Frankenstein*. And I want to do all the illustrations in pen and ink and it's all going to be in black and white and it'll look like woodcuts." And then have the publisher say, "Oh, this sounds like a good idea, but we want color paintings," and want this and want that. I'd been working in comics and publishing for a few years and I knew well enough that you're pretty much at the mercy of the people that are paying. I thought, "I'm not going to do that with this. I'm going to do this on my own time with my own dime. I'm going to do it the way I want it, and when it's all done I'll find somebody to publish it or I'll publish it myself." That was the idea behind the portfolios—a way to finance getting the book published. Of course, it didn't work that way. I printed the portfolios and I sold them, and then the money needed to go to bills and food and taxes and other things. Before you know it, the money's gone. And I still haven't gotten the book finished. I just decided to stop thinking about that. The important thing is to get the book done and I'll worry about getting it pub-

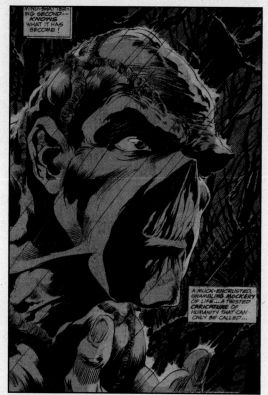

Our first close-up view of what Alec Holland has become, from page 15 of *Swamp Thing* #1 (Nov. 1972).

it. Living in Baltimore, sometimes if the weather was just right and it was raining and the signal bounced off the clouds in just the right direction I could pick up Zacherley from Philadelphia—but it would come in with a lot of snow and static. But our guy was Dr. Lucifer. Yeah, *Shock Theater*, I think Friday or Saturday night at 11:00 or 11:30, and they had the standard personalities—Frankenstein, Wolfman, the Mummy. I was crazy about those movies. It was great stuff and I bought every issue of *Famous Monsters*.

Overstreet: And *Famous Monsters* was great to get just for the Basil Gogos covers.

Wrightson: Oh, yeah. Inside were great photos, background, and stuff about the actors. I think maybe my favorite was *Castle of Frankenstein*. It didn't last very long, but it was just packed, the print was tiny and they just filled those pages with information.

Overstreet: Do you have a favorite piece, something you're really proud of?

Wrightson: I don't know that I have a favorite. I get asked that a lot and I hate to nail it down. They're like my children and I don't want to show favoritism. I really like all of them in different ways for different reasons.

Overstreet: Do you still have any kind of relationship with Frazetta?

Wrightson: I haven't really spoken to Frank in 30 years. We were never really close friends. I've always admired him from afar. I think he's just so huge in my life that I still feel a little intimidated.

Overstreet: Mike Kaluta:

Wrightson: We keep trying to get together. We

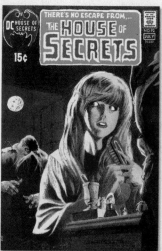

Cover to *House of Secrets* #92 (July 1971), the first appearance of Wein and Wrightson's Swamp Thing.

lished when all the drawings are done. It was six or seven years, I think, that I did the illustrations from time to time. Whenever I had a week or two between paying jobs I would work on a Frankenstein drawing. Sometimes for longer than that until I really needed the money and I'd have to find a paying job. It took a while but I did manage to do it the way I wanted.

Overstreet: The only time it was published was the Marvel trade paperback, right?

Wrightson: No, there is a second edition. Eventually I want to do a subsequent edition and retool it a little bit—not do any new work for it necessarily, but just redesign it.

Overstreet: So how much influence were the old Universal horror films and did you watch *Shock Theater* while you were growing up in Baltimore?

Wrightson: Absolutely. We had a host named Dr. Lucifer who was played by an old B actor named Richard Vicks who used to be in old westerns. Everybody was a rip-off of Zacherley—I think Zach was the first guy to do

correspond through emails and phone calls, and whenever he's in California or I'm in New York we keep trying to get together, but we keep missing. He's one of my oldest, dearest friends and I wish we had more time to spend together.

Overstreet: And Len Wein?

Wrightson: I see Len occasionally. He lives out here in the neighborhood. And Marv Wolfman.

Overstreet: With your love of EC comics, how did you like working with Joe Orlando at DC Comics?

Wrightson: Joe was just an absolute joy to work with. He was the best editor. He was more than an editor, he was a collaborator. I really miss Joe and I really miss those old days.

Overstreet: When you're doing your comic book work, how much photo reference do you normally use?

Wrightson: Very little to none at all. Using reference has always been a real pain in the ass to me. First you have to collect all the stuff; then

you have to organize it and file it; then, when you're working, you have to go find it. There are guys who can do that. I just never got in the habit of using it. It was always easier and faster for me to just make it up, unless I had something really specific. Cars—I hate drawing cars. I'll find ways around drawing cars; maybe I'll just put a piece of the car. When you're drawing cars, you need the reference.

When I started drawing, nobody else in my family [drew], and, except for a friend or two, there was nobody around telling me I couldn't do it this way. I just assumed that everything I saw, all the paintings and drawings I saw, were just made up. The idea of producing a reference just never occurred to me. I just thought, okay, just learn how to draw all this stuff. And that's what I did. Until now, just the way I do it. To this day I hate producing reference.

Overstreet: Any thoughts on Alan Moore's depiction of Swamp Thing?

Wrightson: I love it! He took a character that had really reached a dead end. And literally reinvented it. And just brought so much more to the character and the story. So much more than would have ever occurred to me. When I was doing it he was a monster hero and that was pretty much it. So you have a monster hero so you pit him against other monsters. You pit him against monster villains. And after a couple of years of that I just got tired of it. This really isn't going anywhere. This is basically the same story every month or every two months. So I gave it up and didn't really look at it for a long time. Went on to working for Warren. And then a few years later Alan Moore and John Tottelbon picked it up and I thought it was just wonderful. It was great it isn't even the same character anymore.

Overstreet: It's nice that both versions are remembered. Neither one has eclipsed the other.

Wrightson: That's what kind of amazes me. I saw the Alan Moore stuff and I immediately thought, boy, we're just a bunch of old fogies, now this came

COURTESY HERITAGE COMICS

From the original art, the splash page to *House of Secrets* #92 (July 1971), the first appearance of Swamp Thing, art: Bernie Wrightson.

The stunning climax from Bernie's adaptation of H.P. Lovecraft's "Cool Air," from *Eerie* #62 (Jan. 1975).

along and it's going to completely eclipse what we did and nobody is going to remember that. So, yeah, it really kind of amazes me that people are still so fond of it.

Overstreet: Your latest comic book work has been the covers for the *Batman: Nevermore* miniseries. Do you have any other upcoming DC work?
Wrightson: Not at the moment. I kind of got out of comics. I've been doing it for so many years— just kind of got burned out. I went looking for other things to do. I've done some film work, conceptual stuff. That started with *Ghostbusters*, I worked on both *Ghostbusters* movies and then occasional movie stuff. Whenever something comes along.

Overstreet: If you could be offered a dream project, something that you really like to do, something that you could pour your heart and soul into, what would that be?
Wrightson: At this point I don't know. There is nothing that really springs to mind. At my age I really have to think about getting married to a

project for several years. Just pouring that much time and that much energy into one thing is one of the things that got me out of comics. The last couple of comics things I did just took so long. The *Batman/Aliens* thing that was kind of a turning point, because that was just two books and it took me like two years. And it didn't pay all that well. I managed, I survived but mostly it was the time. I'm too slow to be doing this anymore. Two issues of a comic book shouldn't take two years. I just realized that I just didn't love it that much anymore.

Overstreet: Well, it is a beautiful set of issues. So there is nothing in comic books that you're dying to do, you're done with that?
Wrightson: Well I learned a long time ago to never say never again. That always comes back to bite me in the ass. So I'm not going to say I'll never do comics again, because you know I might change my mind next week. Something might come along or maybe I'll get an idea that is just so brilliant and wonderful that I've got to do it. Right now at 11 AM on August the 7th, 2003, I don't want to. But talk to me next week and the whole thing might change.

Overstreet: Now, still on comics, the horror anthology seems to be dead in comic books— would that be something that you would be interested in doing again, if someone approached you about it?
Wrightson: I don't know. I see horror anthologies like independent things. I don't really much care for the direction that it seems to be going.

Overstreet: I guess I just miss the old days of *House of Mystery*. I miss all of that stuff.

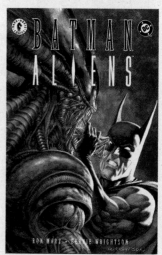

After laboring two years on the two issue *Batman/Aliens* project, Bernie decided he'd had enough of comic book work…for now.

Wrightson: You can still go back and read the ECs.

Overstreet: Are there any current comic book or comic book artists that you enjoy reading? Or that you follow?

Wrightson: I'm so far out of the loop right now that I really can't think of anybody. I occasionally see something that really impresses me, but for the life of me right now nothing comes to mind. I think the last thing that I read that I really enjoyed was *League of Extraordinary Gentlemen*. I liked that so much that I refused to even see the movie.

Overstreet: I think that's pretty much the feeling all around for anyone who has read the comics or the graphic novel.

Wrightson: I just thought, why do I want to see it. I've seen the trailers for the movie, and I thought if I see the movie it's going to taint my memory of the graphic novel.

Overstreet: Tell me about the film work that you are doing and overall what you're working on now.

Wrightson: Just last week I did some conceptual stuff for *Blade 3*. I was working with K&B Effects Company who is putting in a bid for *Blade 3*, and I did some concept drawings for them. There is not a lot of movie work around right now. Not that I know of, or not much of anything that I'm really interested in. Since I've been out here living in the LA area for five years, I designed the monster for *The Faculty* and I worked on *Galaxy Quest*, did some work on *Spider-Man*, and a bunch of movies that never got made. That's the nature of the business.

Overstreet: I was just about to say that. You do stuff and it doesn't come out. Am I mistaken, or does your website mention that the book of your art is going to be put out again? Or are you doing another version?

Wrightson: We're talking about it. You remember *A Look Back*…

Overstreet: Yes, I have it.

Wrightson: We're talking about picking up where that left off, and doing something up until the present.

Overstreet: Would it include everything that is in *A Look Back* and proceed to the present, or is it going to be a whole new volume of stuff?

Wrightson: It will be a whole new volume. I haven't really sat down and thought about it yet. I think maybe a quick summarization of *A Look Back* and then move forward. We'll see. I don't know when it will come out.

Overstreet: Well I want to thank you for all the years of horror and beauty, laughter and entertainment. I really appreciate you giving me the time to speak to you.

Wrightson: You bet, I should mention what's in the works right now. We're trying to get *Captain Sternn* done as a CGI thing—either a feature film or a TV show or something.

Overstreet: That would be great. Didn't he make his first cinematic appearance in the *Heavy Metal* movie?

Wrightson: That's right. His first comic book appearance is in *Heavy Metal Magazine*

Overstreet: Yeah, I loved *Captain Sternn*. When I mentioned laughter that's what I think about.

Wrightson: Thank you. I did a five-issue thing of *Captain Sternn* years ago. And I had a lot of fun doing that. So we're trying to get it off the ground. And we'll see what happens.

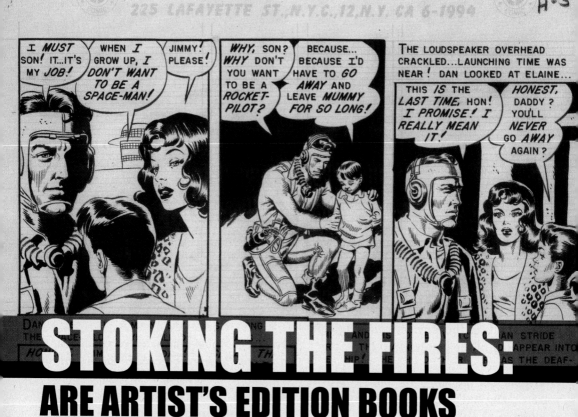

STOKING THE FIRES:
ARE ARTIST'S EDITION BOOKS INSPIRING COMIC ART COLLECTORS?

By S.C. Ringgenberg

In the last several decades, prices for original comic art have skyrocketed, leaving many collectors unable to acquire art that in previous eras may have been expensive, but was within reach for people of even modest means. Back in the '70s, EC Comics fans were lucky enough to have access to Russ Cochran's EC portfolios, black and white collections of stories, with color covers (re-colored by E.C.'s colorist Marie Severin) that were shot from Bill Gaines' legendary horde of original EC artwork. For many years, Cochran's six EC portfolios (published from 1971 through 1975) were as close as any fan could get to owning original EC art. They were printed on matte-finish paper stock that was similar to the illustration boards EC provided to its artists, and the reproduction was crystal clear. Until just a few years ago, Cochran's portfolios

were the gold standard by which all other comic art collections were judged. Eventually, Cochran made a deal with Bill Gaines to publish every EC comic (and all of the Picto-Fiction magazines) in a uniform format, hardbound volumes encased in slipcovers, with black and white interiors and color covers. Cochran even went the extra mile with the *MAD* volumes, publishing them in both black and white, and color volumes (again, re-colored by the great Marie Severin). These books sold out quickly and are now expensive collector's items.

Then, once all of the artwork had been photographed for reproduction, Bill Gaines began selling it off, which generated a great deal of excitement among art collectors (and a nice chunk of change for Bill Gaines, which he was cool enough to share with his original contributors). At

last, here was the chance to own EC pages and covers, including work by Graham Ingels, Jack Davis, Johnny Craig, Wally Wood, Al Williamson, Reed Crandall, George Evans, Alex Toth, Frank Frazetta, and all of the other greats whose work had graced the pages of various EC titles. But, since each page was one-of-a-kind and there was only a finite amount of it, inevitably, some fans were left wanting pages that they couldn't afford and had to settle for buying the collected EC Library. Some EC artists, such as Johnny Craig, Graham Ingels, and Al Feldstein did do paintings that recreated characters and EC covers, but those were also expensive and highly prized.

So, what's an art fan of modest means to do to acquire original art, short of selling a kidney or something? The good news is that IDW, Titan Books, and Genesis West are now offering Artist Editions, limited-edition, large size volumes shot directly from the original art in color, so that every pencil line, brush stroke, smudge, blot of white-out, and mar-

gin notation is visible.

After seeing and handling several of these books, I have to say that they truly are the next best thing to owning the original art, from the large size of the images, to the amount of detail you can see in each page. The editor who deserves all of the credit for coming up with this unique product is IDW's Scott Dunbier who explained that his inspiration for doing the Artist's Editions came from a number of different sources, "For one, I was a big fan of the old tabloids that DC did in the early '70s. I loved seeing Joe Kubert's *Tarzan*, for instance, blown up big, and then later on Barry Smith's "Red Nails" in that beautiful treasury that he did the coloring for. Then, years later, when color copiers came into play, I wound up as a member of an original art APA [Armature Press Association]. I would occasionally contribute color copies of artwork because I found that just black and white scans looked terrible. So, while it was very expensive at the time to do color copies, to get the results, I felt it was worth it. And

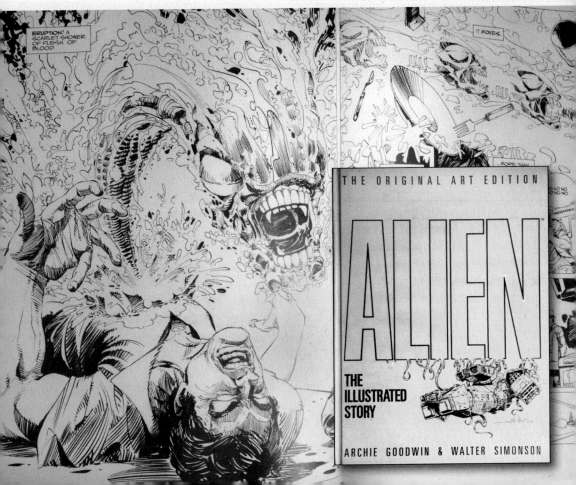

then the third part was probably, there was a book that Chip Kidd did in probably the early 2000s on Batman collecting, and there was a Neal Adams Batman page that was photographed in color from the original art, and that probably was the trifecta, those three."

So far, IDW has been the clear leader in publishing these volumes, but other publishers are taking notice of the strong sales and starting to follow suit, notably Titan Books, which has put out a volume of Walt Simonson's original art for the *Alien* graphic novel adaptation (written by the late, great Archie Goodwin), which has been published in both a general release edition, and a signed limited edition. In addition to reprinting the original art full size, this volume includes these features: Simonson's never-before-published color try-out pages, his early sketches, and a complete, annotated version of Archie Goodwin's script, rounded off with a long, in-depth interview with Simonson and his art director John Workman, detailing the creation of this masterpiece.

Interestingly enough, Simonson noted in a recent interview, the two-page spread of the Nostromo crew stumbling upon the giant derelict spacecraft, and the page showing the Alien bursting from Kane's chest, were done even larger than the other 14" by 17" pages so that he could lavish more detail on those particular pages, and as a result, they are the most striking pages from the entire graphic novel.

At this point in time, Walt Simonson is the only artist to have Artist's Edition books out from different publishers. When asked how his experience differed working with IDW and Titan, Simonson said, "The only real difference I suppose is that I did more real business with Titan by e-mail than by actual phone call, whereas I was talking with Scott Dunbier every twenty seconds when we were doing the *Thor* book. And also Scott came here to scan a lot of the artwork, whereas one of my friends was hired by (Titan). I have an assistant, Steve Hovicky, and Steve did the scanning for the *Alien* book. So, the procedure was a shade

different. He also dropped in the lettering digitally, scanned the lettering as well. So, in some ways it was a bit more work to get the scans for the IDW book print-ready, or at least ready for us to send them off to IDW, because the lettering (originally done on overlays) had to be composited with the artwork, but as far as the two companies, they both treat me very well. I'm delighted with the end product in both cases, and it's nice to have a couple of books of my old stuff out there."

A smaller publisher, Genesis West, has recently entered this new publishing arena, putting out a volume that collects all of Barry Windsor-Smith's 58 pages for the adaptation of Robert E. Howard's *Red Nails* that he drew from Roy Thomas's script in a 14"x19" hardbound book that totals 136 pages and includes creator biographies and commentaries. *Red Nails* originally saw print as a two-part saga in *Savage Tales* #2 and #3, back when the title was revived in the early '70s. You and I will probably never own any of Smith's pages from this story, but we can see what the original art looks like, down to the last smudge and bit of white ink. However, unlike IDW and Titan, both which chose to print their Artist's Edition volumes on matte-finish paper similar to what the original art was drawn on, Genesis West published *their* portfolio on paper with a slick finish. Despite the amount of fine detail visible in the published book, one can only wonder what their editors were thinking in selecting this kind of paper, whose glossy surface makes it harder to view the artwork. *Red Nails* is available from Genesis West for $150.

While Artist's Editions are a great way to look at the work of your favorite artists and they are relatively inexpensive compared to trying to collect original art these days, they are not cheap. Most of them run in the neighborhood of $125 to $150, and all have small print runs (IDW editor Scott Dunbier, who originated Artist's Editions, is tight-lipped about specific numbers), so that if you can't afford the first printing and it sells out, you're out of luck and will

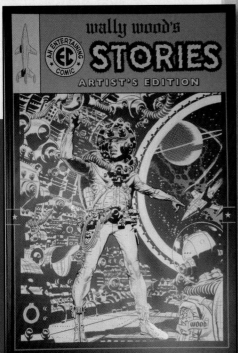

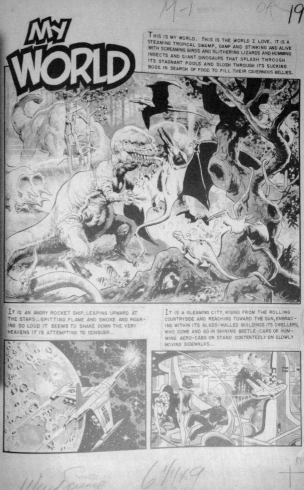

MY WORLD

THIS IS MY WORLD. THIS IS THE WORLD I LOVE. IT IS A STEAMING TROPICAL SWAMP, DAMP AND STINKING AND ALIVE WITH SCREAMING BIRDS AND SLITHERING LIZARDS AND HUMMING INSECTS AND GIANT DINOSAURS THAT SPLASH THROUGH ITS STAGNANT POOLS AND SLOSH THROUGH ITS SUCKING BOGS IN SEARCH OF FOOD TO FILL THEIR CAVERNOUS BELLIES.

IT IS AN ANGRY ROCKET SHIP, LEAPING UPWARD AT THE STARS...SPITTING FLAME AND SMOKE AND ROARING SO LOUD IT SEEMS TO SHAKE DOWN THE VERY HEAVENS IT IS ATTEMPTING TO CONQUER...

IT IS A GLEAMING CITY, RISING FROM THE ROLLING COUNTRYSIDE AND REACHING TOWARD THE SUN, EMBRACING WITHIN ITS GLASS-WALLED BUILDINGS ITS DWELLERS, WHO COME AND GO IN SHINING BEETLE-CARS OR HUMMING AERO-CABS OR STAND CONTENTEDLY ON SLOWLY MOVING SIDEWALKS...

6¾" x 9"

have to buy a copy on the aftermarket, which can sometimes double or triple the original price within weeks of the book selling out, depending on scarcity and the popularity of the artist involved.

Wally Wood's EC Comics Stories: Artist's Edition was the third AE book IDW published. It sold out almost instantly, and proved so popular that it has already gone through several printings, including several different comic con exclusives with variant covers, including editions offered at Comic-Con International: San Diego and Wonder Con. If a book is popular enough with fans, IDW will reprint it, as is the case with the very first Artist's Edition of the late Dave Stevens' *Rocketeer*, which has now gone through several printings, and is still available from the publisher as of this writing. EC aficionados have further treats in store when IDW issues Artist's Editions featuring a second edition of *The Best of EC*, and two volumes featuring the EC work of fan favorites Graham Ingels and Reed Crandall.

The question remains: are these books worth what they cost? If you examine one, you'll see that they are printed the same size that the art was originally creat-ed. Sizes vary since the older art, such as Wood's EC Comics pages, were drawn on art boards that are 15" x 22", far larger than most contemporary comics art. Walter Simonson's art for his *Thor Artist's Edition* and his Alien movie adaptation are on 14" x 17" paper, which are smaller, but still large enough to show every detail (and every small flaw, patch of whiteout, etc.). It's extremely interesting to be able to see and study the condition of the original art. To quote IDW's advertising copy: "While appearing to be in black and white, each page was scanned in color to mimic as closely as possible the experience of viewing the actual original art—for instance, corrections, blue pencils, paste-overs, all the little nuances that make original art unique. Each page is printed the same size as drawn, and the paper selected is as close as possible to the original art board." To get this kind of find detail, editor Dunbier noted that all of

the artwork is scanned at 600 dpi.

However, in Dave Stevens' case, his artwork is just as pristine as it appears in print. Dave was such a perfectionist that if he made a mistake, he didn't use white ink to cover up errors, he'd pitch the page in the trash and begin again. Some of the reprinted Rocketeer pages did contain autographs or inscriptions to the people Dave sold them too, but IDW eliminated these, perhaps to preserve the privacy of the current owners.

But on some of these books, one can see the brown stains left by 30-40-year-old rubber cement, the red lines used to indicate color effects, blue pencil notes, and even the last vestiges of incompletely erased pencil art. In some cases, there are even notes between artist and editor, artist and writer that are mostly functional, but sometimes give unexpected insights into the creative process. It's a whole new way of looking at the cartoonist's art, especially the work of really meticulous draftsmen like Al Williamson, Frank Frazetta, Wally Wood, or Mark Schultz, to name just a few of the talented creators featured in these volumes. These books are unique in that they offer a window into each artist's creative process in a way that you wouldn't get in an ordinary book that simply prints their cover art or stories in a conventional format.

As to the physical package on the IDW Artist Editions: the bindings are stitched and reinforced, just like a museum quality fine art folio. One only has to handle one of these books, and feel its heft to understand why they are so costly. They hearken back to an earlier era of quality illustrated books and folios as they were published in the late 19th and early 20th centuries. IDW in particular, under Scott Dunbier's astute editorship, has done a magnificent job with these books. Aside from the quality of the printed product, Dunbier has also shown excellent taste in providing books that feature a wide variety of different artists and styles, from the bravura art and stories of EC Comics (featuring a wide variety of artistic styles from Al Williamson, Frank Frazetta, Johnny Craig, Harvey Kurtzman, Joe Orlando, and others) to Gil Kane's dynamic and graceful anatomy on Spider-Man, Sergio Aragonés' hilarious, gag-and-tiny-figured-packed *Groo*, to Jeff Smith's

gently humorous *Bone*, two different editions of Kubert's gritty and dramatic *Tarzan*, and his seminal caveman strip, *Tor*, as well as fan favorites John Byrne on *The Fantastic Four*, John Romita on *Amazing Spider-Man*, and David Mazzuchelli on *Daredevil*, Mark Schultz's lushly rendered draftsmanship on *Xenozoic Tales*, an upcoming volume on the wacky and wonderful Basil Wolverton, and of course Wally Wood's amazing drawing and inking on his solo collection of EC Stories. Within the realm of IDW's Artists Editions, there really *is* something for everyone, from old-time collectors to the contemporary fanboy.

One of the real visual treats from IDW is actually one of the smaller Artist's Editions, the *Michael Golden G.I. Joe Yearbook*, which is published as a series of 21 loose plates inside a hard cover. This book is unique in that all of the interior pages are double-sided, so you can either read it as a giant black and white comic book or simply feast your eyes on Michael Golden's lush inking, beautifully-rendered vehicles and hardware, and muscular action sequences without letting Larry Hama's brain-dead, gun-porn script get in the way of enjoying the art. Personally, I think this one is better without the balloons, but it's nice to have a choice.

On the other hand, Titan Books *Alien—The Illustrated Story: The Original Art Edition* benefits greatly from being able to read Archie Goodwin's intelligent, fast-paced script, something artist Simonson heartily agrees with: "Honestly, I kind of like comics you can read. I understand that it's a facsimile art book, really, but reading it, it would be a nice experience to be able to read it big like that in the original art edition that Titan was doing." Golden's *G.I. Joe Yearbook* is also one of IDW's more bargain-priced Artist's Editions at a very affordable $40. So far, the Golden book is the only one that's been printed two-sided, but according to IDW, there may be others offered in the future. Among the other lesser-priced IDW Artist's Editions that have proved popular with fans are Neal Adams' *Thrillkill*, collecting his harrowing, beautifully illustrated story for Warren's *Creepy*, and Berni Wrightson's *Muck Monster*, a gorgeously rendered retelling of the Frankenstein story. Both of them were short: eight loose pages inside a hard cover and both have already sold out, and are now appearing on the aftermarket for several times their original $29.99 price, if you can find them.

So far, the Simonson *Alien* book is Titan's sole entry into this style of art book, though they have put out volumes on various film artists. Here's hoping that Genesis West will score a success with their *Red Nails* collection – just released as this volume is going to press – so they can publish books featuring either more Barry Windsor-Smith artwork, or branch out into collections featuring other creators.

In the final analysis, books like IDW's Artist's Editions are worthwhile for a number of reasons: they afford the true art lover a chance to closely study the comics pages and covers of their favorite artists. They also seem like a superb investment. All of the IDW Artist's Editions that have gone out of print are now selling on eBay and elsewhere for many times their original price. Finally, they offer the average collector a chance to own a book or portfolio that is quite literally the next best thing to owning the original art.

S.C. "Steve" Ringgenberg has been a freelance writer since 1980 and has interviewed over 200 people, including comics professionals, illustrators, painters, film personalities, even two Apollo astronauts. Among his many published works, he has written comics scripts and articles for DC, Marvel, Bongo, Heavy Metal, and Dark Horse. He also authored six young adult novels for Simon and Shuster, co-wrote the book Al Williamson: Hidden Lands, *in addition to contributing articles and interviews to the notes for Russ Cochran's Complete E.C. Library. For 12 years, he wrote the Dossier column for* Heavy Metal. *Currently, he is writing biographies of the E.C. Comics contributors for Fantagraphics.*

BY SCOTT BRADEN

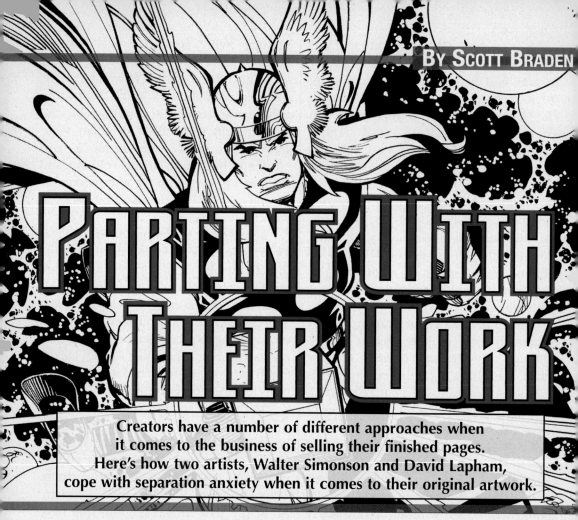

PARTING WITH THEIR WORK

Creators have a number of different approaches when it comes to the business of selling their finished pages. Here's how two artists, Walter Simonson and David Lapham, cope with separation anxiety when it comes to their original artwork.

Eisner Award-winning creator David Lapham, who has worked in comicdom since 1991 ("So that would be about 400 years," Lapham laughed.), found it difficult to sell original art at one time — but he doesn't anymore.

"There's just too much," Lapham continued. "If I really like something then I can keep it, but there's always a new challenge and a new thing to like. If it's important to me, like the first cover I ever did (which was *Rai* #1 from Valiant) then I have that, but by and large, if I can't frame and display it, it's just going to sit in a box. I can scan it or make copies of it easily enough in case I have a publishing use down the line. Now, with that said, I have nearly all of my *Stray Bullets* artwork — which is about its importance to mine and my wife's lives and its market value compared to personal value."

On the other hand, comic book legend Walter Simonson — who has been working in the four-color medium for more than forty years — doesn't worry himself with separation anxiety over his original art. He just doesn't sell his work.

"I sold one page once, and spent the money," recalls Simonson. "Then I didn't have the money and I didn't have the art. So I gave it up."

With all the work that goes into a page of original artwork, Simonson — like others — believe there is a connection between an artist and his work.

"I just think the work is a part of the artist that he or she chose to reveal," said Simonson. "That connection is always there."

Lapham agreed, "I think it's because you do spend so much time on it. For something that the reader is going to look at and turn the page in less than a minute, you spend hours and sometimes days with these images, creating the little details. For me, often times you run little

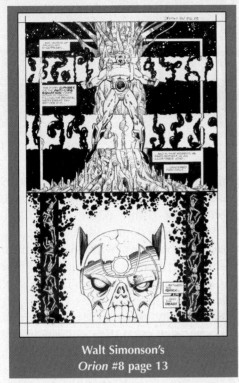

Walt Simonson's
Orion #8 page 13

stories in your head about a background character, 'why is she reacting like that? what was she doing?' or thinking 'maybe some drunk left that broken bottle I just drew in the gutter.' Designing an interior where a fight will happen or a character's home. There's a lot of thinking in the details and a lot of time. All that brings attachment. Or maybe people just think 'I spent 39 cents worth of ink and 12 cents in white out. Not to mention the cost of that half piece of pencil lead I used.'"

While we're on the subject of attachment, how long does the average comic book artist work on a page of original art?

"Wow. I don't know about other artists. I assume everyone is faster than I am. Even guys who miss all their deadlines and only come out with one book a year. I assume they actually only took a half-hour to draw an amazing page and spent the rest of the year laying by a pool sipping Mai Tais and reading Jack Kirby comics. Personally, I think about six hours is an average time. Though it depends on the story and the shot — it could take far, far longer for that special shot.

"I personally have had pages take anywhere from a fraction of a day to two or three days. Time depends on many factors, including storytelling, image complexity, cast of characters, and a host of other things, including deadlines. If you take more than 30 days to do 20 pages, you're not doing monthly comics."

It's not a problem for Simonson, but for Lapham, how does he cope with the loss of his work — or does he?

Well," said Lapham, "hopefully it made somebody happy and hopefully by selling it I was able to do something even more wonderful with the money. By and large, I try to sell art for things that add bonus or good times for my family. Holidays, birthdays, vacations, etc."

As for other comic book artists that can't bear to let go of their work, Lapham said, "Do what makes you feel comfortable. Why sell a page just to sell it if you're going to feel regret afterwards. I would say examine why you're not selling it. If it's because you're a hoarder, then it's probably better to sell the pages before rats and cockroaches poop all over them. Then you have nothing!"

Simonson, instead, offers this advice: "The secret to life is storage space."

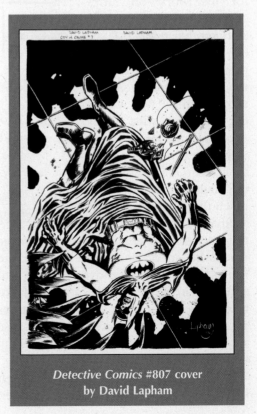

Detective Comics #807 cover
by David Lapham

In the Digital Age, What Is Original Art?

By J.C. Vaughn & Scott Braden

For collectors of original comic art — and indeed art of many different media — the digital age seems to have thrown a monkey wrench into the works. Even when traditional elements are part of the process, the existence of one, true original can be in doubt. To go a step further, though, when a piece is created on a screen and then output, what truly is an original? As it turns out, this is not a new query.

"The problem goes back to the beginnings of print-making. A print maker, a lithographer or silk screen artist, all would insist that their art is not complete until it is printed. And that means every copy of the print is an original," said writer-artist Mark Wheatley, a veteran comic book creator known for his work on *Mars*, *Tarzan*, and *Breathtaker*, among other projects.

"But the art world prefers to think of an original as being unique. And so a compromise was worked out that the artist would sign and number and occasionally remarque the prints to make them originals. In the digital realm, things are much the same. There can be an infinite number of digital originals. A first generation digital image would be an original source. Once the image is copied and re-saved, we are into second generation images and can ignore those. But all the first generation images are originals. Doesn't matter, really, because what most people really want is something unique," he said.

Collectors of original comic book art know that there are differences between the work done in the 1930s and work done today. For instance, in addition to a change in the physical size of the pages, there's a major difference in how lettering is done. Most comic pages through the early 1990s were done with hand lettering or paste-up balloons. With the exception of a few practitioners, most modern lettering is done on the computer. The art itself is not touched in the process.

Additionally, many modern craftsmen know very well what their colleagues will bring to the table. An artist such as Greg Land, for example, understanding what is expected of modern colorists, provides a very minimal amount of illustration on the page compared to someone like Joe Kubert. The final result of Land's work is often considered breathtaking, but those who look for that level of work on his penciled and inked pages may be disappointed. And of course that's just one example.

Consider this: a pencil artist finishes his page. He or she scans it and delivers it electronically to the inker. The inker could actually print it out, ink that printout, scan it, and send it to the colorist. The colorist could then complete his or her work, either on the computer screen (more likely) or on the printout (not as likely), and then send it to the letterer, who plies his or her craft.

So, which page in that process is "the" original? Our first inclination is to say the pencil artist's page, but then what about the inker's page, which is clearly a unique, creative part of the process? This is not something either artists or collectors have

A pencil page from Mark Wheatley's "Skultar" (*Dark Horse Presents*).

answered to everyone's satisfaction yet. One thing we know is that whatever the method or process, there's still a lot of work that goes into making a comic book page.

Brent Anderson is another veteran comic book illustrator, whose credits stretch from Pacific Comics' *Somerset Holmes* and Marvel's *Ka-Zar* to his current long run on *Kurt Busiek's Astro City* at DC, and he knows what goes into the work. "The monthly schedule adhered to by the biggest comics publishers require the artist(s) to produce 20 to 24 pages of printable material approximately every 30 days. Since each page averages four to five panels per page, and since each panel has anywhere from one to five or more visual elements, there are often as many as 300 separate visual elements in the 'average' comic story. This is a lot of work, especially if the artist can't just 'make it up' on the fly and needs to do a little research. Personally, and I'm not sure if I'm 'average,' it takes me at least six weeks to produce 24 finished *Astro City* pages, four weeks to pencil same for another artist to finish, and two weeks to lay out the basic storytelling for someone else to finish. Depending on mitigating factors a single page could take as little as a day-and-a-half or as much as a week to finish," he said.

He said that the positive aspects of creating comic book work digitally is the freedom to undo 32 brush strokes of an unsuccessful

The finished art from the same page of Skultar.

drawing, do very quick ink fills, and to erase pages with the click of a button. It's clean, no hand-washing, and doing detailed work is easier when one can enlarge the image to any size on the monitor. There are negatives, however.

"Not having the same tactile visceral feeling of pencil, pens and ink on paper," Anderson continued. "[There are] no originals at the end of the process, [there's a] reliance on a massive technological foun-

dation to access the work and the need to back up files constantly and consistently," he said.

According to Anderson, he started the transition to digital in the late spring of 2009, using Corel Painter 11, a much more artistic intuitive approach to digital drawing and painting than was available in Photoshop, the industry standard, at the time.

"My first published digital work was *Astro City: Dark Age Book 4* #1 (March 2010). I still do pencil storytelling layouts on paper, but after those sketches are scanned into the computer, everything else is done using the digital tools in Painter," he said.

With this new way of producing comic book artwork, in terms of original art, how does it change the paradigm for collectors? What do creators like Anderson or Wheatley sell to art collectors?

"When I got right down to answering the question 'Why do I do comics?' I came to one conclusion: I don't draw comics to create original art; I draw comics art as a means to an end, to publish and print comic stories. The artwork is a means to an end, a by-product, a disposable step toward the ultimate goal. Disposing of the original art has always been a major pain and, conversely, a major delight when the right piece of art was delivered into the right hands," Anderson said.

For his part, Wheatley said he makes his prints unique. "Just like the traditional print makers — we sign, number and remarque the prints. Other artists have gone out of their way to have some physical piece of art, used in making the final, digital image. But I think that is a bit forced and won't survive, except as needed in specific cases — where a physical brush stroke is absolutely what is needed to make the image work. The fact is, physical art work is going to become much more rare," he said.

Joe Jusko on *Avengers* #58

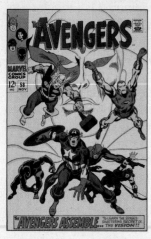 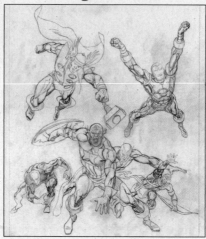 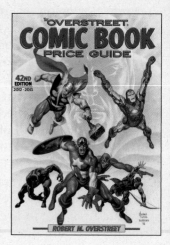

From the *Savage Sword of Conan* to *Vampirella* and from *Heavy Metal* to the 1992 Marvel Masterpieces trading cards, Joe Jusko has painted most of the great comic characters and plenty of newer or lesser-known ones, too.

The lighting, tone, character physiques and dynamic action of his paintings has earned him a distinct reputation, one that we were eager to employ on the cover of *The Overstreet Comic Book Price Guide*. Once we knew Joe was interested in doing a *Guide* cover, we just had to find the right subject. We narrowed it down to John Buscema's awesome cover for *The Avengers* #58, and the result was magic. Joe not only captured the real feeling of the original, he added more power to it.

Overstreet: It's often called a "classic," but what actually makes the original *Avengers* #58 such a great cover?
Joe Jusko (JJ): A lot of things contribute to its "classic" status. Aside from the incredible composition, it's from the year of Marvel's big expansion, 1968, when they truly became the industry powerhouse. It's drawn by one of comics' greatest artists, "Big" John Buscema, whose art became the "house style" at Marvel for a generation and, most importantly, it's the climactic issue to a story arc revealing the origin of one of

Marvel's most popular characters, The Vision.

Overstreet: In approaching a recreation like this one, what's your preparation like?
JJ: While many artists diverge to a great extent from the source material when doing an homage, I like to keep as much of the original cover's identity as possible. I think keeping the proportions, composition and especially the color true to the original helps evoke a sense of nostalgia in the minds of the fans. It's easier with artists whose work is realistically rendered, like Buscema or John Romita Sr., than it is with Jack Kirby, whose anatomy was very stylized and requires a lot more thought when translating his drawing to a more realistic interpretation.

Overstreet: You've recreated Buscema's work before. What are the consistent high points of his illustrations as far as you're concerned? Are they different from what makes his work so good from a fan's perspective?
JJ: Buscema was the artist who most influenced my career path and from whose work I learned to draw as a kid. Since I was so familiar with his work I was always the "go to" guy at Marvel when it came to painting over him. Always an honor but always an

intimidating assignment, as well. John's figure work was beyond reproach. He was able to convey mass, weight and movement in a way that made the most fantastical characters seem real. With a subtle (but not simple to draw) twist of a hip or turn of a head he could project such natural mood and attitude. His figures didn't sit on a chair, they sat in a chair. While he was a true fan favorite during Marvel's Silver Age, and certainly fondly remembered by fans from that era, I think he has become more of an artist's artist in recent years, held up on a pedestal for his pure draftsmanship.

Overstreet: What do you find attractive or compelling about *The Avengers* issues from that era?

JJ: Everything was still pretty new, Marvel Comics as we know it only being six to seven years old. Some of the most popular characters today were being introduced on an almost monthly basis, and the art and stories were a revelation from everything else done before or even at that time from other companies. On *The Avengers*, Roy Thomas and John Buscema were as perfect a writer/artist team as there will ever be and seemed to feed off each other to create really exciting, memorable comics. John's interpretations of Roy's plots and Roy's dialogue, obviously written expressly to the postures and attitudes of John's figures jelled into perfect storytelling.

Overstreet: When you do your own work, it's very imaginative. Do you feel constrained when you're trying to do a faithful recreation or is it more a test of your craft?

JJ: Different sensibilities certainly come into play when doing recreations and reinterpre-

tations. The spontaneity of creating my own work is replaced with a more technical approach because I now have to determine the best way to interpret someone else's work in a totally different medium. Many times the compositions are not something I would have chosen for a painting or the anatomy needs to be tweaked to make the painted figure work, while keeping the original artist's spirit intact. I did a recreation of *Avengers #4* by Jack Kirby several years ago and enjoyed the challenge of translating the King's unique figure work to a more realistic vision, while still keeping the quirkiness of his poses evident.

Overstreet: It always seems like you're able to add something to the pieces. Is that "something" a consistent thing, or is it different from piece to piece?

JJ: I think simply rendering the line drawings into a painted medium brings a lot of my stylistic identity to the finished product. Hard for it not to, even though my main objective is to retain as much of the original artist's soul as I can.

Overstreet: How long has doing an Overstreet cover been on your list of things to do?

JJ: Years! The *Guide* cover has always seemed like a reward more than just another job, sort of an acknowledgment that you've hit a certain level of respect in the industry. I am so totally flattered to have been asked.

In addition to many other projects, Joe Jusko also provided the recreation of John Buscema's Silver Surfer #1 *cover for this book and a recreation of his own Spider-Man piece from the 1992 Marvel Masterpieces trading cards for the cover of the first book in this series,* The Overstreet Guide To Collecting Comics.

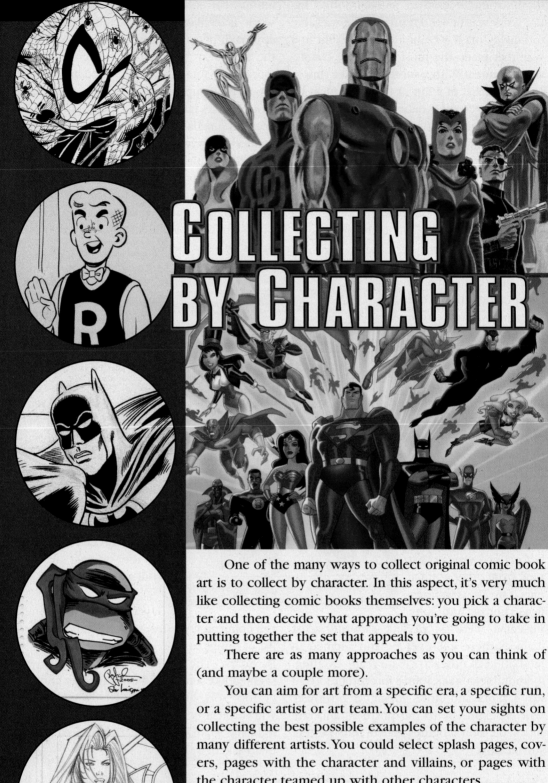

Collecting by Character

One of the many ways to collect original comic book art is to collect by character. In this aspect, it's very much like collecting comic books themselves: you pick a character and then decide what approach you're going to take in putting together the set that appeals to you.

There are as many approaches as you can think of (and maybe a couple more).

You can aim for art from a specific era, a specific run, or a specific artist or art team. You can set your sights on collecting the best possible examples of the character by many different artists. You could select splash pages, covers, pages with the character and villains, or pages with the character teamed up with other characters.

Perhaps you'll only want art by the character's creator or first artist. Maybe you'll decide on just collecting the character from that period he or she was illustrated by your favorite artist and nothing else.

The important thing is it's all up to you.

The two recurring themes you'll hear – or more precisely, read – from the expert dealers and collectors quoted in this book are 1) collect what you love, and 2) get informed. Those admonitions are true no matter what approach you take to collecting, and they're certainly valid when collecting by character.

If, for instance, you're going to collect Batman, there are things you should know right out of the gate: as a very popular, long-lived character that has taken on a life far afield from comic books themselves, the demand for key pages of Batman art is likely to be higher than, say, Aquaman, Ant-Man or Arion, Lord of Atlantis.

It's not that we have anything against those characters. In fact, whether we like them or not doesn't even enter into the equation in terms of evaluating the marketplace. It's about whether other people want the same pages you might be interested in purchasing, and to what degree do they want them.

Again to use Batman as an example, in general pages from *Batman* and *Detective Comics* will have a broader appeal, though pages from the mini-series *Batman: The Dark Knight Returns*, the original graphic novel *Batman: Son of the Demon*, and other series, mini-series, and one-shots have commanded serious attention.

Spider-Man is another character that has been featured in multiple series, and deciding which of those series – or all of them – you want to collect original art from is worth some contemplation. In terms of demand from the market – and just speaking on average – art from *Amazing Spider-Man* attracts more attention than art from *Spectacular Spider-Man* or other series.

"In general that is the case. For proof, look at the prices realized from major auction houses," said Joe Veteri, co-promoter of Comic Art Con. Of course that hasn't stopped some seemingly insane record prices being set for Todd McFarlane's covers and pages from the adjectiveless *Spider-Man*.

And none of that means that pages from Alex Saviuk's beloved run on *Web of Spider-Man* or Cloak and Dagger's first appearance (illustrated by Ed Hannigan) in *Spectacular Spider-Man* aren't worth collecting.

Remember, while there are many things to which we can point to evaluate a piece of art, its appeal to you remains subjective. Only you can make that call. Getting an understanding of the market should aid in your decision.

THE ART OF CAPTAIN AMERICA

One of Joe Simon's recreations of the original concept illustration for Captain America (2000).

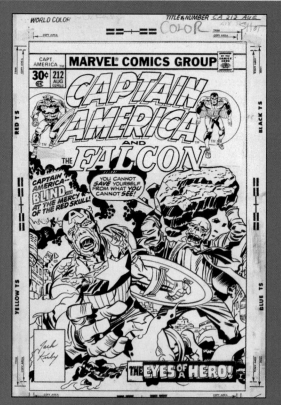

Captain America #212, cover by Jack Kirby (1977).

Hostess Fruit Pie ad page by Sal Buscema and Joe Sinnott (1978).

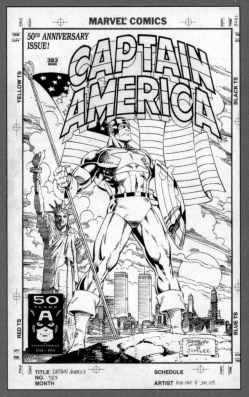

*Captain America #383, cover
by Ron Lim and Jim Lee (1991).*

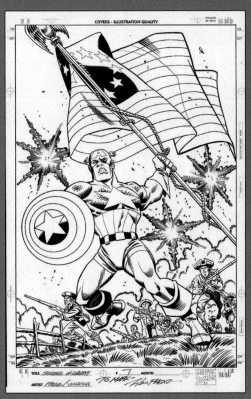

*Captain America: Sentinel of Liberty #7,
cover by Ron Frenz (1998).*

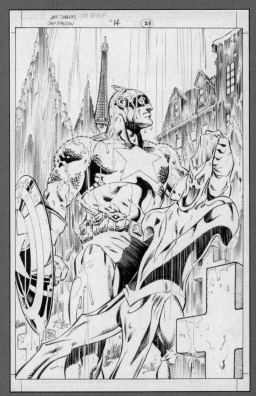

*Captain America and the Falcon #14, page 23
by Dan Jurgens and Tom Palmer (2005).*

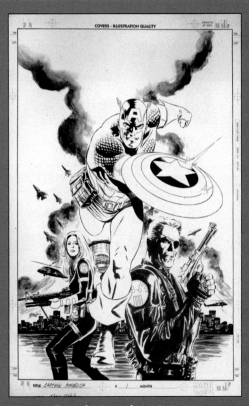

*Captain America #1, cover
by Steve Epting (2005).*

THE ART OF THE BATMAN

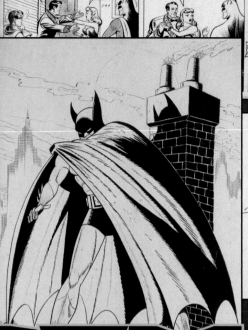

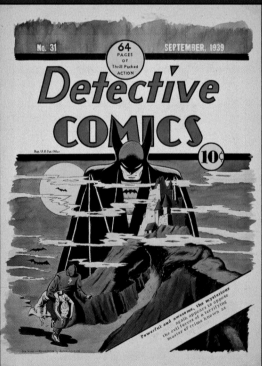

Detective Comics #31, cover recreation
by Murphy Anderson (2001).

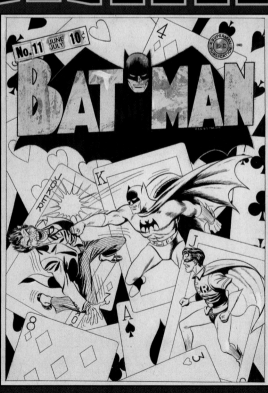

Batman #11, cover
by Fred Ray and Jerry Robinson (1942).

*Detective Comics #415, cover
by Neal Adams and Dick Giordano (1971).*

*Batman: The Dark Knight Returns #3, page 1
by Frank Miller and Klaus Janson (1986).*

*Batman #497, page 19
by Jim Aparo (1994).*

*Kingdom Come #4, page 4
by Alex Ross (1996).*

ORGETTING HER QUARREL WITH
HE CHEETAH, THE LOVELY
MAZON MAID TURNS TO HELP
TEVE!

APHRODITE
GIVE ME
STRENGTH!

Collecting
By Character:

As in collecting comic books or any other niche in the fields of comic character collectibles, collecting original comic book, comic strip and animation art can certainly be attempted as a character-centric endeavor. For Alice Cloos, the character she has focused on has been Wonder Woman.

Cloos has strong opinions about what she likes in her heroes: "I was always attracted to strong female characters with classic themes, so I was eventually drawn to Wonder Woman. I love the fact that her origin is based on Greek and Roman mythology and that she is a liberated, classically trained woman. It's important to me that William Marston's wife suggested he write a story that would have a role model that females could relate to and aspire to be like."

Her collection spans comics, various forms of original art, toys, and more. Like most great collections, it didn't come together all at once. She didn't start collecting comics until she attended her first convention, one of the late pioneering convention promoter Phil Seuling's last ones before his death. As she puts it, "up till then I had no real experience with comic books. I was a science fiction fan before I ever read a comic."

From a reprint in *Wonder Woman* #196 (October 1971), Wonder Woman saves Steve Trevor.

WONDER WOMAN

by Art Cloos

As Cloos got into comics, she found she liked *Angel Love* and *Ms. Fury*, and then developed a passion for the Dell adaptations of classic books like *Alice In Wonderland*. "I really enjoyed those Dell and Gold Key books a lot. Oh, and I really went for Richard and Wendy Pini's *Elfquest* and Eastman and Laird's *Teenage Mutant Ninja Turtles*."

Wonder Woman, though, really caught her attention. She identifies herself as "a completist," so she likes to have the whole set of anything she collects. "So I started going to comic shows and comic stores to look for *Wonder Woman* and *Sensation Comics*. I made up checklists to keep track of what I had and what I needed. I started reading *The Overstreet Comic Book Price Guide* to determine prices, conditions and issues for the series.

"I also started to network with other collectors and dealers to get information and to help locate the books I needed. It was hard in the beginning because dealers didn't always take me seriously because I was a girl until they saw my lists and realized how hardcore I really was. Also in the beginning there were not many older Wonder Woman comics available in the high-grade condition I was looking for at the shows I was going to. I was very particular about the condition of the books and that stood out to sellers. Eventually I finished all the runs and related comics such as the key issues of *All Star Comics, The Big All-American Comic* one shot, etc.," she said.

Even before Wonder Woman, toys were her first collecting love. She enjoyed going to toy shows and antique stores looking for things that appealed to her, particularly wind-up toys.

"I was lucky since a fair amount of vintage Wonder Woman toys were available back then and I was able to find what I wanted in terms of condition which was almost as important to me for toys as it was for the comics. Wonder Woman toys were a natural next step to go along with the comics. I found that I was drawn to the art on the packaging and since some of that art was very appealing to me it encouraged my wanting to buy the toys," she said.

The pursuit of comics and toys brought her to original Wonder Woman art. As sellers realized that she was a serious buyer, they in turn started looking for the specific comics and toys they knew she would purchase. Eventually, since she had everything — at least in their perception — they started asking what she was going to do next.

"I always loved fine art and spent tons of time in The Metropolitan, the Whitney and Guggenheim museums in New York City. That made moving into comic art a natural fit for me. I knew from the beginning I was going to focus on Wonder Woman since I already was collecting the comics and the toys," she said. In the beginning she started by going to the Warner Bros. stores, buying their Wonder Woman art created specifically to be sold by them as limited runs, such as a

giclee painting by José Luis Garcia López, who of course drew Wonder Woman in comics.

"I got a chance to meet him at the store and I was able to get him to sign my painting and personalize it with special highlights on the leaves. I purchased Robert Lee Morris sculptures and jewelry designed by him, too. In addition I bought many of their limited-edition prints including the Warhol-inspired four-image print of Wonder Woman, which is a real eye-catcher when you first see it when you walk into the room where it is hung," she said with a big smile.

Following that, she started buying Hanna-Barbera animation style guides of Wonder Woman by Alex Toth for the *Super Friends* cartoon show, as well as production cels of Wonder Woman and Cheetah (her favorite Wonder Woman villainess). "One of my favorite animation pieces that I have framed on the wall is a cel from a 1981 Post cereal TV commercial, and I know exactly where in the commercial the cel appears thanks to YouTube," she said. "I also have art from the opening animated sequence of the *Wonder Woman* TV show, which is also framed on the wall."

After that, she focused on original comic book art. "My favorite artist is Harry G. Peter. I also love George Pérez and José Luis Garcia López. In addition I do like some of the newer works by Jim Lee, Cliff Chiang and Bernard Chang.

When it comes to a page of art, she said she first looks to see how often Wonder Woman appears on it.

"I want to see if she is in many of the panels or only a few. I like to see her in her Wonder Woman costume. I look for some of my favorite poses like bullets and bracelets. I especially like to see the invisible jet. I also look for Steve Trevor or Cheetah. I focus on the way her face and signature hair are drawn too."

"I will buy the art of any part of a Wonder Woman comic that appeals to me of course but I think I prefer interior pages because I like to see Wonder Woman in action. I love when she is shown standing in the bullets and bracelets pose, riding in her jet or in a romantic moment. I also like when Wonder Woman is showing her strength like lifting a car by herself or beating on a bad guy. Having said that, I do go for covers, too. One of my recent additions is the cover to *Adventure Comics* #460 with Wonder Woman holding Steve as she fights Hell itself to save him. It's an amazing cover," she said.

To her, the value and significance of a particular piece helps determine whether she purchases it to hang on the wall or to simply be added to her portfolio.

"Is it one that has great monetary value? Is it the first appearance of a character? Then I think it may be more protected if it is framed. Of course framing is a problem in general because we fight a constant lack of wall space in our house for any new additions. Putting it into a portfolio is an easier solution, and that gives me more access to the back of the piece, too, as some artists use the back of the boards to do preliminary sketches before starting the finished art. Also, if the piece is in a portfolio, it may be better protected from fading — even with using UV glass for the framed pieces — though generally that is not a concern," she said.

In general, she prefers pieces from *Wonder Woman* or *Sensation Comics* in which Wonder Woman is the main character, but she has purchased pages (material) from other titles such as *Comic Cavalcade*, *Justice League*, *World's Finest* and *Adventure Comics*, among others. When it comes to a personal favorite,

the choice for her is difficult, but she goes to a Harry G. Peter-illustrated page she has framed and on display.

"I would have to say, I love my framed comic page by Harry G. Peter the most because a full page of his is so rare. I like that my page has close up faces of Diana Prince and that Wonder Woman is seen in full-figure running. Of course, I love all my Peter art the most even if all of it is not full-page pieces. I think it was such a horrible thing that DC ordered so much of its early art destroyed and most of what still exists of Peter's art is only panels and not whole pages," she said.

"My second favorite would have to be the full page of a later artist, Bob Brown, from *Wonder Woman #231*. The page has the invisible jet in several panels, a close up of Wonder Woman with Steve Trevor, and dialogue where Wonder Woman says she could stop World War II (during which it takes place) with her lasso, but it would not be a permanent solution. I love that page a lot," she said. "Really, though, it's a tough question because I have Wonder Woman comic art pages from Gene Colan, Curt Swan, Don Heck/Vince Colletta, Mike Sekowsky, Ross Andru/Mike Esposito, Ross Andru/Dick Giordano, Kurt Schaffenburger, Paul Kupperberg/Rich Buckler, Jose Delbo/Joe Giella, Irv Novick/Mike Esposito, Kevin West, and Bernard Chang as well. As you can see, while I collect art and artists from all time periods I tend to favor the more vintage pages and artists," she said.

Cloos collects original sketches as well, if she likes the artist's style or the particular pose of the character.

"I like poses when the face is full-on and the way the expression of the face is designed is important to me too. I like when the artist adds important details like Wonder Woman's lasso, Paradise Island, or the plane. I also like when I get to meet the artist and commission a sketch of Wonder Woman or Wonder Girl exactly how I like to see them, and of course I get to have the signature of the artist that way," she said.

Her sketches include work by George Pérez, José Luis Garcia López, Neal Adams, Ramona Fradon, Lynne Yoshii, Rusty Gilligan and others.

"Irwin Hasen did a wonderful full-color sketch for me a few years back, such a sweet man. I have animation sketch art from Dave Bullock. I have a painting done by Boris that gets a lot of comment," she said. "If Wonder Woman is the subject I will consider it."

Cloos has high hopes for people who collect comic art and the hobby in general: "I think the future is very bright. I think that a lot more people are interested in comic and comic artists than in the past. When I go to shows, I see more eager collectors and artists who are younger getting involved. People are seeing comic art and comics as an investment, so they are willing to spend more. I think the field will continue to expand because it is easier now to do business on sites like Cafe Press, Etsy and Red Bubble, along with the more traditional venues of the past."

Overstreet Advisor Art Cloos, the subject's husband, conducted the interview for this feature at the request of Gemstone Publishing's J.C. Vaughn, who also worked on this piece.

PASSION PROJECT:

Rob Hughes, a comic book dealer, collector, historian, and Overstreet Advisor, felt compelled to create his own comic book character, Luna, Moon-Hunter. A veteran of the industry, he knew how things were supposed to work . . .

When we see the finished product of a comic book artist's endeavors or even when we are afforded a peek at the work in progress, we generally react to the work itself. This only makes sense, doesn't it?

We see the power or subtlety of the scene, the complexity or simplicity of the composition, and the boldness or delicacy of the line work or brush strokes. If the work features familiar characters, we quickly judge their portrayal, or if instead it features new characters we make snap evaluations about its accessibility. And we instinctively evaluate it against that almost-impossible-to-explain standard of "Is it cool?"

So it's not really surprising that when we're holding a beautifully-rendered page or a dramatic cover, the first thing in our minds isn't "I wonder if this artist has a healthy relationship?" or "What's his track record with deadlines?" or "If she takes an assignment, does she communicate well with her editor?" And yet, to state the obvious, artists are people, too. They possess every virtue and fall prey to every vice the same as the rest of society. Except, they have skills that most comic book and comic strip fans only dream about having. Even for those of us who work with artists regularly, their talent and body of work can obscure real-world problems and manage to surprise collaborators or employers.

"When I first began the project, because of the amount of years I had been involved with the various

Luna, Moon-Hunter, has been a consuming project for creator Rob Hughes.

aspects of the comic book industry, I was rather confident that once I had made the initial deal with any particular artist (page rate, deadlines, etc.), that that would be the largest hurdle I would have to face during the life of the project. Hiring the right talent is always the majority of the battle — getting the people who can produce the artwork in the way I envision is paramount to me. I thought that if I got the right 'thoroughbreds,' if you will, then all I would have to do is open the gate and let them run," said Rob Hughes, creator of *Luna, Moon-Hunter*, a long-gestating graphic novel that is entering the final stages of production as we go to press with this book.

"I also figured that since the script was so full and detailed and the fact that I was willing and able to supply the artist with as much reference material as would be necessary, then those factors would be essentially key in aiding them to illustrate the story the way I wanted it to look: epic, grand, and I hope unforgettable," he said. "Unfortunately, there were extenuating circumstances that were unpredictable and completely out of my control. Sometimes they happened to me and other times to the artists involved in the project. I believe that I ran smack into some of the most horrendously difficult problems any creator possibly could face," he said.

"Initially, I had a heck of a time finding an artist whose artwork I really liked and who was available. In an industry that has so many artists looking for work, and because of the fact that I was offering a very fair and competitive page rate for both pencils and inks, I never believed it would have been so tough finding and hiring the right artist for *Luna*," he said. "I remember Thomas Yeates, the artist I worked with on *The Outlaw Prince*, telling me, 'When it comes down to selecting any particular artist for your project, there are three key factors that must be taken

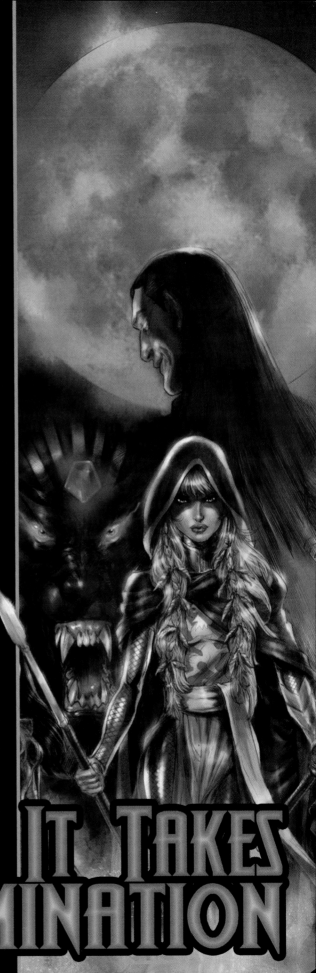

It Takes DETERMINATION

into account. First, do you like the artist's work? Second, can you afford that artist's page rate? And finally, is the artist reliable? If you can get two out of three then you're doing well,'" he said.

Hughes said he understood that since his expectations for both the line art (the traditional pencil and ink pages) and the finished colors were very high, the project would require more time than most for the individual pages to be completed to his specifications. The amount of detail he provided in the script and reference materials elicited a uniformly positive response from the artists and color artists who reviewed them. That, however, didn't stop things from getting bumpy, and the first bump was a big one. "In one profoundly distressing word: death," Hughes said.

"I spent 2005 working on the initial draft of the story, which was originally 64 pages. I then went about looking for an artist and that took me until September of 2006, which I hired Drew Posada as the digital painter. But I still did not have a penciler. So I had Drew do the first cover, color the very first drawing of Luna ever done, and then work on the Luna logo, the bleeding crescent moon," he said. "At that point, I called my friend Buzz and asked him if he knew someone who could do rendered pencils since I was a big fan of the coloring job Drew had done on the Vampirella comic books that Mike Mayhew had beautifully done in rendered pencils. Buzz talked me into doing the book in ink-wash, which I am also a huge fan of (and he knows how to talk me into things). He came on board as the artist. I was ecstatic! At that point I had two of the most talented artists in the industry for *Luna* and was ready to start firing on all cylinders," he said.

"Then everything fell apart. Drew went into the hospital with acute pancreatitis and died there on January 4, 2007.

Luna battles the forces of darkness in the original graphic novel

He was 37 years old. Soon after, Buzz had to pull out as well because of family issues. So, there I was, two years into the project with no artist, no colorist and not one page completed," he said.

After that, the stumbling blocks might not have seemed as dramatic, but there seemed to be no end to them. "You name the problem, and it seemed to find me. Try out after try out with a multitude of artists and colorists that just did not pan out. I met Jeff Slemons online and courted him to become the new *Luna* artist. After a couple of months he finally agreed, but we had a disagreement on the breakdowns of the pages that Buzz had already done and he pulled out as well," he said. "I then hired an artist that I thought would do an excellent job, but he turned out to be rather inconsistent for my high expectations. Some pages were excellent and usable but others were just not making the cut, so I had to let him go about two-thirds of the way into the second issue," he said. "I then sent out a desperate SOS to Slemons who graciously agreed to do some patching, some backgrounds, and redo the pages I wanted completely redone. He came on board as the official *Luna* artist soon afterward," he said.

Hughes had a number of instances of people with terrific talent just not able to deliver what he required. "It wasn't that they could not or were unable to deliver the vision, but that everything under the sun seemed to take priority over my project. That's extremely frustrating, especially when they assure you again and again that they want to do the pages and that they will complete the pages. Then there is excuse after excuse and you're three years down the road with not much to show for it," he said.

Did he ever reach a point where he wondered, "Why am I doing this?" Did he always know he'd get it finished? "There were definitely times I was shaking my head and asking myself those very questions, but I was fully determined come 'hell and high water' to complete the project. I always knew I would, but I just never could have predicted that it would take eight years. But, you must realize that the graphic novel began as 64 pages and increased during the development of the story to double that amount. So, I must take my share of the responsibility as well in the extra time it took to complete," he said.

Hughes said that despite the ups and downs, he learned a tremendous amount from the project. "I believe it was Walt Disney who said, 'There's no teacher quite like adversity,'" he said. "Drew and Buzz were the original team for *Luna* and both taught me a great deal about the comic book publishing world and various aspects of art as well. What's good, what's not. What works and what doesn't, and why. What is good design and what is rubbish. Buzz taught me that an artist's true talent shows up in the panel-to-panel page work, not the covers or splashes. That was one of the most important lessons I learned. Great panel page work is what separates the men from the boys in comic book artwork," he said.

"My ace digital painter in London, Alan Lathwell, ended up saving my butt. He is simply a sensational digital painter and his coloring on the pages is breathtaking," he said. "My other digital painter was a very talented young man out of Bangkok named Sinad Jaruartjanapat. His color work is very reminiscent of watercolors with delicate skin tones that are out of this world."

What advice would he offer for someone starting out on a passion project? "Go for it!" Hughes said. "Just make sure to remain flexible and be willing to adapt and improvise for any problems that you may be faced with."

CONVENTION SKETCHES

By Weldon Adams

There are as many different ways to collect original comic convention sketches as there are ways to collect comic books themselves. Obviously we won't have room to go into all of the options, but this article will give new collectors an idea of where to start, and possibly give more seasoned sketch collectors some ideas on fun options they may want to try.

First off, for the newbies: "What is the difference between a convention sketch and original art?"

Convention sketches are commissioned directly with the artist and drawn specifically for the person ordering them and are not usually intended for publication (although some do see print eventually). Cost can vary depending on the popularity of the artist chosen and their own pricing system. Original art usually refers to the pages created to be used to produce a comic book.

As such, it's easy to see that a convention sketch can be a very personal thing for someone. You get to pick the subject, the artist, and often even the pose. But there is even more to it than that. You get to choose the format as well.

There are four primary formats for convention sketches. And each has its own strengths and drawbacks. It's best if you look at the options and decide which is best for you.

The Convention Sketch

This is just a loose page sketch. The artist will supply the paper, so they get to determine the size and shape. Most are approximately 8.5 x 11 inches, but some can vary wildly. If you plan to frame your

sketches, this might mean some matting will be different than others. If you are not framing them as you go, you will need a safe way to store them. Individual sketches can get bent, folded, wrinkled, yellowed, stained, etc… They need to be cared for the same way you would care for a comic book. Acid-Free backing board of appropriate size, and an inert bag or Mylar is best. If you use the large, stiff Mylars, you won't need the backing board. An advantage to this format is that you can commission as many sketches by different artists at the same time at a show as you have money to pay for them.

Cerebus and friends by Dave Sim

The Sketch Book

This is a hardback or spiral-bound blank book that you can easily purchase in an art supply store. The pages do not come out easily (this is true for the hardbound variety, less so for the spiral-bound versions), so all of your sketches will be in the same book. You can't easily display them, but they are already safely stored. One of the drawbacks to this format is that if one artist is drawing a sketch for you, you can't have anyone else working on the book at the same time. So this may limit you on the number of sketches you can get at any one show.

Some practical advice concerning this format:

Reserve the first couple of pages in the book. You can use these to have someone letter a title page and/or a table of contents once the book has been filled up.

Splurge on the first sketch (at least). Get one by someone you really *really* like.

And don't be afraid to pay a bit extra to get it inked or an extra character or something. Remember, when other artists open your book to do any future sketches for you, they are going to have to see that one *first*. It will set the tone and set a bar for them. They will want to be at least that good, if they can be. You really will get better sketches this way.

If any artist asks if they can "hang on to" the book to do a more detailed sketch (likely because of that killer first sketch you have in there), it's probably okay. Some may ask if they can take it home, do the work, and mail it back to you. This is up to you. You have to decide if you are going to get any other sketches at that show first, and if you feel comfortable with that. We have only rarely heard of this going wrong for someone, but it can happen. You have to be comfortable with the artist making such a request. Usually the sketches gotten this way are truly impressive as the artist had time to focus on it.

Themes work extremely well with sketch books. Maybe you just want Hulk-related characters, Kirby's Fourth World, or even a Star Wars sketch book. It leaves the door open for many different characters and many different artists.

Comic Book Sketch Covers

Gen13 #1-M (1995) is recognized as the first sketch blank cover. While it wasn't officially designed as many blank sketch covers are today, DC's *Zero Hour* #0 became one of the first covers on which artists sketched original images (veteran Golden Age artist and Green Lantern co-creator Mart Nodell was an

A Mart Nodell sketch on *Zero Hour #0*

early practitioner of this).

Since that time, and especially more recently, sketch covers have become quite popular. Originally intended for fans to get a sketch by the artist who worked on that issue, many have taken to simply having an artist of their choice draw something on the cover as if it were just a convention sketch in general. One of the advantages to collecting sketches in this format is that they are all the same size and therefore easy to display/store in various methods. And, of course, you can easily get several of these at one show, provided you have the money and the blank comics to start with.

Many fans "theme" these by asking their favorite artist (not necessarily the artist who drew the attached comic book) to draw a character from that comic title. An example would be to get a Joker sketch on the cover of an issue of *Batman*.

Sketch Cards

Sketch Cards are a relatively new fad growing in the comic convention circuit. In many cases at a convention, you may find artists doing sketch cards at a table for free. If not, the cost is usually more affordable than a full size sketch. Sketch cards are usually the size of trading cards, but some are the size of postcards.

The artwork on them tends to be simple bust shots, as those are quicker and the artist wants to do a lot of these over a short period of time. Many times, there are sketch cards already drawn for sale. But if you have specific requests, you will need an original drawn for you. Sketch cards

can easily be stored/displayed in nine-pocket sheets or large pockets for the bigger cards.

Some practical overall advice to collecting original sketches:

Queue up for the most popular artists at a show first. Many of the bigger name artists are so popular that their sketch list can fill up to the point where they will stop taking commissions. Sketches take time and they can only produce a finite amount at a show.

Know what you want before you approach them.

If the artist in question doesn't usually draw that character, be sure to have some visual reference with you already.

If you want it personalized to you ("To Sammy, Get well soon!"), say so. Artists are happy to put your name on it. That tells them that you don't plan to post this on eBay on Monday.

Make sure that they not only sign it, but date the sketch. In fact, have them put the name of the show on there, too. Years later, it will make it easier for you to remember when/where you got something. Also, there is the chance that you may have the First Ever drawing of a specific character by a specific artist. [Editor's note: See the sidebar about the author's Wolverine sketch.]

If you see an artist's work and like it a

Grendel by Matt Wagner

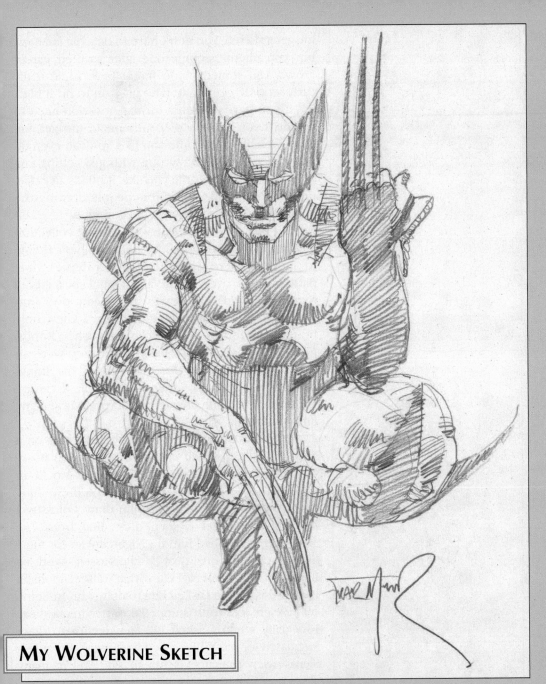

My Wolverine Sketch

The month that Marvel's *Daredevil* #181 hit the shelves, Frank Miller was a guest at Lone Star Comics in Texas. His sketch list for the event had about 15 Daredevils, five Elektras (with or without Daredevil, and a couple of Bullseyes. And then down near the bottom was Wolverine. My sketch. Mr. Miller said that he had never drawn Wolverine before and needed reference material. When he asked why I wanted that character instead of something Daredevil related, I explained about my Mutant sketch collection. And I explained that he drew such cool ninjas in *Daredevil*, and their swords reminded me of Wolverine's blades. I also had the pose picked out and showed him exactly what I wanted. He did a great job and seemed to really enjoy it. A couple of months later the *Wolverine* mini-series drawn by Frank Miller and written by Chris Claremont was announced. Now, I'm not saying that I may have helped cause that to happen. But who knows? What I didn't get on my sketch was the date. Don't let this happen to you.

Mesmero by P. Craig Russell

Sauron by Walt Simonson

Bill Sienkiewicz's Sasquatch

lot, get a sketch. You don't have to be a big fan now, but you might become one later as their career grows. And someday you might have some really early work by someone who goes on to hit it big.

If you have chosen a format, now you need to decide if you want to pick a theme or just get random sketches by people you like. You can even do both. There is nothing wrong with just getting random sketches by people you like. It builds an eclectic collection and usually it is people drawing the characters they are most associated with.

But you may want to try the theme collection method. If your comic book collection has a theme to it somewhere, (Legion of Super-Heroes, only Batman titles, everything Valiant publishes, etc…) then you could easily carry that theme over into your sketch collection. One collector I knew only bought sketches of Dick Grayson (Robin, Nightwing) and Starfire back when they were an item in *New Teen Titans*. That was his thing. Another gets only sketches of the Hulk. It can be amazing to see one character interpreted by many different artists.

At one point in the 1980s, I was working on a Mutant themed sketch collection. And when possible, I tried to pick mutants that in some way fit an artist's art style. I liked how Bob Layton drew shiny metal on Iron Man, so I had him draw Colossus. I liked how Michael Golden drew Bug from *The Micronauts*, so I had him do Nightcrawler for me. I liked the dreamy quality of P. Craig Russell's work, so I had him do Mesmero. I knew that Walter Simonson liked dinosaurs, so I asked him to draw Sauron. Some of these choices really stunned the artist in question. Especially when I asked Bill Sienkiewicz to draw Sasquatch for me. When asked why, I said, "Because a Sienkiewicz-Sasquatch is fun to say." And in many cases they had never even drawn the subject before.

It was at this point that I noticed that I was getting some really amazing sketches done. I noticed that when I would go to whoever the hot artist was at the time, their sketch list would be almost all of the same character. Even a good artist can grow tired of drawing the same character 30 times a weekend. Many of those sketches look essentially the same as the others. So if sketch #24 is a really off-beat character choice, it can snap them out of that and make them really think about what they are going to draw. The level of detail can go up quite a bit. The face on my Sienkiewicz-Sasquatch is amazing. Haunting.

I don't think a Moon Knight at the time, as good as it would have been, would have had quite the same level of depth.

This is not to say that getting someone to draw the character they are most associated with is a bad thing. I have plenty of those as well. In fact, if you can afford a two-character sketch, you can ask for the character they are linked to, and then any other character you want. Think of how much fun a "Marvel Team-Up" sketch collection would be. Spider-Man and <insert artist's character here>. If you are a Batman fan, this concept works for a "Brave & the Bold" collection as well.

And as mentioned above, if you know something about a particular artist's taste or likes (Simonson likes dinosaurs), you can incorporate that and really get them interested in your sketch idea. I knew that Steve Rude liked Space Ghost, so I had him draw a Nexus supporting character and Space Ghost. It's a great sketch!

Weldon Adams is an Overstreet Advisor and longtime comic book collector, dealer and historian. He has worked in just about every facet of the business.

Batman and Wonder Woman
Collectors

WE BUY PRE-1975 BATMAN COMICS
AND MEMORABILIA
AND WONDER WOMAN COMICS
AND MEMORABILIA FROM ALL ERAS.

P.O. Box 604925
Flushing, NY 11360-4925

email: batt90@aol.com
wwali@aol.com

SKETCH COVERS
THE WALKING DEAD
#100

By Ken Scarboro

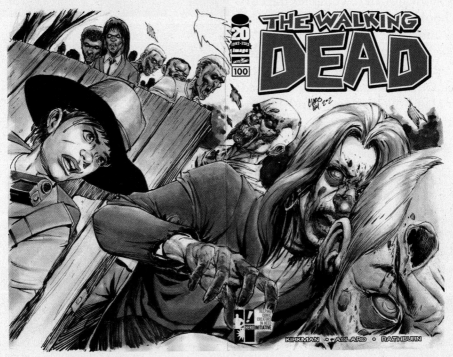

Comic book blank sketch covers have been turned into a dynamic means of fundraising by the Hero Initiative. Writer-photographer Ken Scarboro attended the one-day gallery showing Hero's The Walking Dead #100 *project in Los Angeles as the first eBay sessions of the fundraiser were getting under way. When the project concluded its series of weekly offerings, a total of $111,498.61 had been raised for Hero.*

Zombies circled a table covered in pulled meat dripping red. This was no buffet for shambling corpses, though. It was a feast for the eyes at the Hero Initiative's gallery show for their *The Walking Dead* #100 gallery project.

On May 31, 2013, Over 100 unique covers for *The Walking Dead* #100 issue were on display at the GUSFORD gallery in Los Angeles in a special one-night showing before auctioned off on eBay to raise funds for the Hero Initiative, the 501 (c)(3) charity dedicated to helping comic book creators in need. In the end, all 106 covers in total are headed for the auction block in one form or another as part of the campaign.

Several of the artists were in attendance and Todd Nauck drew a cover live that sold on-site for $2,100. A cover from Gabriel Ba raised another $650 from auctioning it off at the GUSFORD.

Additionally, two covers closed on eBay during the opening bringing in another $1,925 for the cause. All of the other covers on display will also be auctioned off on eBay in waves beginning June 4, so the bidding is already underway.

Mike Malve, a member of Hero's board of directors, said auctioning the sketch covers through eBay has brought in more money than just live auctions ever could.

"Rather than the 50 people in the room, we have thousands of people competing for the covers," he said.

After each of their Hero 100 Project gallery showings, Hero compiles the covers in books for those who might not be able to afford one of the originals.

The Walking Dead 100 is the sixth show and fundraiser for the Hero 100 Project. Other collections have featured Spider-Man, Wolverine and Justice League of America.

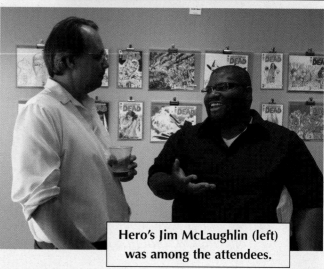

Hero's Jim McLaughlin (left) was among the attendees.

Todd Nauck working on his cover during the gallery show.

"We'd been thinking about working with Hero for a while," said Shawn Kirkham, Director of Business Development at Skybound. "With issue #100, it was a special opportunity to do something with Hero."

Among the covers up for bid in the first session were ones by Image Comics co-founder Jim Valentino, and fellow artists Ken Lashley, Chris Moreno, Tom Raney, and Shawn McManus.

There were many that exceeded the $1,000 level, but the record-holder by far of these one-of-a-kind offerings is held by Charlie Adlard, the regular artist on *The Walking Dead*, whose cover sold for $12,100.

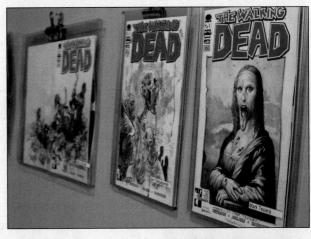

The artwork ran the gamut from adorable to gruesome: Agnes Garbowska (right) and Charlie Adlard (below).

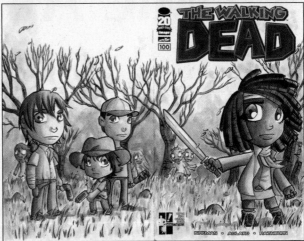

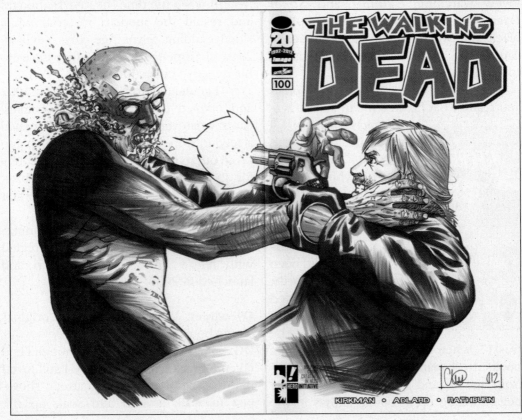

DAN GALLO

THE ORIGIN OF COMIC ART CON

BY ART CLOOS

Dan Gallo first started reading comics he picked up from the spinner rack at his local stationary store in 1982 when he was 12 years old. The titles included *Iron Man*, *Thor*, *Amazing Spider-Man* and *Marvel Team-Up*

"I don't remember buying any DCs when I was younger which looking back seems a bit odd considering how much I loved watching *Batman* and *Super Friends*. Even the *Superman* TV show in black and white I enjoyed, yet when it came time to buy comics I gravitated towards Marvel, he said.

"I started buying more as I got older and really what hooked me to Marvel was

Secret Wars. I think that was 1984. That led to the whole Spider-Man black costume series," he said.

His first collecting habit had been baseball cards, which he started at age nine, and continued until he was 17, when he went 100% with comic books. He began selling at comic shows from age 16 and around the same time began setting up at comic shows in the

New York City area.

By the time he was in college, he was running ads in *Comics Buyer's Guide*, purchasing then-hot titles such as Todd McFarlane's *Amazing Spider-Man* issues, *Incredible Hulk* #340, *Captain America Annual* #8, *Punisher* #1, *Wolverine* #1, and the Rob Liefeld's run on *New Mutants*.

"It was a fun time," he said. He bought and resold the modern material while slowly adding Silver Age keys such as *Tales of Suspense* #39 and other issues to his personal collection.

"I graduated from college in May 1992 and opened up a store, selling comics, cards, whatever was hot. In 1993 I opened a second store. By 1997 I had enough and I sold out to my partner and left the hobby for about three years before getting back in around 2001, when I bought my first piece of original art," he said.

And that brings us to underpinnings of Comic Art Con, the show Gallo created with fellow enthusiast Joe Veteri and launched in 2008.

Overstreet: What lit your fire for original comic book art?
DG: I really don't know. Even though I had taken a break from the hobby, I still loved it, loved the genre. I would attend shows just to walk around and soak up the

atmosphere. I was at one of the NYC "church" shows when I just started flipping through a dealer's portfolio, totally out of the blue, with no previous plans or thoughts of doing so. There were a few pages that caught my eye and the next thing I know I was walking away with five pages.

I even remember a few of the pages: a Deodato *Wonder Woman* page, a Bagley *Amazing Spider-Man* page, and an Ed Benes Artemis page. There might have been two Deodato pages plus one other that escapes me.

Now that I mentioned Deodato *Wonder Woman*, I remember when I had my store and I was putting the new *Wonder Woman* issues on that rack, flipping through them and thinking how fantastic the art was. I guess when I came across an original it all came back to me and I grabbed it. Since then I have owned dozens of pages from Deodato's run on *WW* and have what I consider his best work, the cover to the *Wonder Woman: The Challenge of Artemis* trade paperback, (a piece that I have resisted selling for almost 10 years now...which is saying a lot for me!).

Overstreet: We have heard collecting original comic art called a niche of the broader comic collecting hobby. What is your take on that?

DG: I agree; it is a niche. The comic hobby is now broader than ever with all the Hollywood, licensing, and mass marketing of the characters often taking center stage. There really is something for everyone in this genre even if you don't read the comics themselves, which is really a shame though. You can read new issues, collect runs, buy old stuff, invest, collect original art, buy toys, whatever it is, there is someplace for everyone to land. Collecting original art is just one small part of the hobby, which brought me to co-creating Comic Art Con.

Overstreet: Why did you create the show?
DG: We wanted everything under one

roof, so to speak. If you go to a big con, there is a dealer over here, another way over there, you have to walk through crowded aisles bumping into people searching for their $1 books. Then, when you get to the dealer table, you may have to fight your way in or wait to grab his attention. It was just too much commotion and hassle. Also, I would see guys walking around with portfolios and wonder what they had in them. Overall, the environment was not conducive to what we were looking for.

How great it would be to have a small room, every table filled with art, all the big dealers, people walking around with their portfolios looking to trade and network with other collectors, knowing that everyone there is just like you?

Also, having a low cost attached to it would encourage people who were not dealers, didn't have a lot of stuff, and couldn't afford the time and or money to go through the [New York Comic Con] for four days to have a chance to sit behind a table for a fun afternoon. What a great dynamic it would be to have a

room like that!

Seeing the show now, the way it has grown into what we envisioned, has made us both very proud. We love to see a packed room with collectors out in the lobby making deals with each other and walking by the bar and seeing people in there talking art. It's turned into a party.

Overstreet: It seems like you have most of the art dealers in the country attending, or is that overstating it?

DG: We have a lot. There are a lot of dealers and artist reps who don't do any shows or maybe just do San Diego [and who] haven't done ours, but as for the dealers that you often see at comic shows, we pretty much have them all or have had them in the past. We really have gotten great support from our core dealers and we would not have gotten off the ground without them. I always acknowledge that fact and am very appreciative of them giving us a chance and sticking with us.

Overstreet: Are there plans to get more creators to set up?

DG: Yes. Originally we were conflict-

ed about having creators as we wanted the focus to be solely on the art. We wanted every person who walked through the doors there for one thing and one thing only the art. We didn't want the room to be packed with people there to have their books signed while the dealers sat and watched. Over time, though, our attitude has changed a bit as for one, people started requesting creators, and two, it really was a natural fit. Also, we figured that creators would also have some of their own art to sell or trade and that would just add to the dynamic.

Overstreet: With no widely accepted price guide for original art, how are prices for it set? Is it all dealer-driven?

DG: It's tough. Dealing in comic books is so much easier. The art market is a strange market. One reason is that there is no guide. Another is that each piece of art is unique. Sure there may be comps but in the end it is still a one of a kind item. Prices are set by a variety of ways. Dealers, of course, and especially dealers who have a broad variety of art.

Auctions are another. The artists themselves affect the market. Private sales, whispers, rumors, and tall tales all add up to how prices come about. The most important part of the equation just may be the passion of the collector and what he or she is willing not only to pay but what it would take for them to sell.

Overstreet: Do you think that the collector market would die off? Would the current values being realized for vintage comics and art decline with a lack of interest?

DG: Absolutely not. Americans like their history, their past, things they grew up with, so there will always be that yearning for nostalgia. I am as bullish on the hobby as one could be. Spider-Man, Superman, they will always be there. They will never die and neither will the interest in them.

Art Cloos, an Overstreet Advisor, has been a passionate comic collector since the age of 10. The original version of this interview was the seventh in a series that appears in Gemstone Publishing's Scoop *email newsletter.*

Williamson, Krenkel, & Frazetta:

A Convention Tale

By Robert Beerbohm

In the summer of 1971, my friend Steve and I each scored six to ten Hal Foster *Prince Valiant* full Sunday pages, clipped from 1938-1949 newspapers, which came out of the basement of a pharmacy in Tulsa, Oklahoma. We bought the two-foot-tall stack from the guys who got them out of that basement, Robert Brown and Don Maris, during the 1971 Dallas Comicon.

We drove from there to Seuling's New York City show, which was a week or two later. We had just graduated from high school. Back then Phil Seuling's fabled NYC July 4th weekend show — not San Diego — was the center of the known comics universe. This was the second one we were attending.

Thursday morning as the room opened, a guy walked up and let us know he had lovingly cut out all the '30s and '40s *Prince Valiant* pages as panels. He had pasted them into scrap books, but by that time — 30 years later at that point — the rubber cement he used had stained through all that wonderful Hal Foster art work, so he was overjoyed to see he could replace most all of them from us in one fell swoop. He proceeded to start going through the stack, picking out the best page from each date. We were asking $3 each for the ones from the '30s, $2.50 each for '41-45, and $2 each after that.

After a while an older gent walked up, and he had all sorts of EC preliminary sketches, panel by panel, to nearly every Al Williamson/Frank Frazetta story. There were a few hundred of these. He proceeded to inform us that he taught Al Williamson — and to a limited extent Frank Frazetta — how to construct comic book stories.

Being semi-crazed EC fans, we recognized the EC stories in almost all the panels this guy was offering. They were all done in a very thin ink, with no pencil used. Incredible stuff. He was asking fifty cents to one dollar a panel. Steve and I fell all over ourselves picking out $100 worth of those panels, all the time gushing to him we are huge fans of Williamson and Frazetta. This guy just kept going on and on about how he taught Al "how to do it," and the guy picking through the *Prince Valiant*s kind of smiled and kept going through the two-foot stack.

Meanwhile, this lovely lady walked up. We had three tables, one for Sunday pages, one for vintage comic books, and one for all sorts of '30s and '40s Disney artifacts. She informed us that she and her husband had just moved to East Stroudsburg, Pennsylvania from New York, and wanted to "do" her kitchen in Disneyana stuff.

Among the Disney artifacts we had uncovered in our searches in the midwest were unopened rolls of '30s Disney wall trim, plus many glazed *Fantasia* "planters" and other items. This lady proceeded to pick out about $3,000 worth of this Disney material, then turned to talk with the guy with the EC sketches and the guy looking through the *Prince Valiant* Sunday pages.

About this time the *Prince Valiant* guy finished up — it took him over an hour — and then, since we had bought a

major portion of those EC prelim sketches from the older man, asked if would we be interested in trading for some actual Al Williamson original comic art.

We said yes, so off he went. He came back with an art folio — and at this stage we realized he was Al Williamson at our tables all this time. And then we found out the older guy was Roy Krenkel. Yowza!

So, we did our trade and ended up with some 60 *Secret Agent Corrigan* dailies and a small stack of comic book pages. About this time Al, Roy and the lady begin to make motions to vacate, off to some sort of lunch. They were talking, and the lady semi-imperiously turned around and said something to the effect for us to go to a third-floor suite in the hotel and inform her husband we had $3,000 worth of trade credit, and then they were gone.

That was basically the first hour of the first day of Seuling's four-day show. We were still two Midwest high school guys who were just getting to know our way around NYC and all the industry professionals who lived in and around and worked there.

All day Thursday went by. Around 2 p.m. on Friday I told Steve that I was going up to to see the lady's husband about buying all that Disney stuff that was now piled up behind our tables. Other people were expressing interest in some of that Disney material by that point. We had come to New York City to raise money to go to university and Steve's last words were, "Make sure you get the money. We need it for college."

Up I went. The elevator let me out on the third floor. Down the hallway I went, got to the room, and the door was ajar. I swung it open.

The next thing I heard was my jaw striking the floor as I took in all the Warren paintings on one wall, all the Edgar Rice Burroughs Tarzan (and other) paintings on another, and many neat miscellaneous paintings on another wall.

In the middle of this room were many *Johnny Comet* dailies all piled up, having for the most part never been put out for sale before. The dailies were $35 each, three for $100; Sundays were $100 each.

In a chair next to the large stack of *Comet*s was the guy who had produced all this wondrous art: Frank Frazetta.

I went up, introduced myself, and started talking about the '30s and '40s Disney artifacts piled up behind my tables downstairs.

"So you're the guy who bamboozled my wife," he shot back good naturedly.

Many of the paintings he had for sale were around $3,000 each, but there were two of us and I knew if I traded for a single painting, Steve and I would most likely fight over it and a friendship might end.

So I opted for *Comet* dailies at three for $100. The Sundays were just two-tier, so my now semi-feverish young brain rationalized "More bang for the buck" scoring three dailies per $100. All thought of getting any actual money for any of the $3,000 had left me.

I had 90 *Comet*s to pick out and as I flipped through the stack, I placed ones which struck me off to the side. When I got to 90, there was still a ways to go, so I would get to a "neater" one, pick it out, then go back into my stack, pull one out and put it back.

After about a dozen times doing that, Frank suddenly said, "Hey, they are all good!"

Whoops. That was a subtle hint, and I stopped.

At the end of that 1971 Seuling show, Frank gave all the remaining *Comet*s to Russ Cochran to place on consignment to be sold off. Russ immediately made the dailies all $100 each, thereby tripling their value from a couple days earlier. Russ was also a bit peeved at the time — but just a little bit — that I had cherry-picked so many of the "better ones."

I replied to Russ then, "Well, Frank said they were all good!"

Robert Beerbohm is a pioneering comic book and original comic art retailer, historian and Overstreet Advisor.

The Apex
of Elegance
and Class

Archangels

4629 Cass Street Suite #9
Pacific Beach, CA 92109 • USA
RHughes@Archangels.com

Archangels.com

Fine Vintage Collectibles

Golden-Age
Silver-Age
Bronze-Age
Original Artwork

For the Connoisseur Collector

Behold, the Mystery, Magic and Majesty of

Marada
The She-Wolf

By Rob Hughes
© 2013

and John Bolton. All other images ©2013 respective copyright holders.

Great stories begin and end with great characters. A super-strong central character is the single most important element in storytelling - the gold standard. This is absolutely key! Without exception, iconic characters form the foundation of unforgettable writing by establishing identification. And identification penetrates to the very core of human emotion. Seasoned scribe Chris Claremont would strike the perpetual motherload when he teamed-up with the super-talented British artist John Bolton, to create the brave and beautiful heroine Marada Starhair, surnamed "The She-Wolf."

An absolute gem in every aspect, this saga was written with sublime sophistication, passionate panache and unabashed courage. And the artwork? Well, these lush illustrations are nothing short of truly breathtaking! Bolton delivers his vivid vision in spades with a masterful blend of bold and elegant brushwork, so akin to the ultra-famous and unmistakable style of the great Alex Raymond himself, leaving the reader salivating for more like a Pavlov dog.

Marada is the summit of storytelling that not only rewards the reader with a sense of wonderment and awe, but simultaneously inspires and uplifts one by igniting the creative flames within our own hearts and souls. And, it is the heart and soul of Marada Starhair, which makes her story so very special.

Ironically enough, it nearly never happened. Marada was born by accident. Brought forth out of necessity to circumvent the problematic legal and financial shackles of the licensed property Red Sonja, which was owned by the Robert E. Howard Estate. Red Sonja is a high fantasy sword and sorcery heroine, created by writer Roy Thomas and artist Barry Windsor-Smith for *Conan the Barbarian* #23-24 (Marvel, 1973). Thomas in turn had based his concept on Howard's Red Sonya of Rogatino from the historical fiction short story "The Shadow of the Vulture," first published in *The Magic Carpet Magazine* (January, 1934). The original Sonya was a 16th century gunslinger of Polish-Ukrainian origin harboring a fierce grudge against the Ottoman Sultan Suleiman the Magnificent, while Sonja is an expert swordswoman living in the completely fictional Hyborian Age. Both have distinctive red hair with fiery tempers to match and are greatly respected for their prowess on the field of battle. Some theorize that Howard may have drawn his initial inspiration for Sonja from the famous French "The Maid of Orléans" herself, Joan of Arc.

The Marada saga was originally written and illustrated as a Red Sonja story, but once a large portion of the pages had been completed, there was a problem…a BIG PROBLEM! Claremont explained, "Marada wasn't ours – that is, John Bolton's and mine – to begin with; her genesis began as a fully owned Marvel property with the fully owned Marvel magazine, *Bizarre Adventures*. So, here we were, with a pile of pages of spectacular fully finished artwork by John and we can't print it because there was some hang-up with the Howard Estate who owned the Red Sonja license. What to do?

"So, I sat down with Archie Goodwin and Editor-in-Chief Jim Shooter to discuss options. I told Jim our troubles of how John had put all this time and glorious effort into the story, and was living in a house with naked pipes hanging loose in the kitchen, with holes in the floor of the bathroom, raw walls, unpainted bits, oh, it was awful – and noted, casually, in passing, that Archie was willing to print our story, could we maybe buy it back and sell it to Epic, please! He said, 'yes.' So I argued for a few more minutes more, really warming to my task. He said 'yes' again – Marvel would transfer title and ownership to us no problem. Sounds like a great idea.

"And that's exactly what we did instead of paying the Howard estate a pile of cash. You see, that is part of what made Marvel so great – the flexibility for creators and creator-owned material. To Jim's credit, when Marada became a creator-owned property, John and I had already been paid our page rate, but Jim did not make us pay back the money, but magnanimously choose to recoup it from the sales of Epic. Jim was at times, the most empathetic and generous of bosses and at other times he was your worst nightmare. But, he understood the vital importance of maintaining the delicate balance between the creative talent and the corporate brass."

In a rarely granted interview with John Bolton, he offered, "It was my work on Kull for *Bizarre Adventures* that drew Chris Claremont to my work. Chris and I met up in the U.K., and he pitched the idea of collaborating on the story. Fate, however, interceded and with the story more or less

wrapped-up, Marvel lost the license to Red Sonja. As luck would have it, Marvel had recently launched *Epic Illustrated* and this seemed the perfect home for Marada. It is well documented that Jim Shooter's mother selected the name Marada."

If character is paramount, then selecting the proper name is its twin peak. Claremont said, "Stan Lee taught me that great names transcend time and embed themselves in people's psyches; Spider-Man, Batman, Superman, DOCTOR DOOM! A great name is invaluable! All of us had notebooks that we tucked away full of cool sounding names for future use. And Jim did what the best editors should do, he gave support and offered ideas. Jim's mom came up with the name Marada."

And what about Marada's unique last name "Starhair" and sur-name, "She-Wolf?" Claremont answered, "Those were me – a catchy cover gloss because I wanted the name to be really cool."

Thus, the three originally black and white episodes were slated to appear in *Epic Illustrated* #10-12 (Feb., April and June, 1982), but some adjustments needed to be made to fully mold Red Sonja into Marada. Bolton explained, "Chris and I set about restructuring the story. We changed Sonja's hair from red to silver-white. I then

THE MARVEL MAGAZINE OF FANTASY & SCIENCE-FICTION / FEBRUARY 1982 / $2.00 ~75P

epic
ILLUSTRATED

featuring
MARADA THE SHE-WOLF
by Chris Claremont & John Bolton

designed a new costume and Marada was born."

When asked about how much of the artwork needed to be redrawn, Bolton answered, "When Chris originally sent me the plot there was already some uncertainty as to Marvel retaining the rights to Red Sonja. So, Chris wisely limited the appearance of Sonja (in her scale-mail bikini armor) to just about one page. I was only midway through the story art at that point and so, there was very little reworking needed. I only had to redraw the Sonja flashback page by changing her costume."

Claremont added, "Everything is adaptable in comics. And sometimes, black and white art can cover a multitude of sins."

Marada would debut as the headline cover story in *Epic Illustrated* #10 (Feb., 1982), with the script by Claremont, art by Bolton, letters by Tom Orzechowski and editorial by Jo Duffy, Goodwin, Ralph Macchio and Shooter. Bolton depicted Marada on the cover as a beautiful, but fierce silver-haired sword-wielding warrior in full melee with her devil-horned tormenter, the disgusting demon-lord Y'garon. It is a dark and intense scene that set the ideal stage for the pulse pounding adventure within.

When asked about what type of medium he chose, Bolton answered, "The Marada covers were painted in oil – a medium that

at the time I liked. But, oils take longer to dry and they don't 'recognize' deadlines, so later on in my career I started painting covers in acrylic. In all, I painted four Marada covers."

Claremont shared his insight into his premise for the historical foundation for Marada, "The story unfolds during the first generation of Julius Caesar, in the tumultuous century bracketing the birth of Jesus Christ. Rome was bidding the final farewell to her Republic and experiencing the birthing pains of growing into an Empire – the dominant force upon the face of the entire earth. I was writing historical fiction with Julius Caesar being the grandfather of Marada.

"What most don't know, but what I discovered in my research is that Julius Caesar had two daughters." The first was named Julia (c. 76 B.C – 54 B.C.), who was the fourth wife of Pompey and who died in childbirth while Caesar was in Britain. "But, it was this mysterious second daughter, who

"Et tu, Brute?"
Gaius Julius Caesar

Born July 100 B.C. Roman General, statesman and Consul. Grandfather of Marada Starhair.

supposedly died in infancy that I was basing my historical premise on. My thought was, 'What if, this daughter of Caesar did not die, but survived and lived on into adulthood.' And, it was this daughter of Julius Caesar that would be Marada's mother.

"I wanted to set the stage from the point when Caesar invaded the Isle of Britain (in 55 and 54 B.C.). My idea was that during the invasion, Caesar had captured a Celtic Prince, who in turn, met and fell in love with Caesar's daughter. When Caesar returned back to Rome, this Celtic Prince and Caesar's daughter were married and had Marada.

"When Caesar had been assassinated, any children of his direct linage would be considered a serious threat to the surviving powers who were now violently vying for the throne. If Brutus and Cassius had been victorious at the Battle of Philippi (42 BC), then the entire lineage of Caesar would have been wiped out.

"We are dealing with the fringes of Roman reality here. Would Marada, being of the direct bloodline of Julius Caesar, have a legitimate claim to the throne? Octavian had been adopted by Caesar, but was not a biological son of the dictator. This fits in very uncomfortably with Octavian's bid for the rulership of Rome.

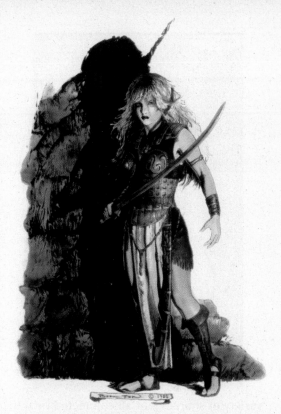

"Marada and her father and mother are now major liabilities in the eyes of the ruling powers that be. It was so much more fun writing Marada because she is based in historical reality, instead of completely make believe Hyboria (Red Sonja). I wanted to present an established practical landscape."

The very first episode headlined with the title, "Marada the She-Wolf," later retitled "The Shattered Sword" for *Marvel Graphic Novel* #21, and was beautifully rendered in black and white ink-wash. Bolton is "in the zone" here, fully dialed in and at the very peak of his performance with a staggering display of his grandiose and utterly uncompromising vision. He has chosen a more cinematic approach to his layouts, character positioning and scenery and his various cuts between wide-angled and close-up panel-to-panel shots is simply superb, more reminiscent of a master film director than a comic book artist. His work is rendered in the classical and timeless Renaissance style, accented with exquisite detail and fluid movement. This is romantic realism at its apex – a brilliant balance between bold bravado and intimate elegance.

When asked about his greatest influences, Bolton offered, "My influences are deeply embedded in the past and are from a

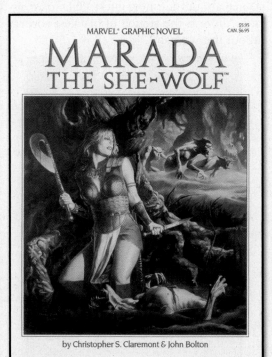

by Christopher S. Claremont & John Bolton

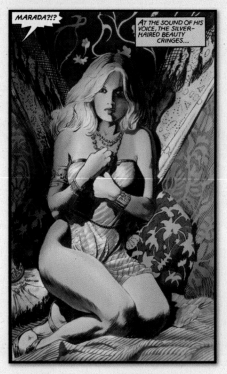

from the desert highlands of Galilee to the rough craggy stronghold of mystic Ashandriar – a place of learning, mystery and power. Claremont writes, "It is a remote place, made more so by its reputation. Even Druids shun this part of the isles, this keep that is far older than Stonehenge. For legend says that those who rule Ashandrier are not human, but sidhe – the immortal gods of goddesses of faery. Like all legends, these have some truth to them." This is a maxim that will present itself time and time again during this saga. Claremont is at the top of his game, superbly scripting with such creative cleverness that is rarely encountered in this medium. Furthermore, he is just beginning to ingeniously impart upon the mind of the reader the subtle juxtaposition, the inner workings between the natural and the supernatural worlds with a skillful interweaving of history, myth, legend and lore.

Here, Donal and his mother Rhiannon, the High-Witch of this domain, are both perplexed and troubled at the extreme change in Marada's demeanor. What sort of terrible ordeal had transformed this woman who had once been one of the most renown and fearsome warriors throughout the empire into such a frightened and timid empty halfshell of her formidable former self? Rhiannon makes a cryptic observation to Donal about their new guest, "Take care, my son. There is the stench of blackest sorcery about the woman."

variety of sources, but all connected by one underlying theme – the interesting and the bizarre. From Dali, Brugel and Turner to German Expressionism - far too many to mention. I also love cinema; De Mille and Hitchcock being amongst my favorites. You have to embrace all kinds of inspiration wherever you can find it, from real life, film and literature. In my current work, I am looking at Italian medieval masters."

Claremont added, "My goal with Marada was to do a series of stories that you just couldn't publish in other regular titles. I was going for a more European style of storytelling, infused with much more graphic textual and visual sophistication. I wanted an all-inclusive presentation for this saga…equally eloquent, but much more realistic and more sensual than usual – darker, more disturbing in nature and more adult oriented.

At the opening of the first episode, 'The Shattered Sword,' Marada is being returned back to Rome by a Roman Tribunal who is trying to procure favor from the Emperor. I was exploring the idea of Marada slowly circling her way back to Rome and a possible confrontation with Emperor Augustus Caesar."

After being rescued at the hands of Donal MacLlanllwyr, Marada is teleported

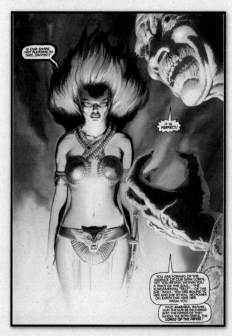

Claremont clues us in as he transports us to the ancient city of Damascus in Syria…to "a certain palace that fronts the plaza of the sacred way…" This is the residence of a man who is greatly feared by king and commoner alike – the evil wizard Simyon Karashnur.

Now, the veil of physical reality has been fully drawn aside as author and artist escort us behind the scenes to provide for us a glimpse of high ceremonial black magick at its deepest and darkest levels – satanic to the very core.

Simyon has entered his unholy high tower chamber and screams, "I [serve] the dreams and desires of gods. And the gods desire one thing…the life and soul of Marada Starhair, called the She-Wolf! She has power…both temporal and arcane – though she knows it not." With this, the wizard evokes an evil entity up from the infernal pits of hell he labels a "Reaver." This foul fiend is an unholy hybrid creature created from the perverted combination of the evil essence of the "dark lords of the abyss" and a piece of the soul, or "the fundamental self" of Marada herself. The Reaver chooses to materialize as a foreboding and vicious version of the She-Wolf, with a relentless glare full of murderous intent and equipped with the warrior's former armor. Basically, this foul abomination is conjured into existence to be an "astral bloodhound" if you will, to seek out and hunt down Marada in order to abduct and deliver her unto the hands of its malevolent masters, the Mabdhara.

Claremont said, "Simyon is transcendently evil. He is speaking in a transcendently bombastic tone…as all evil wizard's speak." Evil wizards always seem to make for excellent villains and Simyon is certainly no exception.

The dreadful Reaver is unleashed to seek out and hunt down Marada. She envisions this in her dreams, and then wakes suddenly from her nightmare to cry out in abject terror. Donal, Rhiannon and members of the Nightwatch guard immediately rush to her side and are interrupted by the innocent voice of a love-

ly young lass, who is standing with the drapes drawn aside as she wipes sleep from her eyes. This is the gentle dove Arianrhod, who is introduced in a small panel that Claremont selects out by saying, "Notice how Arianrhod is standing slightly pigeon-tied? This is John's forte - utterly realistic posturing that you so rarely see in comics."

The author was asked, "Do you mean detail?"

Claremont is adamant, "No! It's not detail. Detail is crap! Detail is easy and nearly any artist can do detail. What I'm talking about is the eloquence of physical presentation that John is capturing at this precise moment. It is that so elusive realism, which establishes a recognizable human beat that transcends mere genre. John is making the characters more real and more relatable to the reader. He is creating the all-important bond of identification."

Bolton was likewise asked about such subtleties in his art, to which he said, "This is a difficult question to answer as I think it's intuitive to understand how to convey

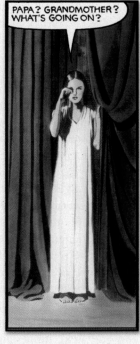

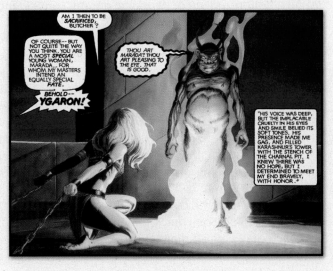

words using body language. It is something you observe, rather than taught."

Marada and Arianrhod become fast friends and inseparable companions as Claremont and Bolton begin to develop a mother-daughter relationship here as well as a growing love interest between Marada and Donal. Claremont now gently nudges us ever nearer to the pivotal plot point as Marada decides to open up to Donal and reveal her haunting secret of dark despair that has plagued her for the entire episode. This is the moment at which the crux of the whole story arc is revealed; when the graphic novel penetrates through to such a profoundly personal and engaging level that few before or since have equaled it – the making of a true masterpiece.

In Damascus, Marada had been knocked unconscious with a goblet of drugged wine, and the next thing she remembered was waking up in the high tower of Simyon palace, within a mystic circle with both her wrist's shackled in iron. Bolton then zooms in for a very unsettling close-up of the evil wizard who smirks with sardonic disdain, as he divulges, "In exchange for human lives, human souls, my masters – the Mabdhara, the dread lords of the abyss – grant me power."

Marada pulls her chains taut, defiantly asking, "Am I then to be sacrificed, butcher?"

Simyon replies, "Of course – but not quite the way you think."

We have now arrived perhaps, at the most impressive page and most important scene of the entire book; the rape of Marada. Bolton reflected, "Working on any story, a tremendous amount of work goes into the preparation of each page long before the final pencils are done. By this point, I've already decided on the look of the character(s), what they are wearing in the various scenes, which I have specifically designed appropriate to the action that will be taking place.

"When handling the rape scene, it had to be dark and disturbing. Marada had to be vulnerable and Y'garon had to dominate the encounter. I definitely did not want the scene to be too graphic. Sometimes, a more subtle approach can be much more effective."

Obviously, this was tremendously taboo

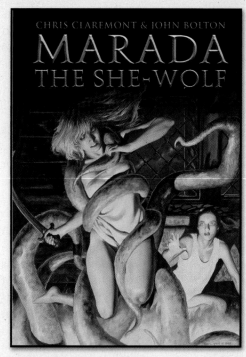

and potentially disastrous subject matter that Claremont and Bolton had decided to tackle, especially for a graphic novel in the early 1980's. The story had now taken on a very bizarre and darkly erotic twist that, believe it or not, has its roots firmly grounded in historical reality.

Claremont reminisced, "Up to this point, Marada has been rather arrogant in her physical prowess and battle skills. She had prided herself on always being able to outfight any man. Out drink any man. Out gamble any man. Basically out man any man. Now, she realizes that this is certainly not the case and the all-important question lingers, can she come back from such a gross and insultingly intimate violation of her person?"

A profound question that many of us will come face-to-face with in our own daily lives…and how we react to these personal trials and tribulations will define our very character – reveal who we really are and what we really believe deep down in our own hearts and souls - a universal theme and timeless truth that makes the saga of Marada Starhair, the She-Wolf so very, very special.

For the very first time ever, the entire Marada the She-Wolf saga (all five episodes) will be collected in one single volume and released by Titan Books in November 2013.

John Bolton is as mysterious and elusive as he is gifted. Shunning the spotlight, very seldom appearing at conventions and/or agreeing to interviews, he prefers to let his remarkable art and overall body of work do the speaking for him. He was born in London on May 23, 1951 and has been a professional artist since 1971. Bolton graciously agreed to take some time out of his hectic schedule to talk with us about his artwork and career.

Overstreet: To begin with, please give the readers a glimpse inside the mind of John Bolton. You have done a great deal of work in comic books over the past 30 years dealing with a myriad of subject matter. When it comes to deciding on what project you want to take on, what are the key factors in any particular story that attract you? What sort of elements must be present to prompt you to say, "Yes" to illustrating it?

John Bolton (JB): The most important thing for me is the story. Remember, I will probably work on a project for one to two years and I want to be excited and interested throughout that time…so the story is all-important. It has to have elements that will intrigue and stretch me. I want to excite and sometimes disturb the reader and I also want to enjoy myself.

Overstreet: You also seem to have worked in all sorts of art mediums over the years, from rendered pencils to pen and ink-wash to fully painted stories. Once you have chosen the project to illustrate, how do you come about deciding on what medium you will use for that particular story?

JB: Each medium offers up different moods. The atmosphere of the story will help me decide on what medium to use. For Batman, I wanted an urban feel and by using acrylics it gave me the density and opaque feeling I wanted. With *Shame* I used watercolors, which gave me the ethereal delicacy I was looking for. Background texture is also highly important to me, so that the smooth flesh tones against a highly textured background can intensify the contrast between the two.

Overstreet: Do you ever allow any other artists to ink your pencils or color your black and white artwork?

JB: Very rarely, as I am passionate about my own work.

Overstreet: Will you share with us some information about your most current project, the three book series entitled, *Shame*?

JB: I am currently working on Book 3 of *Shame*. This project came about when writer Lovern Kindzierski called me back in 1988 to introduce himself. We chatted for a while, and he expounded for me the story of Shame, which really intrigued me. So much so, that I wanted to work on it immediately even though I was in the middle of another project. I did numerous character sketches and even a painting, not knowing that Lovern and I would have to wait 22 years to find a publisher - Alexander Finbow of Renegade Arts and Entertainment. This is an unusual macabre story, visually exciting and I have been able to combine my love of costume and theatre design into this strip, which is being painted in watercolor - quite a disciplined and difficult medium to master for a comic strip.

Original pages by John Bolton
from his most current work,
Shame – Pursuit.
Written by Lovern Kindzierski
(Renegade, 2013)

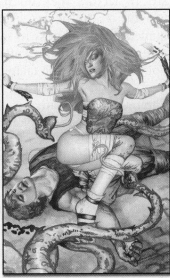

John Bolton.com
BoltonStudio.com

Assessing Value Of Comic Character Original Art: Newspaper

Comic Art Appraisal Rating (CAAR)
100 Point Value System

By Joe Mannarino

©2013 Joe Mannarino

The **Comic Art Appraisal Rating** reflects the various key factors that affect value in the comic art market through a 100 point value system. The following "rules" apply to the Original Newspaper Comic Strip Art Market.

The rating reflects the factors that one would use in determining the relative value in the current market place.

Although it is a 100 point scale and there are 10 factors they do not bear equal weight of 10 points each, rather the numerical points next to the factors indicate the highest potential number of points for each value factor.

The ratings are relative to their classification which may be broken down by specific categories and/or time periods e.g. humor, funny animal, action, adventure, science fiction, etc.

The ratings are relative to their classification as to format in regards to Sunday page to Sunday page, daily strip to daily strip, sketches to sketches, special published projects, to special published projects, e.g. books, packaging, film art etc.

The terms supply and demand have purposely been excluded. These terms tend to artificially simplify and inhibit the process of assigning an accurate rating. The goal is to quantify the factors that create demand.

The sum of the points assigned to these value factors result in a relative score that should be used when discussing the comparative merits in terms of value of a page of Original Newspaper Comic Strip Art. The process should be viewed as a filter, a lens if you will, whose focus can blur or sharpen as conditions, tastes and interests change as such, the categories and associated points may be revised in the future.

FACTORS IN ASSESSING VALUE OF ORIGINAL NEWSPAPER COMIC STRIP ART MARKET.

The more factors that apply, the greater the value. The list of Value Factors, in alphabetical order are:

Condition	5 Points
Configuration	10 Points
Confirmation	5 Points
Content	10 Points
Context	10 Points
Continuity	10 Points
Creativity	12 Points
Creator	20 Points
Cross-over	8 Points
Cyclical Interest	10 Points

Condition

A general state of poor conservation significantly decreases the value of a collectible item. Mass produced items are greatly effected, originals to a lesser extent. The presence of paste-overs for corrections, white out and glue stains on a page of art as well as tears can decrease value. The only exception to this rule is logo and copyright label. With rare exception, the logo and copyright information are photographic copies; known as stats. Stats were routinely glued to the page of art with rubber cement which quickly yellows with age. Collectors recognize this as being a necessary part of the process used to reproduce the art and accept these faults with little impact to price.

Original Newspaper Comic Strip Art may be professionally cleaned and restored to correct condition issues, this is known as restoration, archival repair or conservation. A qualified professional should always be used and should be able to provide a report of work performed. Restoration may include, cleaning, diminishing or eliminating defects such as: glue staining, tears, yellowing, white-out, dirt and in some situations the replacement of a missing piece. As of today, unlike printed comic books, cleaning and light restoration does not significantly add or detract from the value of the art. Redrawing of art, adding to the substrate, coloring of art does reduce its value.

Configuration
• Overall dimensions of art.
• Dimensions of individual panels.
• Hand colored by the artist especially in a field where this is not common
• Panel layout

Confirmation
• Authenticity
• Provenance - Provides a direct lineage documenting proof of authenticity and ownership.
• Signature - The vast majority of work in the field of original newspaper comic strip art is signed. However, many prominent artists worked with assistants (known as ghosts) that may have actually drawn all or part of the art. The art may bear the 'signature" of the artist but to the degree that the work was performed by an assistant may affect the value. In the case of Walt Disney features, all were drawn by Disney artists but studio signed "Walt Disney".
• Inscription - An inscription may add or detract from a work of art depending on the placement and/or significance of the person that the item is inscribed to.
• Pedigree - The market normally applies a premium to items with a documented, notable lineage. The more notable the lineage or collection the greater the premium.
• Rarity - Non-professionals, non-enthusiasts or amateurs often look first to the age and rarity of an item and feel that value should be greatly influenced by these factors. In fact, age may have little if anything to do with the value of an item. Many items from the '50s, '60s and '70s are worth considerably more than items from the '20s and '30s or even the turn of the

century. Rarity only comes into play when an item also reflects other listed factors. Unfortunately, when age and rarity of items without any other factors are evaluated, it may be old, it may be rare but for lack of value factors there may be little interest. One must keep in mind, that over the history of the medium, thousands of features have been created by hundreds of professionals. Many features lasted a short time, were picked up by few publications, never gaining any popularity. The art may be rare or hard to find but may have little value.

Content

Refers to the actual content that appears within the page of art, this can be a hero, villain, girlfriend, boyfriend etc.
• The appearance by any principal character, the more significant the character the greater the number of points
• The appearance of a popular adversary, foil, nemesis or opponent
• Appearance of a popular character
• Beautiful women
• Action as opposed to static (fight scenes, love scenes etc.)
• Character in costume, popular pose or attire
• Size of subject
• The depiction of something controversial such as; death, bondage, intense horror, needles, scantily clad women, swastika etc.
• Patriotic themes
• Prime (sought-after) period for the artist (also in Cyclical Interest)

Context

Refers to the historical significance of either the item itself or the subject depicted.
• The first appearance by any principal character, the more significant the character the greater the value
• The origin of a character
• Retelling of the origin of a character
• Early or first example of a feature
• The very first publication by a syndicate. As well as the significance of the feature, (was it sold or adapted by another company).
• Groundbreaking either in art, content or storyline.
• Trendsetting
• Popular storyline
• Portrays a historical moment or figure.
• Involved in a historical event in the medium.
• Published vs. non-published (non-published currently receive 0 points)

Continuity

The longer a feature, publication, syndicate or character appears, the greater the interest tends to remain. This includes cross-over licensing such as books, toys, movies, television, radio, advertising, food packaging and institutional interest within academic circles. The longer the duration of popularity the more exposure leading to greater and consistent appeal.

Creativity

Defined as the aesthetic of the art, (relating to the sense of the beautiful and to heightened sensory perception in general) as well as technical mastery.
• Design
• High contrasts (dark background)
• Subject facing forward
• Quality of inking
• Composition
• Perspective
• Mass
• Style – In the case of a collaborative effort (penciller/inker) the preservation of the penciller's original vision.
• Modeling
• Proper proportions
• Effective and accurate foreshortening
• Anatomical correctness
• Ability to change the readers vantage point
• Control of values
• Use of wash
• Use of color
• Size of characters
• Innovative techniques including breakthroughs
• Uncommon medium for the milieu.

Creator(s)

The reputation, standing and talent of the individuals involved in the creative process are paramount in determining the value of an item, in particular original art. Obviously, the factors utilized in determining values for fine art and antiques apply.

However, consideration must include the fact that in some situations, newspaper comic features were collaborative efforts and as such the example may not represent the sole "vision" of a single creator. In addition, the work of art may not represent the "final published" product. In most cases the primary artist, an assistant and writer combinations must all be taken into consideration when assigning value points.

An artist may be an innovator or become associated with a particular feature, genre, or subject matter. As such an artist's value may vary from feature to feature.

An artist's style or focus may change over time or assignment. Value will vary accordingly.

Cross-over

Both into and out of their normal niches. Any feature, depiction and sometimes even mention of popular, niche individuals or properties may add value as a larger audience will have interest. This will naturally increase appeal as collectors from other areas also pursue these items.

Niches include: celebrities, world leaders, politicians, popular movies, TV, Disney characters, novels, robots, atomic war, western, planes, rockets, golf, baseball, football, sports in general etc.

The appearance of a popular character (hero or villain) crossing-over from another title will increase the value of an item.

Cross-over appeal - The character depicted in the art is so influential and prevalent that they translate into many mediums out of their primary niche. This includes: toys, movies, television, radio, advertising, food packaging, books as well as institutional interest within academic circles. Prime examples would be Popeye, Superman, Buck Rogers, Batman, Spider-Man, Mickey Mouse, Donald Duck etc. These characters would receive points in this category based on their universal appeal.

Artist cross-over - Often times an artist, writer, inker or other professional will cross-over into a different field. This can include fine art, illustration, movies, television, fantasy, sci-fi etc. Winsor McCay, Frazetta are prime examples.

Cyclical Interest- In all fields of collectibles, cyclical interest can lead to spikes in value within a particular segment. Spikes are usually temporary but in some instances remain on-going. Factors include:

A collector(s) entering a field and impacting pricing by offering uncharacteristic prices for a very narrow range of items Institutional interest such as an exhibit or academic event

A happening such as a character or feature's anniversary, a movie or TV adaptation may increase (usually temporarily) interest leading to speculation.

In addition, within each collectibles market there are definite segments; original newspaper original art contains genres; adventure as opposed to humor, syndicate, continuities as opposed to individual daily pieces, specific time-frames etc.

Characters and story lines enter in and out of favor as do artists and titles. In determining a value rating, this cyclical interest should be taken into consideration

Freshness to the market as defined by the number of times a particular piece of art has been offered as well as the length of time between offerings

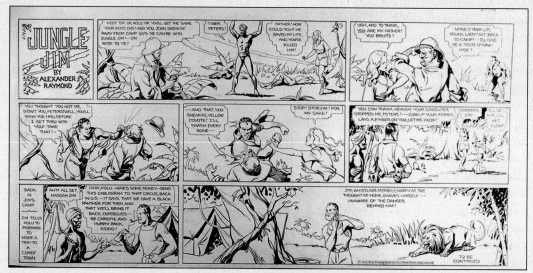

Alex Raymond, *Jungle Jim* February 11, 1934

Condition: 5 - Excellent condition.

Configuration: 7 - One double panel, excellent center panel, large art but at this point the topper to *Flash Gordon*.

Confirmation: 5 - Full points, authentic, Rarity, Feature was a Sunday only, not all examples are known to exist.

Content: 9 - Pluses: Main character and/or villain in each panel. Lush detail, strong large figure of main character in center panel throwing punch. Woman. Lion all present.

Context: 9 - Pluses: 6th day of the feature. First punch being thrown. Negatives: page contains neither the origin, or first appearance.

Continuity: 5 - *Jungle Jim* while known due to Raymond, after he departed the feature, interest waned.

Creativity: 10 - Effective layout and composition, figures in action, excellent figure poses in main double panel

Creator: 20 - Within category of original newspapers strip art Alex Raymond at very top of value scale. At this point no assistants.

Cross-over: 6 - *Jungle Jim* was a secondary feature to *Flash Gordon*. Inspired by Tarzan while movies, books and other products followed the character was not as popular as other features.

Cyclical Interest: 3 - Great interest in the artist, however not his prime period as he had not yet incorporated "dry brush inking techniques" for which he is known. Character has little current interest.

TOTAL : 79 Points

MILTON CANIFF

REMBRANDT BEGINS HIS MASTERPIECE

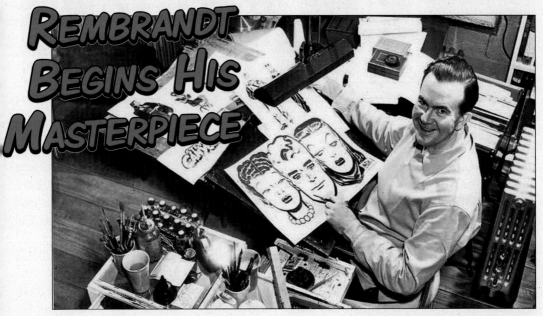

BY BRUCE CANWELL

The last time he changed strips, it was 1934. That move generated no hoopla, no fanfare in the press, and those who really cared that he was giving up *Dickie Dare* to begin a new venture called *Terry and the Pirates* could be counted on one's fingers and toes, with a few leftover digits to spare.

Now here it was, 1947, and Milton Arthur Paul Caniff had shifted from the Chicago Tribune New York Daily News Syndicate to Field Enterprises. After bidding a memorable farewell to *Terry*, the launch of *Steve Canyon* was being treated as News with a capital "N." The papers were offering coverage that far outpaced the efforts of the powerful King Features Syndicate publicity machine Field was using to sell the series, while on newsstands Caniff and his freshly-minted brain-children graced the front of *Time* magazine – yes, *Time* magazine! — with a cover-date that matched that of the first *Canyon* daily. NBC-TV also put the artist and one of his models (the delightfully-

curvy Carol Ohmart, a former Miss Utah) before their cameras, making *Steve Canyon* the first newspaper comic to be touted on national television.

Much had changed in a dozen years.

The Rembrandt of the Comic Strip was painting on a fresh canvas, yet not everything was brand-spanking-new. Stories were still being constructed and paced in the Milton Caniff style, featuring the kind of fast-paced, sassy dialogue readers had come to expect. While the underpinnings were familiar, the settings were entirely different: *Terry*'s China and environs were in the rear-view mirror and, as its name implied, *Canyon* gave Caniff wide vistas to explore: the series opened in a contemporary American urban setting, moving south of the border before returning Stateside to the oil fields of the southwest, then journeying to the far reaches of remote Africa and the exotic Middle East. It was surely liberating, having the entire world as a stage upon which adventure could unfold!

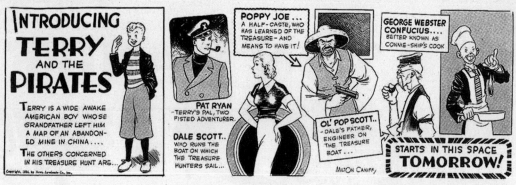

Milton Caniff's teaser daily for *Terry and the Pirates*, October 21, 1934

It was also refreshing to have a different type of protagonist around whom to build stories. Stevenson B. Canyon was no Terry Lee or Pat Ryan. As Caniff wrote in a 1984 essay, he had a specific template in mind as he built his hero:

From the beginning, I have always referred to *Steve Canyon* as a picaresque novel. *[NOTE: In fact, Caniff makes this reference as early as 1946, in an early publicity piece that appeared in the November 23rd edition of* Editor & Publisher.*]* The dictionary attaches two definitions to the word "picaresque." The first one applies to escapist fiction such as *The Arabian Nights*. Scheherazade told the Sultan Schahriar exotic stories every night to con him into prolonging her sister's life for just another day. They were loosely-connected episodes and the Sultan was left hanging for more. This is a picaresque novel. But the basic definition is a story in which the hero is a flawed hero, a *picaro*, which by the way is the Spanish word for "rogue" ... there is Heathcliff in *Wuthering Heights*. Heathcliff was a bastard. Everybody hated his guts. He was a stableboy whose disappointment in love banishes him to America. He returns with a bundle and his boorishness comes across when, to punish his true love, Cathy, he marries her sister. He is a flawed picaresque hero. It can be a great flaw or a little flaw, but this keeps the hero from being Jesus Christ ...

Picaresque heroes, in almost every case, are travelers, because if you don't move around, you don't encounter the new bad guy. When your heroes go to far-off places, they can go with good Right Stuff reasons, but after they are there awhile and run out of money, they find themselves making little deals. Some guy asks them to run a load of something ... it turns out to be guns! The heroes didn't mean to be bad guys, but suddenly they are. There is a very thin line between legitimate and illegitimate in picaresque fiction, and that's why it's very important for these people to have a legitimate income ... In switching over from *Terry* to *Canyon*, I thought a long time about the means for Steve to have to support himself.

Another picaresque aspect is that the hero has a sidekick, somebody to talk and bounce things off of. Don Quixote had Sancho Panza, Mr. Pickwick had Sam Weller, Huck Finn had Jim, Steve Canyon has Happy Easter, and [by late 1948] Reed Kimberly. These secondary characters are important for a change of pace and tone. Canyon can say something and Happy Easter can say, "I don't think you can do that, because ..." Hap, then, is the experienced person. Or the kid can say, "Gee, I think we can cross here ..." and Canyon can reply that, "No, we can't because ..." It keeps Canyon from being a know-it-all and adds a different focus. It makes the person giving the information look good. He's the wise one ...

[But] the stage gets crowded very quickly. At a given time three, maybe four at the most, characters are all the reader's

mind can handle in terms of continuity … I had too many people on the stage at one time, too much going on, too much talk. It was time to shift gears and push a few off, because if you lose your audience, you've lost your point. We continuity strip guys are like Scheherazade. We tell our stories to live just one more day.

Not all of Milton's experiments worked out to his satisfaction. The initial *Steve Canyon* cast parallels that of Lester Dent's *Doc Savage* pulp supersagas, in which the hero is supported by five expert, adventure-loving stalwarts and occasionally by a woman respected by her compatriots for her competence even as the rest of the male population is struck by her beauty. Feeta-Feeta — the Samoan business manager for Steve Canyon's Horizons Unlimited outfit — fulfilled the latter role while Breckinridge Nazaire, "Oily" Reilly, "Two-Way" Touhey, "Beadeye" Rugger, and Mudder McGee served as the analogue to Doc Savage's five irrepressible aides. It took the first eleven months of 1947 for Caniff to decide his strip was suffering from over-crowding; he pared down the roster in the first panel of the November 30th Sunday, which opens with Steve saying, "My crew is convalescing in a decent place [after a cholera epidemic and their struggles against the devilish *Herr* Splitz/Madame Lynx alliance]". **Poof**! Five guys, dispatched with a few strokes of letterer Frank Engli's pen.

Fortunately, by that time the cartoon-ist had established Happy Easter as a one-man supporting cast, the comics equivalent of grizzled motion picture bit players like Walter Brennan, Al "Fuzzy" St. John, Pat Brady, and most especially Gabby Hayes. "Happy Easter started with the name," Caniff noted in 1983. "I needed a character like all the Westerns had. The bearded second banana … everybody is familiar with this person. Happy Easter is the court jester." Happy admirably fulfilled his duties through early February, 1949, when he was given an unexpectedly dramatic exit scene, moving aside to allow teenaged Reed Kimberly to step up as Steve's sidekick.

Even as Milton tinkered with his supporting players, his bravura artistic facility and keenly-honed auctorial skills were in full display. Yet not even someone as savvy as Caniff was able to please all the people all the time. Cultural differences took the occasional bite out of international sales for his new creation, as *Time* reported in their August 25, 1947 issue:

To the editors of Lord Beaverbrook's *London Daily Express*, the six-month trial run of *Steve Canyon* had been quite a trial. Steve had been a problem to the 3,870,000 readers of the *Express*, too. Milton Caniff's comic-strip airline operator was a likable enough chap, but how was one to understand him without a pony? Even to inveterate followers of the U.S. cinema, such terms as "leg it," "front boy," "Hood" and "gee" were hard to translate. *Express* editors, who have had to doctor much of the Canyon dialogue for

The first *Terry and the Pirates* daily - October 22, 1934

British readers, were nonplussed by "Delta and I will go out and butter up some of the key peasants." At last they decided that "some of the key peasants" meant "some of the big locals."

Because of such problems, the *Express* also decided that Canyon and his jive talking crew had to go; Steve & Co. vanished from the *Express* without so much as a waggle of their wings. Steve's passing gave a clue to the differences between U.S. and British comic-strip tastes. *Blondie* is a fixture in the *Daily Graphic*. Said an editor: "It never gets beyond the trifling happenings that go on in everyone's life all over the world." *Donald Duck*, *Mandrake the Magician*, and *King of the Royal Mounted* have been accepted because they are easily understood, and Super-Sleuth Rip Kirby is doing nicely in the *Daily Mail*. "He's a fairly quiet chap with pipe and glasses," said a Mazlman, "and our people seem to go for that type of hero."

Milton was loathe to lose readers in any country, but more than counterbalancing the loss of the *London Daily Express* was the fact that Stateside sales of *Steve Canyon* were brisk from the outset. "We were off the nut," Caniff told Shel Dorf in a 1978 *Buyer's Guide* interview. "We were in the black before the first line was ever drawn — before I ever had a name for [my hero], as a matter of fact." One hundred sixty-two daily and ninety-six Sunday U.S. newspapers had signed up to run the strip, sight unseen, based solely on the strength of the artist's impeccable reputation. Editors from coast to coast were willing to bet money that Caniff would build a high-powered storytelling engine to rev up their sales. As the series unfolded, its shifting locales and steadily-evolving cast proved that Caniff was not just a master builder, he was an avid tinkerer, eager to plug in the perfect replacement parts or refine the mixture that fueled his conflicts and character interactions for better performance.

Those editors and their readers,

enjoying how smoothly *Steve Canyon* purred on the page, would have been downright amazed had they known the rapid pace at which Caniff constructed his engine.

Things are never easy for geniuses, and circumstances conspired to force the Rembrandt of the Comic Strip to plan *Steve Canyon* with his hands figuratively tied. In developing the details of a new project, creators typically fill sketchbooks with head shots and character turns, costumes and clothing details. They populate reams of paper with biographical notes on the heroes, villains, and those in supporting roles along with information about the settings, themes, motivations, and ideas for plots. It is a stochastic process of picking and choosing, weighing one option against another until order emerges from the chaos, the series takes shape, and work on the first episode begins.

For Milton Caniff, this already-difficult approach was complicated by a need to create much of *Steve Canyon* only in his head, developing ideas without keeping the typical stacks of concept-filled notes. He was not cutting capers; he had specific and sound reasons for committing very little of his *Canyon* planning to paper.

More than two years previously, in the waning days of 1944, Caniff completed several weeks of relaxed, almost breezy negotiations with wealthy department-store-heir-turned-newspaperman Marshall Field. The result was the deal that would give birth to *Canyon*, a clear "win-win" agreement for both parties. Field got to add the popular and prestigious Caniff name to his fledgling Field Enterprises syndicate and Milton was guaranteed complete ownership of whatever property he chose to create — copyright, trade mark, merchandising, and all other proprietary rights would belong to him and only to him. He was also savvy enough to negotiate full editorial control for himself — Field Enterprises could not change a line of the artwork or a word in the dialogue

without his approval.

This was the sort of sweetheart deal Caniff had long dreamed of finding. During the early 1940s he had stayed at home when so many of his contemporaries had been called to arms in World War II because he was classified as 4-F (medically unfit to serve). He suffered from phlebitis — a chronic condition that could create life-threatening blood clots — as well as narcolepsy, which could cause him to unexpectedly fall asleep at any moment, night or day. Neither condition was conducive to a successful tour of duty in the armed forces, yet it still rankled a man as patriotic as Caniff not to be in uniform. By late '44, with the Nazis teetering on the brink of defeat, Milton's concerns had shifted away from his 4F status. Instead he was haunted by thoughts of what would happen to his wife, Esther "Bunny" Parsons Caniff, should his health fail: their income was completely dependent on his ability to produce *Terry and the Pirates* day after day, year after year. He also worked on the strip solely at the

discretion of the Tribune News Syndicate. Were they likely to replace one of their superstar artists? Hardly – but the fact they *could* if they so chose was not lost on Milton, nor was the fact that insurance companies viewed his medical records with alarm, making coverage for the Caniff family an expensive proposition.

Marshall Field's offer represented a thirty-three percent raise in Caniff's annual base pay while also setting him up to profit from the additional revenue streams his creation might generate (and throughout the years *Steve Canyon* would make money by appearing in a number of different forms, most notably in comic books and on television). This was a degree of financial security Milton had never known in his then-thirty-seven years.

The problem that prevented Caniff from keeping copious notes during the brainstorming of *Canyon* stemmed not from the terms of his agreement with Field, but from the ripple effects of its timing. Word leaked at the very beginning of 1945, less than a month after the hand-

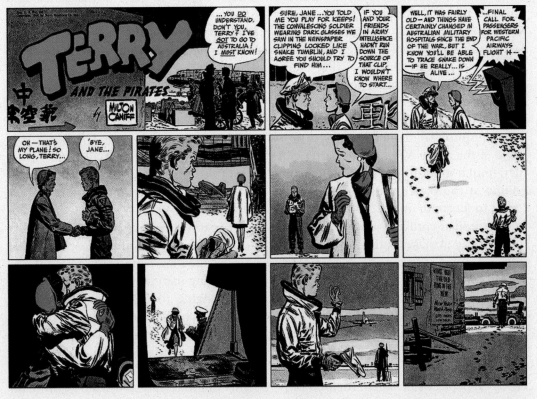

Milton Caniff's last *Terry and the Pirates* page - December 29, 1946

shake had sealed the deal. The media announced that Caniff would depart the Tribune News Syndicate when his contract expired in late 1946. Public exposure so early in the game meant the artist faced two years as a known "lame duck," a far-from-comfortable situation.

Captain Joseph Patterson, ramrod of the *New York Daily News*, was turning sixty-five when the story of Caniff's defection broke; he died in the spring of 1946 — never living to see his star talent's stunning farewell to *Terry*, let alone the debut of *Steve Canyon* — and he spent the last years of his life refusing to have any sort of contact with Caniff. More, he created an atmosphere at the *Daily News* that transformed Milton into an unwelcome outsider. "They wouldn't mention [Caniff's] name at all around the office," reminisced sports cartoonist and journalist Bill Gallo, whose career began as a copy boy at the newspaper. "It probably emanated from the old man, from Patterson, who felt if you left the *News*, you committed a mortal sin and you could never come back. You couldn't even come through the front door. It didn't matter how good you were."

Caniff began interfacing with the *Daily News* through proxies, using a local boy nicknamed "Bimbo" or household assistant Wilhelmina "Willie" Tuck to deliver the last years of *Terry* strips to the syndicate. Milton remained *persona non grata* at the *Daily News* for a quarter-century, until noted author Pete Hamill, while editing at the paper in the 1970s, asked Caniff to illustrate one of his own stories. But more than cordiality and business etiquette were at stake during Caniff's lame duck period — there were legal niceties at play, as well.

The language in the artist's contract with the Tribune News Syndicate was worded loosely enough to make Milton fearful the Syndicate might make a legal claim to ownership of anything he put down on paper while still in their employ, and certainly the "big chill" in relations between the *News* and Caniff did nothing to assuage those concerns. Because he was acutely aware of that risk, Milton kept his ideas in his head. Developing *Steve Canyon* under normal circumstances, filling sketch pads and notebooks with ideas for the new series, would run the risk that his soon-to-be-ex-employers might make a play not just for the notes, but also for the ideas they represented. Long before the phrase "intellectual property" had become common currency among creators, Milton Caniff understood the concept and its ramifications under the law. If he doodled or jotted down ideas — and there is no known evidence he did — they were quickly burned or otherwise destroyed, since even items languishing in the studio waste basket or home garbage cans might be fodder for a legal claim against him. As a result today, though Caniff was a packrat who stored prodigious amounts of detail related to his career, his papers contain none of the prep material one might expect where *Canyon* is concerned. Given the level of ambition the artist routinely brought to each of his panels and the depths imparted through his characterization and plotting, keeping the bulk of such work between his ears helped demonstrate that Caniff not only had artistic ability that evoked the name of Rembrandt, he also had skills worthy of mentalists like Alexander the Crystal Seer or Theodore Annemann. Another factor would also help foster such a conclusion – as 1946 unfolded, Milton was helping give birth to something besides *Steve Canyon*.

Creating comics is solitary work. Despite the long hours he spent alone with his drawing board, Milton Caniff was an outgoing man who placed a high value on belonging to organizations. Growing up in Ohio, his youth was shaped through his participation in the Boy Scouts; as a member of the studentry at The Ohio State University, he was pledged to the Sigma Chi fraternity and would eventually be named a "Significant Sig" as a leader in

his chosen field. He continued to proudly promote both groups throughout his lifetime.

During the War years Caniff was one of the mainstays in a loose band of cartoonists who were kept Stateside due to medical conditions or age. One of the ways they did their part was by visiting wounded soldiers in military hospitals, using their artistic and storytelling talents to boost the morale of those from whom the conflict had exacted a terrible toll. Caniff was one of the most popular of these visitors, in part because he often appeared with lovely Dorothy Partington in tow. (Partington modeled for Milton, serving as the real-life inspiration for Miss Lace, the heroine of the *Male Call* series he produced for the U.S. Government without pay throughout the War years. On her hospital visits the beautiful brunette dressed in the slinky cocktail dress Caniff had selected as Lace's standard-issue uniform, making her a hit with GIs who read *Male Call* in camp newspapers published around the globe.) Among the many other cartoonists who participated in these visits were Al Capp, Otto Soglow, and Rube Goldberg.

When the War ended the pleasures of continuing to find a reprieve from their drawing boards appealed to many of those who had made the hospital rounds, and a permanent cartoonists' society was formed during a March 1, 1946 dinner at New York's Bayberry Room. That far-famed meeting adjourned with Rube Goldberg named the group's first president, Russell Patterson Vice President (Otto Soglow soon became a second VP), *Pete the Tramp*'s C.D. Russell was selected as secretary … and Milton Caniff became the inaugural treasurer. Subsequently an official club organ, the *Cartoonists Society Bulletin*, was prepared; the inaugural edition articulated the fledgling outfit's reason for existence in a freewheeling, tongue-in-cheek style:

We are not a [labor] union, but purely a social group, which we proved the opening night by almost coming to blows twice. First in the selection of a name and again when we tried to decide what the hell a cartoonist was.

Aside from its officers, the founding members of the Cartoonists Society included *Superman*'s Joe Shuster, Gus (*The Gumps*) Edson, Fred Harmon of *Red Ryder* fame, *Nancy*'s Ernie Bushmiller, Bill (*Smokey Stover*) Holman, and twenty-two others. In an effort to reach out to artists from coast to coast, the membership soon agreed to amend the name of their club, officially becoming known as The National Cartoonists Society (NCS), the name by which they are still known today.

Recruitment in those early months was brisk: as the NCS entered its second year its ranks had practically quadrupled, growing over one hundred strong. Certainly Caniff's lifelong experience participating in various organizations helped steer NCS to its early successes. The Society recognized Milton by presenting him with its first Cartoonist of the Year award in May, 1947. Though technically given for work produced in 1946, the final year of *Terry and the Pirates*, the award was primarily in recognition of the first *Steve Canyon* strips, and also in honor of the prodigious and very savvy talent who not only created such memorable material, but also engineered the profitable business arrangement that made it all possible.

The NCS had a further honor to bestow one year later, in 1948, when Rube Goldberg stepped down and the membership elected Milton Caniff as their second president. Milton led NCS for the next two years, succeeded in 1950 by Alex (*Rip Kirby*) Raymond. Even after his terms in office, Caniff remained active in the Society and was eager to support its initiatives and goals. Like the Scouts and Sigma Chi, the National Cartoonists Society was an organization Milton wholeheartedly supported until the day he died.

While orchestrating the end of his involvement with *Terry and the Pirates*

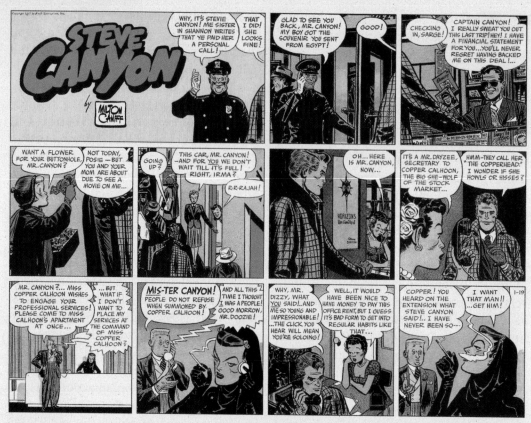

The first *Steve Canyon* Sunday page - January 19, 1947

and helping launch NCS, comics' Rembrandt was giving great amounts of thought to his new leading man. Faced with *tabula rasa*, his challenge was to fill that blank slate with a post-War hero readers could admire yet find relatable, someone with skills and a background that would prepare him for a life of adventure, a handsome sort cut from the Pat Ryan/Terry Lee mold, yet visually distinct from either. It was no small task, but one Milton was more than capable of meeting.

The January 13, 1947 *Time* magazine article on the birth of *Steve Canyon* chronicles the care Caniff took in building his new creation, right down to the selection of a name: "Caniff plotted his new characters as carefully as any fiction writer. 'The guy, now, had to have a name that would stick,' Caniff explained. 'It had to be three syllables — Dead-eye-Dick, or John-Paul-Jones … Steve-Canyon. Not a real name, or one you could turn into a dirty word. But a guy who'd have a girl in every port, and could do all the things that a youngster like Terry [Lee] couldn't.'"

The visual components came from a variety of inspirations, among them popular movie actor Gary Cooper, whose career spanned more than one hundred films, including *Sergeant York* and *Pride of the Yankees*. Cooper built his reputation by portraying quiet-yet-ruggedly-individualistic characters, and that Cooperesque flair could give Milton's new top dog the ability to be cool and unflappable in one panel before erupting into fast, intense action in the next.

Caniff lifted select facial features from his paternal grandfather before adding other physical aspects. Those he jotted down as marginalia in a special promotional piece he prepared for *Coronet* magazine: "Tall! Lean!", the page emphasizes. "Like an old plains scout."

Hair color was more problematical. Comic strips abounded with sturdy blond heroes like Flash Gordon and black-haired leading men ranging from Li'l Abner Yokum to Mandrake the Magician — and

of course, Terry Lee's hair was light, Pat Ryan's dark. Caniff's solution to this matter was nothing short of inspired: he chose to make Steve Canyon primarily blond, with a black streak in his hair sweeping backwards from the center of the forehead. This touch made Canyon distinctive from Caniff's prior creations, as well as from every other hero on the nation's comics pages. (By the 1960s, artists Jack Kirby and Steve Ditko would use similar visual shorthand — white streaks in otherwise brown or dark hair — to indicate the more mature heroes in the early Marvel Comics universe: Reed Richards, Nick Fury, Stephen Strange.)

The initial choice to make Canyon the proprietor of a shoestring air charter company allowed Milton to make use of the copious knowledge about flyers and flying he had cultivated during the War years on *Terry* and through his friendships with real-life aviators like the late Frank Higgs and Colonel Phil Cochran. A pilot-protagonist would allow stories to unfold anywhere on the earth or above it while allowing Caniff to make use of the colorfully staccato airman's lingo he loved so much. A generous sprinkling of insider's jargon could allow Canyon to sound sometimes carefree, sometimes sarcastic, always distinctive from many of his employers or adversaries.

As Canyon himself took shape the villains, conflicts, supporting players, settings, and themes coalesced around him; Caniff was then able to begin crafting the introductory episodes of his new series. Much has been written since January

1947 about that first week of *Steve Canyon* – about the dailies featuring an extended encounter between Steve's secretary, Feeta-Feeta, and stuffy Mr. Dayzee, the front-man for wealthy businesswoman Copper Calhoun – about how Milton build suspense by keeping Canyon off-stage (Feeta-Feeta produces a head-shot photograph of him in the Thursday installment, but otherwise he is initially unseen) – about the incredible first Sunday page that revealed so much about Canyon's background and character before he was seen for the first time, walking through the Horizons Unlimited door. That launch-week of *Canyon*, juxtaposed against Caniff's final *Terry and the Pirates* work, remains an enduring example of the work of a comic strip virtuoso, using words and pictures as skillfully as Jascha Heifetz used his violin. Milton brought down the curtain on events in China, only to raise it on a new adventure, a new sensibility, and a new cast ready to offer readers a daily thrill ride full of globe-trotting derring-do, romance, humor, and action.

Following that first week of continuity, Caniff weaved a story of skullduggery and simmering passions set amidst the Calhoun plantations in Mexico. The crafty Pino Pluma romances Copper Calhoun even as he makes Canyon out to be a drunkard and a womanizer, ultimately mousetrapping the *Americano* into a forced hospital stay. Steve's Horizons Unlimited crew hatches a scheme to free their boss, then events rush at top speed toward an unexpected denouement.

The plot of this story and the next,

Steve Canyon - **July 18, 1947**

Steve Canyon - September 16, 1948

featuring Delta and the shady Black Champagne Oil Company, evoked the feeling of Warner Bros.'s popular B-pictures, yet by the third *Canyon* saga – featuring that Eastern bloc Mata Hari, Madame Lynx – Caniff began inching toward more topical story content that reflected the tenor of the times – and in the second half of the 1940s, the global air carried a distinct chill.

In the period following V-J Day, focus shifted away from the Pacific Rim toward Europe, where a shattered Germany required rebuilding and the Soviet Union held sway over countries such as Romania, Hungary, Czechoslovakia, and Poland, among others. America and Great Britain grew increasingly concerned about the expansion of Soviet influence even as Greece became a locus for the conflicting ideologies, with its existing regime, which primarily favored Western interests, threatened by Communist-influenced rebels. The perception within the corridors of power in Washington, D.C. and London was that if Greece changed governments and moved under the "Red" sphere of influence, neighboring Turkey would inevitably follow suit. (This was the earliest example of the Domino Theory that infused the democracies' approach to the Third World through the Vietnam War era.) A Greece and Turkey no longer allied with the West, coupled with the sizable post-War presence the Soviets retained in Iran, could potentially cut off the West from access to the Mediterranean and, more important, from the Middle Eastern countries and their increasingly-vital oil supplies.

Seeking to solidify U.S. interests throughout Europe and Asia, U.S. President Harry S. Truman to set forth a doctrine bearing his name that called for America to supply hundreds of million dollars in foreign aid to both Greece and Turkey while seeking to establish a policy of "containment" of Soviet influence. This doctrine formed the basis of Western foreign policy from its release, on March 12, 1947, until after the fall of Saigon in 1975.

Three months after The Truman Doctrine was rolled out, America announced the Marshall Plan, designed to rejuvenate war-torn Europe and relax trade barriers with an influx of thirteen

Steve Canyon - October 25, 1949

billion dollars into the Continent. Western European nations were Marshall Plan participants; the Soviet Union and its satellite countries rejected the Plan, with the Soviets proclaiming that "Marshallization" should be resisted and thwarted whenever possible, even as they labeled the U.S. and its allies as enemies to Communism. The level of intransigence was rising on both sides, giving fresh life to a term George Orwell of *1984* fame coined at the end of World War II: *the Cold War*. Respected journalist Walter Lippmann chose Orwell's phrase as the title for his influential 1947 book that helped inculcate the concept at the grass roots level.

With America's global goals focused on curtailing Soviet hegemony in the developing nations, the Cold War polarizing countries on both sides of the Atlantic, a major emphasis directed at the countries of the Aegean Sea, and a desire to befriend the Mid-East and develop their oil reserves, there were no shortage of juicy current events that could serve as Caniffian story fodder. As a result, Milton

moved Canyon and Happy Easter into a brush with espionage, introducing Madame Lynx on July 27, 1947 as the linchpin in a plot to derail the Horizons Unlimited crew, whom Lynx's spymasters presume to be agents of the American government assigned to curtail Soviet oil development. By the spring of 1948, with Lynx fully neutralized, Steve and Happy are prowling the fringes of the Persian Gulf and stumbling onto a secret base for constructing submarines. There they fall under the sway of Captain Akoola, whom Milton would later describe as, "the first real Russian operative to appear in *Steve Canyon*. 'Akoola' means 'shark' in Russian. Now, the Russians have always made a big noise about their women doing various things, as well they should, so why not make one a commander of a submarine? In 1948 the idea was unheard-of ... I modeled Captain Akoola after my wife, Bunny, but then, Bunny has been the model for most of my female characters at one time or another."

Though careful to keep his cast col-

Steve Canyon - December 24, 1950

orful and the menaces rather larger-than-life, Caniff viewed himself as first and foremost a newspaperman, someone whose job it was to help sell not just today's edition, but tomorrow's as well. He knew that using elements borrowed from the front pages helped him do his job by making his series seem richer and more immediate; he also knew that the U.S. newspaper audience during *Canyon*'s early years was heavily weighted with World War II veterans – more than one out of every ten U.S. citizens during the period had been in uniform during the Second World War. The political viewpoints expressed in *Steve Canyon* reflect the prevailing U.S. worldview of the time, which was embraced not only by Milton, but by the majority of the United States citizenry as well. It was an approach that worked supremely well as the Cold War deepened, yet failed to change over time, which eroded readership during the civil unrest of the 1960s.

No matter how compelling his stories, it was Milton Caniff's skill with pencil and brush that set him apart from not only his fellow cartoonists, but also from the prose novelists of the day. The combination of Milton's artistic skill and writerly savvy allowed him to serve up a unique brand of entertainment audiences could find nowhere else. He continued to challenge his skills by taking advantage of fresh capabilities in newspaper printing technology – his Sunday pages began to make vivid use of color holds that would never have been attempted in the *Terry* years. Fans sat up and took notice, and Milton had literally millions of fans. One of them was a then-teenager named Bill Chadbourne who would eventually enlist in the Air Force, find himself stationed in Japan, and produce a weekly comic strip called *Captain Comet* for his camp paper. Bill had been a Caniff devotee for many years when, in 1960, he got the opportunity to meet Milton and Bunny on their first-ever trip to the Far East. Long before that red-letter day, however, young Chadbourne avidly followed the adventures of Milton's two most famous works. Interviewed for this series, Bill contrasted his perspectives on *Terry and the Pirates* and *Steve Canyon*:

Terry was like a first love. We believe no other will ever quite measure up – but then one matures and moves on to new and better things. That's my opinion of the difference between *Terry* and *Canyon*. The early *Canyon* strips were even tighter than the 1940s *Terry* panels (which I studied over and over). Then, over a year or two, *Steve Canyon* became looser and more nuanced, and Steve was less the movie star with the vivid streak in his hair.

With his new strip, Caniff got even cuter with his dialogue. Between *Steve Canyon*, Madison Avenue jargon, and John Ford movies in the 1950s, the real Air Force Information Office (the branch in which I worked) often sounded like a spoken *Canyon* script!

The 1950s – with Bill Chadbourne in uniform in real life and Steve Canyon wearing similar colors on the comics page – were still part of the future on the day when Rembrandt unveiled his newest creation. Fallout shelters and the Korean Conflict and the beginning of the Space Race were as yet undreamed-of. Now here it was, 1947, and Milton Arthur Paul Caniff, like a contemporary Scheherazade, was beginning to weave a tale that would span four decades, a tale that would hold spellbound hundreds of thousands of newspaper-reading sultans.

Having done work for both DC and Marvel Comics, former book and film reviewer and lifelong comics fan Bruce Canwell is the associate editor and a lead writer for The Library of American Comics, where he writes biographies of talents as diverse as Milton Caniff, Alex Raymond, George McManus, and Alex Toth. You can contact him at info@loacomics.com.

AL WILLIAMSON

IT ALL STARTED WITH FLASH GORDON

In a field where words like "legendary" are thrown around with little or no thought to their actual meaning, Al Williamson was actually a legend among both fans and his peers. Over a span of five decades, those who didn't know him personally became familiar with his work, which ranged from penciling and inking stories in EC's *Weird Science-Fantasy* in the '50s to inking John Romita, Jr. on *Daredevil* for Marvel in the '90s, or newspaper work including *Secret Agent Corrigan* (also known as *Secret Agent X-9*) and the daily and Sunday *Star Wars* strip.

"Al Williamson is one of only a handful of top-rated comic creators who have spent their entire careers working in our industry. Too often our very best talents are lured away by promises of fame and fortune in other venues. I think that Al stands as a shining example of the lifelong craftsman who works constantly to improve his already considerable talents; by the entire scope of his career he announces to every other person in the industry that this is a field fully worth the commitment of a lifetime of creations," writer-artist Mark Wheatley said on Williamson's induction to The Overstreet Hall of Fame in 2009.

Williamson passed away in 2010, but his legacy remains. The following feature appeared in its original form in *The Overstreet Comic Book Price Guide* #30, which celebrated the 50th anniversary of

EC's "New Trend" titles, under an EC-esque science fiction cover by Williamson.

It started with *Flash Gordon*, the action-filled, meticulously illustrated adventure comic strip of the 1940s by Alex Raymond. *The Spirit*, Will Eisner's smoky creation, Hal Foster's exquisitely rendered *Prince Valiant* and other strips followed close behind.

In Spanish, of course.

Fans and historians know Al Williamson for his highly evocative art. Many, though, don't know the full scope or variety of his efforts.

During his career, he worked with the proverbial Who's Who of comic book talent. The list of names includes John Prentice (the artist who took over *Rip Kirby* in 1956 following the death of its creator, Alex Raymond), Roy G. Krenkel,

Angelo Torres, Wally Wood, Joe Orlando and the rest of the EC gang.

When publisher Bill Gaines and writer/editor Al Feldstein brought that group together, they must have known in some sense the amazing level of talent they had assembled. There is equally no way they could have known what a permanent impression they would make on the industry or the art form.

Williamson, along with artists such as Wally Wood, Harvey Kurtzman, and others carved out a distinctive — and as it turns out, lasting — niche in American comics with the quality of their work on the EC line.

Although it has been more 60 years since the "New Trend" began and more than 55 since it ended, today's top creators routinely cite the horror, crime and science fiction comics that comprised the "New Trend" as being among the most influential comics in the history of the medium.

While more experienced fans might know Williamson for his EC work, younger enthusiasts might know him exclusively for his inking abilities. Then, as now, he maintained a distinctive style that is neither entirely old school nor entirely new, containing elements both classical and innovative.

South America

For a young Al Williamson growing up in Colombia, the world of comics held incredible fascination. His wonderment was encouraged by his mother, who regularly bought comics for him (she would read them, too). Her favorite, he says, was *The Spirit*, printed in Mexico, and he quickly developed a liking for it as well.

It wasn't his favorite, though. That honor was reserved for Alex Raymond's legendary run on *Flash Gordon*.

Even *Flash Gordon* wasn't his favorite from the beginning, though.

"The first artist to inspire me was an Argentine artist called Carlos Clemen, then Bill Everett, creator of Amazing Man and Sub-Mariner," he said.

Thoroughly revved up by the Buster Crabbe serial, *Flash Gordon Conquers the Universe*, and the realization that Hollywood was making movies from comics, he was hooked.

"I was immediately taken with it and really just overwhelmed by it," he once told an interviewer. "It took over my life at the age of ten."

With the excitement of the serial and subsequent introduction to Hal Foster's work on *Prince Valiant*, Williamson's career was set in motion.

"I started drawing in school every chance I got," he says.

A page of Al Williamson's pencils, inked by Frank Frazetta, from *Crime SuspenStories* #17

North America

When his parents split up and his mother decided to return to North America, Williamson wasn't all that concerned with the differences he would experience or the situations that might confront him. He had other priorities." This was where comics were done," he said. "This was where Alex Raymond lived."

In 1943 Williamson and his mother settled in San Francisco where he promptly began to devour his daily helping of Raymond's *Flash Gordon*. Then the unthinkable happened. Well, unthinkable to a 12-year-old fan at any rate.

Raymond joined the war effort and his duties on the strip were taken over by Austin Briggs. No reflection on Briggs, but he just wasn't Raymond, whose departure was not sufficiently explained. Not that any justification would have sufficed for the young Williamson.

"The next year my mother and I moved to New York. I went to the office of King Features Syndicate, owners of the strip, and demanded an explanation," he said. He was 13 years old.

"A lady there was very nice and she offered me proofs of Briggs' strips, but I turned them down. I suppose it wasn't very polite, but I didn't want them," he said with a laugh.

EC — A World of Its Own

Becoming an artist is different for each individual. Williamson described himself as "pretty much self-taught," although he counts the high standards of influences such as Roy Krenkel and Frank Frazetta as benchmarks.

"I was working with Frank on *John Wayne Comics*, and this particular scene called for John Wayne and a sidekick to be going along when a rabbit darts out in front of them. Frank said, 'I've never drawn a rabbit.' He closed his eyes for a moment, then drew a great looking rabbit," Williamson said.

He had made his first successful foray into comic book art in *Famous Funnies*. "I did a couple of spot illustrations," he said. That title, ironically, had been the first American comic book he had ever seen.

In the process of breaking in, he became friends with a few of the artists working for publisher William M. Gaines at EC Comics.

"Wally Wood and Joe Orlando kept on telling me to come up and meet Bill," he said. "I finally met him at a party at Wally's. I was 20 or so. He was always very nice, but he demanded respect. You knew you couldn't mess around with a deadline."

Williamson said Gaines was quick to give him a chance, but that chance came with the caveat "If you're late, you don't work for me again."

"If the deadline was in two weeks, I made it in two weeks, but Bill always made a production of it, like he didn't think I was going to make it or he'd been sweating over it all day," he laughed.

Not that Williamson didn't cut it close.

"I was a goof-off," he said. "I would have a bunch of my friends come over the night before an assignment was due and we'd knock it out. It wasn't the most professional situation, but it was a great time."

Secret Agent Corrigan - **February 25, 1967**

The camaraderie of those late night sessions was one of the perks of working for EC. Even though Williamson was the youngest, he got along well with the other creators.

"They were all sweethearts," he said. "They were all good artists in that group, and they were good people, too."

The End of EC

When Senate hearings — inspired by Dr. Frederic Wertham's claims about the negative influence of comic books on youngsters — came about, so did the Comics Code. The Code put an end to the axes-in-heads, hangings, electrocutions and other graphic depictions on the covers of the "New Trend" titles, although they had never really been a big factor in the science fiction titles with which Williamson was more associated.

On the heels of the demise of the "New Trend," however, Gaines launched the "New Direction" titles; and Williamson's artwork was featured prominently in *Valor*, though it, like all the "New Direction" titles, was short-lived.

"I don't think any of us thought about how long it would last," he said of his time at EC. "It was sad when it was over, but Bill had *MAD* and I was already working for Stan Lee doing westerns over at Marvel [then Atlas], so it wasn't as if I lost my livelihood."

After EC

After the end of EC's comic book line, Williamson worked for several other publishers. He also ended up working with John Prentice on the newspaper strip *Rip Kirby*.

"Johnny was wonderful to work with. He was very patient, but he was the best schooling I could have had on meet-

STAR WARS

Written by
ARCHIE GOODWIN
drawn by
AL WILLIAMSON

ing a deadline. He always made it clear how important that was," he says.

Rip Kirby, of course, was not the end of Williamson's newspaper work. In addition to a run on *Secret Agent X-9* he teamed up with his old friend Archie Goodwin for a long, respected run on the *Star Wars* strip. He remembers the collaboration fondly and identifies him as his favorite writer to work with.

"When King Features called me to do the strip, I immediately thought of Archie to write it," he said. "We had lunch. Archie said to me, 'I'll write if you draw it,' and I said, 'I'll draw it if you write it,' and that's how we got together for that."

Archie Goodwin, who launched Marvel's creator-owned Epic line, had also worked for Warren, but was best known as a writer-editor for DC Comics.

"Archie was very good," Williamson said. "He wrote a story you could draw. He wrote with the artist in mind."

Another great DC Comics editor, Julie Schwartz, switched the track of Williamson's career by offering him an inking assignment. Here he could still inject elements of style and detail, but he could work without the time-consuming undertaking of designing and laying out each page. In other words, he could work faster.

As a result, a whole generation of comic book fans grew up knowing Williamson more as an inker than as a pencil artist. Whether it was over Curt Swan's pencils on a Superman comic or John Romita, Jr. on *Daredevil: Man Without Fear*, his inks tended to bring their own elements to a story without subordinating the style of the penciler.

In 1995, he illustrated a 2-issue *Flash Gordon* series for Marvel with his good friend Mark Schultz, creator of *Xenozoic Tales*. "It was hard work, but fun," he said.

Hy Eisman:
Ghost Artist & More

BY MARK SQUIREK

Over the last 50 years Hy Eisman has spent a lifetime working at his craft, drawing and often writing some of the best-known comic books and strips in the world. Since 1976, he has been a teacher at the Joe Kubert School of Cartoon and Graphic Art in New Jersey. As of this interview in August 2013, Eisman is still writing and drawing the *Popeye* Sunday page. His experiences show a side of the comics industry that many of us don't ever see or even think about.

Overstreet: How did you end up working on an Army newspaper with Hugh Hefner?

Hy Eisman (HE): The War ended while I was in basic training. I was sent to Camp Pickett in Virginia and started drawing for the *Camp Pickett News*, the paper that Bill Mauldin started. When I got there, the staff was two WACS, an editor, and another cartoonist whose name was Hugh Hefner.

Overstreet: Did you get along at the time?

HE: Oh yes, but I didn't think he was any good! He loved cartooning though. As the years have proven he is one of the great supporters of the art form.

Overstreet: When did art become a career choice for you?

HE: When I first saw comic strips in the newspaper, I was hooked. I read *Dick Tracy* when I was five. Early on, I loved the work of Alex Raymond and Hal Foster. I looked forward to *Prince Valiant* the most. They were unbelievable. Even today *Prince Valiant* fascinates me.

Overstreet: What was the next step after your discharge from the service?

HE: There was never any question that I was going to go to art school. Specifically, I wanted to go for comics, but no one taught comic art at the time. So I had to go to a regular art school. There was a good school named "The Art Career School" in the Flatiron Building, so I commuted from Jersey to New York every day. There were three of us in the class who loved comics: Frank Thorne, who went on to do *Red Sonja*, Al Kilgore, who ended up on *Rocky and Bullwinkle*, and me.

Overstreet: What happened after graduation?

HE: Looking back, it was at the worst possible time in the industry. I had no idea at the time, but things were changing rapidly. Sometimes they changed in the space of days.

Overstreet: Why?

HE: The Senate Investigations were going on and all the shops that bought or produced comic art were closing down

overnight. The Kefauver Committee was shredding my job prospects.

Overstreet: Were you even able to get an interview with a publisher?

HE: At one point, Hillman Publications saw my portfolio and told me to come back in one week, there would be some work. One week later, I showed up and they weren't there. They had literally gone out of business and packed up in one week! If I remember correctly there were over 40 publishers in business when I was first making the rounds. By the time the hearings were over, there were maybe four or five.

Overstreet: Were you able to get in to see anyone else after the Hillman interview?

HE: One time I went to DC. I waited patiently with my portfolio and work and finally someone came out to see me. Years later, I found out that he was the elevator operator! They would send anyone out to the lobby to deal with people!

Overstreet: How did you finally get published?

HE: In order to make ends meet, I took a job with a company that made Valentine and greeting cards for the big retailers, like Sears. During this time I developed a strip about New Jersey. I planned to take it around to all the newspapers in New Jersey and charge each of them ten dollars for the strip. So, naturally my first stop was the largest paper in Jersey.

Overstreet: This was another walk-in interview?

HE: Yes. And amazingly they loved the strip and decided to publish it. I was ecstatic! When I told them that I would be taking the strip to other papers, they told me they couldn't allow me to sell it to their competition. So, while I suddenly had a regular job and a large readership, I had accidentally screwed myself out of a couple of hundred bucks by succeeding so well!

Overstreet: Did you worry about that at the time?

HE: I didn't mind. For the next three years, I did the Valentine job, which paid the bills, and the newspaper strip taught me how to meet deadlines and deal with the business.

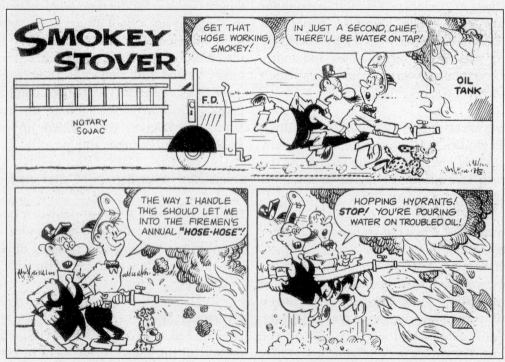

Smokey Stover Four Color #827 - 1957

Overstreet: Were you still pounding the pavement, talking to publishers during this time?

HE: Yes, I just kept trying to get into comics. One of my earliest experiences was a direct result of the book, *Comics and Their Creators* by Martin Sheridan. He wrote about Alfred Andriola who did *Kerry Drake* and said Andriola never turned down an interview. I got the phone book and found him. He was kind enough to see me. He gave me six Bristol boards and asked me to do a week of dailies. I celebrated for two days before it dawned on me that I had gotten what I wanted. I also knew I wasn't going to get the job.

Overstreet: Why?

HE: They were badly drawn because I had wasted valuable time celebrating the assignment for a couple of days instead of giving it the attention it deserved. When I teach I tell these stories about deadlines and pressure and speak from very real experience, mine.

Overstreet: What was the outcome?

HE: I went back to Mr. Andriola and he was nice, but he told me that he couldn't use me at the time. He kindly paid me for the effort, which truth be told he wasn't obligated to do, so I thought that was very generous of him.

Overstreet: A lesson to learn.

HE: And I did. Five years later, after I had gotten some work, I was able to join The National Cartoonists Society. By then I had been working on another long forgotten classic, *Smokey Stover*. One day, at the club, I ran into Mr. Andriola. He remembered my work and asked me what I was doing. He needed somebody to help on the pencils for *Kerry Drake*. He needed some time away from the strip because he was trying to work up another strip, *It's Me, Dilly*, and sell that one to the syndicate. Once again he gave me six boards. This time, I spent a week doing the pencils properly. He liked what he saw and hired me.

Overstreet: How did you get the job on *Smokey Stover*?

HE: Frank Thorne, whom I knew from school, was working for Dell on one of their titles. I think it was *Turok*. One day he called to tell me that Matt Murphy at Dell was looking for someone to ghost on the *Smokey Stover* book. I went to see Matt and that day he handed me a script for *Smokey Stover*. After that, the next step was working for the American Comic Group.

Overstreet: Some of those ACG books were really nice. They had a lot of artists who worked under pen names so the other publishers wouldn't find out.

HE: A lot of folks would work there under false names in order to pick up extra cash. Through the National Cartoonists Society I had met Kurt Schaffenberger. At the time he was doing a lot of work at DC. Everyone knows how good he was on the Superman titles. But he moonlighted at ACG.

Overstreet: What was ACG like at the time?

HE: It was an odd place to work, but I didn't realize it at the time. Richard Hughes was the guy I worked with. He would give me these tremendously overwritten scripts signed by some unknown Japanese writer. Being young, I was quick to voice my opinions about how this guy would overwrite. Hughes would cut the pieces without question. Years later, I found out that Hughes was the one writing everything! Some months, he was doing seven or eight books and signing pen names to all of them! He never said a word to me about that.

Overstreet: At the time you were still doing *Kerry Drake*?

HE: That lasted until about 1959. The strip Andriola had been working on just didn't fly, so he came back to Drake and resumed the pencils. Working on *Kerry Drake* was like attending a graduate school for comic art. It taught me what I

needed to do in order to get six dailies and a Sunday out every week. There is no replacement for experience. I am grateful that I was given another chance. After the time I spent on *Kerry Drake*, I was ready for anything.

Overstreet: When did you start to develop the strip that you were trying to sell, *Joe Panther*?
HE: Right after I lost *Kerry Drake*. The title *Joe Panther* was actually a series of books that was being written by a guy named Zachary Ball, which was the pen name for Kelly Masters. With only a fourth grade education, he had built a career writing stories for *Colliers* and *The Saturday Evening Post*. When he came up with the series of books for *Joe Panther*, he didn't want the magazines to know that he was writing teenage adventure stories.

Overstreet: Why?
HE: This was a different time and it was a question of appearances. Magazines were really big and they provided a lot of short story work, which was where he was making his money. Masters didn't want to alienate his regular market by working in a format (teenage adventure/comic strips) that might give the magazines cause for concern. Anyway, looking to develop *Joe Panther* as a newspaper comic strip he had contacted another cartoonist.

Overstreet: Who was that?
HE: Lank Leonard, who was doing *Mickey Finn* at the time, just couldn't take it on. He knew that I had just lost *Kerry Drake*, so he put the guy onto me. Masters and I talked and we began working on the strip by phone and through the mail.

Overstreet: This was when, 1960?
HE: Yes, we spent a lot of time on it. The original stories were about a 17-year-old Seminole Indian boy who lived on a reservation in Florida. For the newspaper strip, Masters changed that concept. He added ten years to the character of Joe Panther and changed the scene to a much more urban environment. Panther was now a private detective and drove a Corvette. I swear that when *Miami Vice* came on in the '80s, I thought it was Joe Panther!

Overstreet: What did you have to do to submit to a syndicate?
HE: We put together two weeks of dailies and two Sundays. In addition, we put together an outline of the strip's development over the first few months. Eventually, we thought we were ready to begin taking the strip around.

Overstreet: Even though you were getting comic book work and had *Smokey Stover*, it seems the goal was to get your own newspaper strip.
HE: Yes, definitely. A successful newspaper strip is security, it is a job. In every profession there is a hierarchy, a job that is a bit better than yours. If you go back far enough, the cartoonists working on early newspaper strips wanted to be illustrators or painters, but many of them couldn't make it. When comic books came along, comic artists wanted to be newspaper artists.

Overstreet: How long did it take to get the attention of a syndicate?
HE: We went everywhere that published newspaper strips. The process seemed to take forever. Finally, we got in to see United Features. They took the strip and said they would get back to us with their decision.

Overstreet: What did they come back with?
HE: They said they thought the strip could sell, but they felt some changes were needed. They were really concerned that the idea of a Seminole Indian moving through White society wouldn't be able to sell to Southern newspapers.

Overstreet: In the context of the times that was an important consideration.
HE: It was something that Masters and I hadn't even thought of on any level! The

Eisman worked on the teen title *Bunny* in the late 1960s

syndicate suggested that we make Joe Panther ten years younger and put him on a reservation in Florida. That way, his interaction with white people would be as tourists. What was ironic was that their suggestions were a lot closer to what Masters had been writing in the books, so we brought back his original supporting cast, a girl named Jennie Rainbow and an uncle who served as a sidekick. We quickly put together an outline and did a new set of dailies. We turned that into the syndicate. They were pleased with the changes.

Overstreet: Did they come to you with a contract?
HE: Well, it was their version of a contract!

The standard contract was this: fifty-fifty split, after expenses. That meant my share was 25 percent, and I still had to pay for all my own brushes and pens and boards.

Overstreet: You had been in the industry for quite a while by then. This must have amazed you.
HE: Since they were the only syndicate that had shown any interest, we had to listen to what they offered. At first, we thought that such a rate was an opening gambit in negotiation, but it turned out they were inflexible! This was their standard contract! In addition, it can take over a year for a strip to begin to earn money, so we had to support ourselves while this whole year was going on. In essence, we were being asked to do the strip on spec!

Overstreet: How did the deal work out?
HE: We ended up turning them down. We took it around to a few other syndicates. We showed one editor the revised version, and she only looked at the very first daily. Her response? "Who wants to see alligators on a Monday morning?" She wouldn't even look at it any further than that first daily!

Overstreet: Where did *Joe Panther* ultimately end up?
HE: After that brush with United Features,

we just couldn't convince anyone to pick up the strip. Masters was a good guy, but we weren't great friends or anything. We did stay in touch. He went to Hollywood and began to try and sell scripts. He finally had some success with Disney. He had written a script about a boy and a really ugly dog called Bristle Face. It was made into a TV movie. As for *Joe Panther*, it was eventually made into a feature film starring Brian Keith and Ricardo Montalban! I saw it and it looked like they had taken the dailies I did and used that as a storyboard for the opening scene!

Overstreet: Which concept did they use, the urban Joe Panther or the one who lived on the reservation?
HE: They went with the younger version. Anyway, right after we did all the work on *Joe Panther* I started to get a lot of work in comic books and was also ghosting for other strips as well. I had a family to support, and I always liked to work, so I wasn't really preoccupied with the strip's failure to sell. In comics I did *The Munsters* books and others. For newspapers I picked up some daily work on *Bringing Up Father*. Vernon Greene had started to become ill and he didn't want King Features to know.

Overstreet: This is the same Vernon

Little Iodine - October 14, 1979

Greene who did *The Shadow* strip that ran in the 1940s?

HE: Yes, he was a great guy and did wonderful work. His work on *The Shadow* is stunning. As for *Bringing Up Father*, Greene was ill at the time and was really worried that the syndicate would take the strip away from him if they found out how sick he was. At first I would take the strips down to the Veterans hospital for him to sign. After a while, his wife asked me to just do his signature. After that, I got regular work with Harvey doing a new comic book for them called *Bunny*.

Overstreet: How did *Bunny* come about?

HE: Harvey and some toy company had decided they were going to do a Barbie-type doll together. The gimmick was that the doll was ultimately tied into the comic book. Ultimately the toy company fell through but Harvey decided to go along with the comic book anyway. It was written by Warren Harvey. If I recall, he was one of the sons of the owner. For a while it was actually really popular.

Overstreet: Even with a comic book that was selling, was a newspaper strip still in the back of your mind?

HE: Oh yes. Right after *Bunny* started, I had gotten a call from King Features. Funnily enough I had applied at King Features right after graduation from Art School. After the interview they told me to go home and wait for a call. Seventeen years later I got the call!

Overstreet: What did they want?

HE: They wanted to know if I was interested in doing *Little Iodine*. The creator Jimmy Hatlo had been gone for a few years and Bob Dunn and Al Scaduto were doing both of his features, *They'll Do It Every Time* and *Little Iodine*. They asked me to pick up the *Iodine* Sunday page.

Overstreet: By now you must have acquired a reputation as a dependable ghost artist.

HE: Tex Blasdell had stepped in on *Little Orphan Annie* when Harold Gray passed away. Somehow, over the years, I had become known as the poor man's Tex Blaisdell. He always joked that he was known as the rich man's Hy Eisman! For me, after all those years of ghosting comics and drawing books, *Iodine* provided me with my first byline in a newspaper. I worked on *Iodine* for almost twenty years.

Overstreet: That must have felt good after, what, almost 20 years in the business?

HE: Actually, it was 17. I got *Iodine* in 1967 and I had been working since 1950. That run on *Iodine* turned out to be a good one. I was able to do comic books like

Katzenjammer Kids - January 18, 1987

Tom and Jerry and I also drew *Iodine*. A few years later, Joe Kubert opened his school and approached me about a teaching job.

Overstreet: What set that up?

HE: Joe had found a mansion in his hometown in Jersey. He invited my wife and me to see the place to show us what he was going to do. Out of the blue he asked me if I would want to teach there. I was going to turn it down, but my wife told me to take the job. Her reasoning was that it would get me out of the house and give me a reason to bathe and shave more regularly!

Overstreet: As time has gone on you picked up a few other strips after *Iodine*, didn't you?

HE: Yes, that led me to picking up the Sunday pages for both *The Katzenjammer Kids* and *Popeye*. Today I am still drawing and writing the Sunday *Popeye* pages.

Overstreet: After all these years, is doing a Sunday page still a challenge?

HE: Oh yes! The great thing about doing the *Popeye* Sundays is that I love putting a page together, trying to improve it. It is still a kick. On the production end I have to deal with the demands of panel arrangement. When doing a Sunday today, as opposed to forty years ago, you have to be very careful. Some papers will drop one panel out or even change the format. So what those readers see may not turn out to match your design. Some papers, in order to fill a space will stretch the panel, causing your art to distort. The job is always a challenge and always a joy. And who doesn't want to write *Popeye*?

Overstreet: What is on your agenda for the future?

HE: I plan on doing the Sunday for *Popeye* as long as I can. Teaching at the Kubert School also keeps me busy.

Overstreet: That early love of newspaper comics has meant a lot to you.

HE: In over fifty years I have never left comics. I made a decision that I loved them a long time ago. From as early as I can remember I absolutely had to draw. There is nothing else I could have ever done.

HISTORY
FOR THE COLLECTOR

www.gemstonepub.com

BACK ISSUES NOW AVAILABLE

The Overstreet Comic Book Price Guide • Overstreet's FAN
Comic Book Marketplace • Overstreet's Comic Book Monthly
Overstreet's Golden Age & Silver Age Quarterly
Hake's Price Guide To Character Toys • The Overstreet Comic Book Grading Guide
Overstreet's FAN Edition Comics • And much more!

GEMSTONE PUBLISHING

All characters ©2013 respective copyright holders.
Overstreet® is a Registered Trademark of Gemstone Publishing, Inc. All rights reserved.

EVERYONE DESERVES A
GOLDEN AGE

GIVE BACK TO THE CREATORS WHO GAVE YOU YOUR DREAMS

Support The Hero Initiative, the only charitable fund dedicated to helping yesterday's comic creators in need.

THE HERO INITIATIVE

HERO
HELPING COMIC BOOK CREATORS IN NEED

For more information or to send donations
11301 Olympic Blvd., #587
Los Angeles, CA 90064
or visit www.heroinitiative.org

Captain America is a trademark of Marvel Characters, Inc. Copyright © 2006 Marvel Characters, Inc.

LD $95,155

MONROE OWNED
SOLD $18,239

SOLD $94,875

SOLD $12,197

SOLD $17,906

SOLD $95,200

FULL SET
LD $22,278

SOLD $37,041

SOLD $22,412

SOLD $13,244

Since 1967

THE CONSIGNOR'S BEST CHOICE OVER 1 MILLION ITEMS SOLD

Hake's is the premier source for Pop Culture Collectibles. We are America's first and most diversified collectibles auction house.

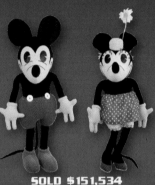
SOLD $151,534

★ OVER 200 CATALOGED AUCTIONS CONDUCTED SINCE 1967 ★

★ WORLD RECORD PRICES SET IN EVERY AUCTION ★

★ OUR EXPERTS USE THEIR COMBINED 250 YEARS OF KNOWLEDGE IN THE FIELD TO SHOWCASE YOUR ITEMS ★

★ 20 AUTHORITATIVE COLLECTIBLE PRICE GUIDES PUBLISHED ★

SOLD $75,000

SOLD $31,625

SOLD $12,776

SOLD $41,264

SOLD $13,210

SOLD $33,674

CONSIGN NOW
WWW.HAKES.COM

P.O. Box 12001
York, PA 17402
(866) 404-9800

A DIVISION OF
GEPPI'S

ANIMATION ART GLOSSARY

The purpose of this glossary is to provide a basic reference to aid in understanding both the terminology and the different kinds of animation art a collector may encounter. It appears courtesy of S/R Laboratories Animation Art Conservation Center, Westlake Village, CA, USA. ©2013 S/R Labs. All rights reserved.

Two things are helpful in understanding animation art. One is a comprehension of the basis of cel animation itself, in which sequential images of the character are rendered on paper, transferred to cels, placed over a background, photographed and projected one at a time at the rate of 24 frames per second to create the illusion of motion.

The second is recognizing that animation art is divided into three distinct categories:

> *Pre-production:* Preliminary artwork created in the developmental stages of the film.

> *Production:* Artwork actually photographed and used in the release print of the film.

> *Post-production:* Artwork made after the film for advertising or publicity purposes. Also included in this category is artwork created for consumer products, limited edition cels, serigraphs, and dye transfers.

CEL: A clear plastic sheet on which the character has been rendered. Although there are variations, the most common method is for the animator's drawing to be inked or xerographed onto the front of the cel and then painted on the back. Animated props and special effects - such as water or lightning - are also rendered on cels.

CELLULOID®: Cellanese Corporation's brand of nitrocellulose. It was the first man-made plastic, and the first material used in the manufacture of cels. The term cel derives from celluloid and is still used today, although nitrocellulose was replaced for animation industry use by cellulose acetate, a safer and much more stable material, about 1940.

BACKGROUND: A piece of artwork, usually a painting, over which the finished cels are placed to be photographed, and which serves as the setting for the action.

> *Production Background:* A background used in the release print of the film; also referred to as a master background.

> *Preliminary Background:* A background painting created during the production process of the film that did not appear in the release print.

> *Art Props or Studio Background:* A background painting created by studio artists for publicity or display purposes.

> *Hand-Prepared or Display Background:* A non-studio background created solely to accent a cel.

> *Printed Background:* A lithographed reproduction of a background used to enhance cels.

> *Background Layout:* The finished drawing used for the background painting. Often erroneously called line test background.

OVERLAY: A portion of a scene, generally a foreground element, painted on or applied to a cel and laid over the action to create the illusion of depth.

SET-UP: A combination of a cel, or cels, and background. A set-up may also include addi-

tional elements from a scene, such as overlays or special effects.

Matching or Key Set-up: Cels and backgrounds - and other elements, such as overlays, if applicable - that appeared together in the final, released version of the film.

Non-Matching or Married Set-up: Similar to a matching set-up, however, the elements may have come from different scenes of the film.

DRAWING: A wide variety of drawings are created during the making of a film. The most characteristic are the animator's drawings of the character. In addition, there are story and layout drawings to establish direction and staging; concept drawings to work out elements such as design, atmosphere, or color; character studies; and many other types created during the different stages of production. These can be large or small, sketchy or fully rendered, and may be in any media from pencil or charcoal to pastel.

COLOR MODEL: A preliminary cel created to work out the color styling for a character, which may or may not be in the final colors used in the film. Once colors have been established, color model cels are created as guides for inkers and painters. Color models are also created as guides for non-production uses, such as character costumes.

MODEL SHEET: A sheet containing several drawings of a character or characters, showing construction, poses, expressions, and relative sizes, used as a guide by the animator to assure consistency of appearance. These may be either originals or stat copies created in small quantities by the studio for distribution to the artists involved.

12-FIELD: Standard cel size of approximately 12 1/2" wide by 10 1/2" high.

16-FIELD: Standard cel size of approximately 15 1/2" wide by 12 1/2" high.

PAN: A cel, background, or set-up that is wider than standard, and is used for moving camera shots.

PUNCH: The characteristic holes that appear at the edge, usually the bottom, of production drawings, cels, and backgrounds. These holes fit over corresponding pegs and keep all elements in exact register or alignment throughout the production process.

COURVOISIER SET-UP: Courvoisier Galleries®, San Francisco, were the first to offer original Disney animation art. From 1937 through 1946 they sold and distributed Disney production cels, drawings, and related materials from several features and shorts in specially prepared set-ups, which included custom backgrounds, certificates, and mats.

CUT-OUT: An image from which the excess cel material has been trimmed to the character line. Cut-outs are usually affixed to a background. They are not uncommon, and are frequently seen with Courvoisier set-ups and Disney studio-prepared set-ups from the 1950's. May also be called a partial or trimmed cel.

IN REGISTER or REGISTERED: Refers to a portion of a character on a cel that is incomplete or cut off, because it has been drawn to align with background or other elements.

LAMINATION: The encapsulation or sandwiching of an object in thermoset plastic. Courvoisier laminated cels, as did the Disney Original Art Program. Lamination is not an appropriate form of preservation.

LIMITED EDITION: Artwork created for retail sales in order to meet the demand for animation art of vintage and classic characters. Characters are usually depicted in ideal poses and the artwork is numbered, showing the edition number and total pieces in the edition. Limited edition cels are often presented as set-ups with printed matching backgrounds.

SERIGRAPH OR SERICEL: Artwork created for retail sales to resemble a cel, but utilizing a mass-produced, screen printing procedure, instead of production techniques.

DYE TRANSFER: A high quality, printed reproduction of a cel set-up.

Courvoisier Galleries® is a Registered Trademark of S/R Labs.

Jim Lentz on Animation

Although there has always been a market for classic, key animation pieces, for many years it seemed as if the animation market as a whole was in the doldrums. That might no longer be a true observation as Heritage Auctions has announced the addition of animation expert Jim Lentz to their staff and an Animation Art Auction to their roster of specialties.

We talked with Lentz about his background, the market and why it's a good time for animation art.

Overstreet: What was your first experience with animation art?

Jim Lentz (JL): Seeing hand painted cels at Disneyland as a kid.

Overstreet: What made you look at it as business rather than just as a fan?

JL: I felt that animation art was one of the great American art forms we as a country had produced. I couldn't believe you could own a piece of an animated short or feature film. When I was growing up Prime Time network animation was on every night: *Alvin and the Chipmunks* on Monday night, *Bugs Bunny* on Tuesday night, *Bullwinkle* on Wednesday night, *Huckleberry Hound* and *Yogi Bear* on Thursday night, *The Flintstones* on Friday night, Disney and *The Jetsons* on Sunday night, and of course Saturday morning cartoons. Also I vividly remember the experience of my parents taking me to the theater to see *Sleeping Beauty, 101 Dalmatians,* etc. I felt that the baby boomer generation was really a cartoon generation, and a gallery devoted to this type of artwork would thrive.

Overstreet: How did you actually get into buying animation art?

JL: I was in Los Angeles in late 1980s on business and went to a collectibles auction called Camden House. I was looking at the handful of animation pieces they had when someone asked me if I knew anything about animation. He mentioned he had an estate from a woman who was a script reader at Disney and to look in Sunday's newspaper to see the auction in East LA. I got the paper, and flew back the following week on my own money and I bought a few boxes of animation art. I bought scenes from the Mickey short *Canine Caddy,* and wonderful storyboards and model sheets and drawings from *Pinocchio.* I met someone at a cel restoration house there, and paid him to teach me first hand about animation cels, drawings, authenticity, paint types, restoration etc. He became a lifelong friend.

Overstreet: Prior to joining Heritage, you ran your own animation art gallery chain, Stay Tooned Galleries, in the mid-west. What was involved in that?

JL: I ran three galleries with my wife, Tracy, devoted to animation art. Two in Chicago land and one in Minneapolis area. I wanted to not be the biggest, just the best, so I started the Mid-West Animation Lecture Series and brought everyone in the business out to speak. Animators, directors, studio heads, writers, historians, voice talent, etc. It turned into a who's who of animation both young and old. It was something to this day I am very proud of. It was free and the crowds were huge. It was like going to college of animation to hear these peoples stories first hand. I look back on it now and I'm in awe of who attended. I recently ran into June Foray at a UPA Film Fest in California, she was turning 95. She talked with me at great length at her appearances in this series!

Overstreet: You also spent time with Disney Fine Art and as a consultant to Walt Disney Art Classics. What did those positions add to your experience?

JL: I learned so much about the rich heritage of Disney, the brand of Disney, and the respect they have for keeping an archive of their animation legacy. The quality in everything they do made an impact on me as well.

Overstreet: What brought you to Heritage at this juncture?

JL: I noticed their unbelievable success in comic books and comic art as well as in all their collectible categories, and I noticed animation was becoming a regular section in their comic book auctions.

Overstreet: The animation art market has seen lots of highs and lows over the years. What are some of the notable ups and downs you've observed during your career?

JL: In the 1990s animation art went crazy due to the second Golden Age of animation. The market was driven by the unbelievable success of feature films like *Roger Rabbit*, *The Little Mermaid*, *Beauty and the Beast*, *Aladdin* and *Lion King*, etc. Not to mention the creation of Nickelodeon, Cartoon Network, Boomerang, and Toon Disney. The *Roger Rabbit* auction prices caught everyone off guard with its success. Animation art ran hot for a very long time. *Tiny Toons*, *Animaniacs*, *Rugrats*, *Batman*, and *Ren and Stimpy* were all really well written cartoon shows. Quality was reigning supreme in both feature and television animation. Watching the interest in animation art for almost 15 years was a joy. The lows were really driven by poor economy, some poor box office films and the closing of Warner Brothers and Disney stores.

Overstreet: To a casual observer, it seemed like the "manufactured collectibles" really put a damper on things years ago. Was that really the case or did it just seem that way?

JL: Nothing stays hot forever. Your audience got older, 3D and digital animation took over. The market, like all collectibles, had a glut of limited editions, like all collectibles in the 1990s. They were really well done. The reason for damper I feel was simply too much was produced, pure

and simple. There are limited edition pieces today that are still in hot demand.

Overstreet: How would you characterize the market at the moment?

JL: It seems like there is a renewed interest in animation art. With virtually everything going digital, the realization of animation art being hand drawn, hand painted is having real appeal. You see Disney releasing classic films in 3D and scoring big at the box office. Older animation shorts and features are coming out in Blu-ray and in box sets, and they are attracting new audiences once again.

Also you see Cartoon Network doing its second season of *Bugs and Daffy* and getting ready to start a new *Tom and Jerry* series,. It says that everything old is indeed new again. The book market is also really embracing animation with the Disney Archive Series on Animation, Story, Background

and Layout not to mention new books on all *Toy Story* films, as well as a book called *A Disney Sketchbook* that is simply loads of Disney animation drawings.

New books on *Mr. Magoo's Christmas Carol*, the history of *Peanuts* animation and a stunning book on the making of *Snow White* all came out in 2012 time frame and I hear [they are] selling well. In fact a feature *Peanuts* film I hear is also in the works.

You now also have many studios making animated features. It's not just Disney. You have Disney, Pixar, DreamWorks, Sony Feature Animation, and Fox all making major box office dollars via animation.

The bottom line is, some of the greatest artists this country has ever seen have worked in animation art. I personally find a vintage animation drawing of Mickey Mouse, Bugs Bunny or Snow White simply breathtaking. I watched *How the*

Grinch Stole Christmas, A Charlie Brown Christmas and *Mr. Magoo's Christmas Carol* this year with my kids and they were as magical as they were when they first came out some 40 – 50 years ago.

Overstreet: How much of this renewed appreciation do you think can be traced to the notion that key players at Pixar and other firms are themselves fans of classic animation?

JL: I think this is very important. Talk to any of today's animation filmmakers and they will tell you story, character development and understanding of traditional drawing methods are still very important today! In reading the four volume Disney Archive Series on Animation, Layout and Background, Design and Story, the introductions written by John Lasseter tell you how important it is today! I looked at great length over the amount of hand drawn character design and concept art in the *Art of Hotel Transylvania* book and it was simply amazing!

Overstreet: What are some areas of the market you think deserve special attention from collectors or would-be collectors?

JL: I have always felt the animation drawing is so undervalued. Animation roughs breathe so much life. You can hold one drawing and see what Frank and Ollie called "The Illusion of Life" in your hand. I find all animation drawings something all collectors of any type of artwork should look into. I also feel the Hanna Barbera Studio is sometimes overlooked. They shaped American Saturday morning television as well as had a major staple of Prime Time shows (*Johnny Quest, Jetsons, Flintstones, Top Cat*, etc.). Vintage animated character storybook artwork I also see emerging as something special these days.

Overstreet: Most collectibles markets benefit from getting the word out to their consumer bases. What are the best avenues for this in the animation market?

JL: Animation art auctions are on the rise again; this really gets people's interest going. I think new art, never before seen brought to market, is something that stimulates big time. Web sites like *Scoop*, Cartoon Brew, mainstream Fine Art and Auction magazines, alerting the marketplace to animation art always helps as well. I can't believe the amount of calls I'm getting once Heritage announced its first Animation Art Auction! People, collectors both old and brand new, seem very, very excited.

Overstreet: If there was one misconception about animation art that you'd like to address head on, what would it be?
JL: That it's dead! This wonderful hand drawn, hand painted artwork is a type of artwork that stirs emotions, brings back specific memories, and makes you smile. It never grows old…

Ron Stark Gets Animated:

INSIDE S/R LABS

by Mark Squirek

Ron Stark is the President and founder of S/R Labs. Founded in 1976 by Stark, his wife and a few friends, S/R Labs is the only animation art conservation center in the world. Located just outside of Los Angeles, CA, the Labs have built a close relationship with Disney animation.

Their auctions, held twice a year, contain some of the rarest and most desirable Disney animation art available in the marketplace. We spoke with Stark about the history of collecting animation art, especially as it pertains to the Disney Studio, the role that restoration plays in the animation art marketplace, as well as the outlook of the marketplace.

Overstreet: Where did your interest in animation art come from?
Ron Stark (RS): My father was a music copyist at MGM and my uncle was Louie B. Mayer's lifelong assistant. I come from movie stock! Animation was part of my early days, but I had aspirations towards other ideas at the time.

Overstreet: Like what?
RS: I had many and varied interests, but I did enjoy the spiritual. Ultimately I attended seminary for while. Eventually I became a radio, TV and film producer for the American Heart Association. I also worked as a liaison with many TV shows during the early 1970s including *The Waltons*, *Police Woman* and others. As the decade went on I worked on movies and TV every day. Shows such as *Bonanza*, *Cannon* and *The Beverley Hillbillies*. Voice-over work was important to me. I had Daws Butler as a voice coach. My voice-over work included Goofy, Mickey, Woody Allen and oth-

ers for educational media companies. Animation art began to be important in my life.

Overstreet: How did voice-over work, directing and the like lead to restoring animation art?
RS: One day the wonderful June Foray, whom everyone knows as the voice of Rocky the Flying Squirrel, invited me to a meeting of The International Animated Film Society located in L.A. The organization was filled with volunteers, the famous and the non-famous. Without planning to, I became part of the Board. In order to raise money, June created a cel sale. I renamed it the animation art festival and ran that for seven years. As a sideline to this, and because I had a background in art and science, I learned to repair animation art. Around 1976 I started to restore the art as a hobby. This turned into a project that we unceremoniously called the Search and Rescue team. The search was finding the art. The rescue was restoring it. That's the origin of the name S/R Labs.

Overstreet: How did you build such a good relationship with Disney?
RS: My uncle was L.B. Mayer's right hand man. So I was familiar with the motion picture industry. As the producer for the American Heart Association, I had a professional standing in the community. When I moved into animation I got to know the people over at Disney Studios. More specifically the people who knew the art program. During this time there were a good number of people from the early days still there or stopping in. Frank Thomas and Ollie Johnson still worked there and in fact the majority of the nine old men were still there. I was able to get to know them as well as the new animators.

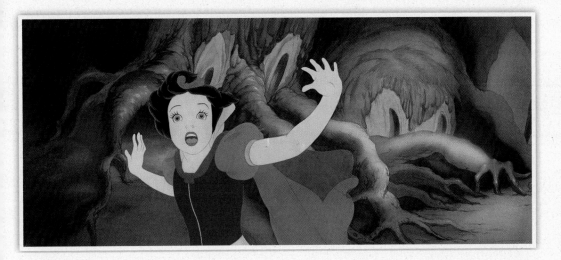

Overstreet: Had they considered restoration or even the value of the art itself?

RS: When S/R started, the idea of restoration was still a very new concept. Back then Disney didn't want to tell anyone about their secrets. Things such as the way their paints were made. Disney had the most elaborate paint style. Other studios such as Hanna-Barbera used different techniques.

Overstreet: What did it take for them to begin to change their mind towards restoration and the art in general?

RS: Slowly and slowly everybody around the animation scene began to loosen up. I have to say I can't blame Disney's initial reluctance to letting anyone in on their secrets. They had been burned a lot of times. But through a burgeoning relationship with Roy E. Disney, one of the kindest men I have ever met, I became familiar with many great artists at the studio.

Overstreet: What stands out for you from your early days of working with Disney art?

RS: Their special effects artists were as magical as their inkers and painters. If you look at *Fantasia* it is astonishing. Roy and the studio in general were very kind to me. Disney's last real chemist was Emilio Bianchi and he is the one who trained me.

Overstreet: Why did Disney have a chemist on the lot?

RS: The studio made its own paint for the backgrounds as well as cels. They called it "poster paint." As I learned we documented exactly how everything had been done. We were able to get many of our supplies from the original manufacturers. Paints were provided by Winsor/Newton, who supplied Disney with the original paints they used. They provided us the actual pigments to work from. Eventually we recreated the entire Disney Color system at S/R Labs. David Brayden came here after doing his stint at Disney and became our colorist.

Overstreet: Tell us about the coloring of a Disney cel.

RS: Color restoration is a science unto itself. Disney colors are compilations. They will often use three or four hues in one color. Disney had more color palettes than any other studio in history. At their peak there were using as many as 10,000 colors.

Overstreet: What about the color on the cel itself?

RS: Over time the studio changed the cel material from nitrate to acetate. The difference in the material affects the color concentration as well as how the paint lays on the cel. Also, over time, the front has been bombarded with light and the back of the cel is dirty. It has been lying on newspapers, tables, drawing tables. As a result each side of the cel is deteriorating not only for a different reason, but at a different rate.

Overstreet: Loose chips of paint are a problem for many cel collectors. Some people claim you can just glue a chip back in place.

RS: This is an unrealistic concept. Re-gluing a chip changes the tension of the cell. It can't breathe the way it once did. Eventually the glue will tear the cel apart. The glue is an unnatural part of the equation.

Overstreet: What about drawings?

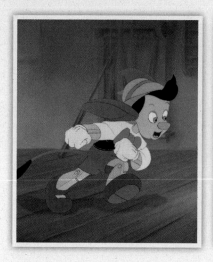

RS: They have a specific structure, a different morphology. During the restorative process paper requires a whole different mindset and skill set. There are holes, stains, fly specks, actual material that gets into the paper itself. You cannot erase it. The dirt fuses with the paper or becomes solid on its own. Sometimes we can remove it, sometimes we can't. Steps may include mechanical cleaning, washing or bleaching. Pencil on paper is very permanent. Animation drawings are great collectibles and it is a magnificent medium to work with.

Overstreet: What can you tell us about forgeries in the marketplace?
RS: It's hard to write about what to look for in fakes because we don't really want to educate the bad guys! It is extremely difficult to forge a Disney cel. It is near impossible to create the original materials. Even then you would be hard pressed to make these in quantity because an expert knows the materials Disney used. As to drawings, they are of course easier to make. Always try to buy from an established dealer and ask for a provenance or history of sales. Talk to people about the art. Learn to understand what the art is about. Also, your gut will tell you. Like almost anything in life, if what you see or hear is too good to be true, it probably is.

Overstreet: How did you get into the auction business?
RS: In 1987, one of my long-time friends from Disney said he didn't know what to do with a large amount of Disney art that he had. The art was amazing. It was great work from *Alice in Wonderland* and much, much more. Since he was my friend I offered to send out a list to

other collectors. We called it Lab Listings. Someone suggested we do the whole thing as an auction. We shot pictures in our living room. The first auction went well. We ended up having to be bonded and licensed. Once this started we were approached by other people who wanted our help selling their art. We never owned the art ourselves. We still only deal in consignments. NY Auctions were big at the time. Disney hired me to go back to NY to certify art as authentic. We are the only animation auctioneers from the '80s who are still in operation.

Overstreet: When did you begin to notice an upswing in collectors looking for animation art?
RS: Serious collectors began really appearing around the mid-1980s. Many of them were looking for what they considered the ideal moment in a given film, that single piece that speaks for the entire film. Fortunately that standard is subjective, or the number of wonderful pieces of art would have been gone long ago. Still, a lot of collectors have purchased a lot of art in the last nearly thirty years. But don't kid yourself, not nearly all of it.

Overstreet: What do you think triggered the shift to a more hard-core collector coming on the scene looking for Disney-related art?
RS: Around 1984 there was a big auction in animation art and it got a lot of attention. The event really rocked the pop culture world. The rush was on.

Overstreet: Were there any problems with the sudden influx of new collectors?
RS: At that time practically no one knew any-

thing about the art itself. The details were vague for a lot of folks. There were no real established standards like we see in coins or comic books. There were big questions about the artists who created drawings and cels. Sometimes people were unable to tell what film the art was even supposedly from.

Overstreet: The difficulties facing both seller and collector must have been tough.

RS: Can you imagine not even knowing if the *Pinocchio* cel you're holding in your hands is really from Walt Disney's *Pinocchio*? At the time most collectors took these things on faith. There was no real home media at the time, so you couldn't do your own research. In 1984 no one had a VHS copy of the legendary film. In fact, *Pinocchio* wouldn't release on VHS until 1993, nearly a decade later.

Overstreet: What was available in the way of reference books to help the collector?

RS: There were few good ones, but most accurate information about collecting, restoration and almost anything about animation art took place among a small circle who knew each other. One of the changes, and a crucial one, that has taken place since the mid-1980s is the number of excellent books on animation and animation history that have been published. Books by John Canemaker and Pierre Lambert, Charles Solomon, or Mark Kausler are aesthetically beautiful as well as worth their weight in fascinating and valuable information about this art form.

Overstreet: Can you explain the importance of Courvoisier Galleries to the collectors market?

RS: They were the first to demonstrate to Walt Disney that his artwork was something artistic and salable. That makes them very important to the history of animation art as well as to the preservation of the art form. I believe that Courvoisier is responsible for creating the first wave of interest in animation art.

Overstreet: Why?

RS: Walt Disney's *Snow White and the Seven Dwarfs* premiered in 1937. At the time, The Gallery was in San Francisco. We often forget how big the risk was for Disney. Walt and his people were unsure that an audience could watch a full-length animated feature for 83 minutes without getting a headache or dozing off. So they put extra thought into promotion. What they came up with was incredible and very original, especially for the time.

Overstreet: How so?

RS: Disney prepared dozens upon dozens of cel set-ups as lobby cards for theaters, exclusively for those showing *Snow White*. These were wonderful, brilliant cels, the original set-ups created for the title cards made for these showings. When people went to the theatre,

they saw the artwork before they even saw the movie! Guthrie Courvoisier saw the art and was wowed by it. He and his father spoke to the Disney Brothers about their art. In the end they worked directly with Kay Kamen on this. By 1938 they were the exclusive distributor for Disney Art.

Overstreet: Earlier you said Courvoisier was responsible for creating the first wave of interest in animation art. What followed?
RS: The second wave was in 1955 with the opening of Disneyland. Much has been written about the Art Corner at Disneyland. There and throughout the park they sold animation art.

Overstreet: After that came the auction in 1984, right?
RS: The record prices caused many collectors to think all they had to do was buy the art, wait a bit, and sell it for even higher prices. They thought they were sitting on a treasure trove. But things didn't go that way.

Overstreet: What were the repercussions of that?
RS: What they didn't realize was that more than 40 years had passed between the late 1930s and the mid-1980s. Nor did they anticipate the glut of artwork that would emerge from garages and basements because of animation art's new notoriety.

Overstreet: What else?
RS: The biggest thing was the clock was ticking. The art, already decades old, was aging and there was no one to whom they could turn for help. Plus a lot of art was scooped up with almost no understanding as to its quality or importance. People would buy cels of Donald's

hand or Mickey's foot assuming that they would be able to find the rest of the character sometime later. They had little or no comprehension of the fact that there might have been only one body or head to go with dozens of arms.

Overstreet: What was the biggest problem?
RS: Misinformation. In the rush to explain animation art to those who were buying it up, writers, often ignorant themselves of the animation process, began deluging animation art collectors with erroneous and misleading information. Ironically this information came from the selfsame collectors who knew little or nothing. Some of them just flat out made up terms.

Overstreet: Like what?
RS: There were countless people who said they collected "gels," "cellules," "Jellos," "Plastipanes," "Cellos," and so forth. Questions like, "what does it mean when there are no holes?" Another standard one was "Where should the holes be?" Or the word "Glassing." It was like being in a house of mirrors.

Overstreet: Was there a reaction over at Disney?
RS: Disney, having missed seeing the mushroom cloud from the 1984 explosion, jumped on the bandwagon with their own art program and licensing deals. The first one was with Jack Solomon's Circle Fine Arts. Disney-authorized galleries stretched from coast to coast.

Overstreet: What were they selling?
RS: Disney began producing limited edition cels in ever-increasing numbers and varieties. There were technical drawbacks though. In

order to keep the cels from showing any signs of wear, the Studio began laminating them, giving collectors the impression that this was a viable means of preservation.

Overstreet: How does this affect the cel?

RS: It is only a matter of time before the lamination fails, eventually requiring a professional response to reverse such a treatment. Disney only did the lamination for about ten years. Today S/R Labs is able to address the issues left behind by the well-intended practice of lamination. Some others, like Hanna-Barbera, had active animation art programs that flourished at this time as well. I was working over there at the time and explained why they should avoid that step and they were kind enough to listen.

Overstreet: What happened as the '90s progressed?

RS: The number of collectors continued to increase. In the mid-nineties there was the introduction of Sericels. The process was really just serigraphy, a process of silk-screening. This new product, Sericels, confused a whole new wave of animation art collectors who thought animated character merchandise had now become animation art.

Overstreet: What was the effect of their introduction on the rest of the market?

RS: Sericels are a nice collectible, but they can hardly be recognized as real animation art. They stuck around for a while with all the other merchandise Disney and other studios were cranking out to satisfy a seemingly insatiable collector market. Disney even created 3-D animation art with the introduction of the Walt Disney Classics Collection. The program lasted more than 20 years and populated many

a mantle piece with Disney characters in classic poses. As we have in the past, when Disney introduced a new collectible S/R Labs expanded to be able to repair them too. In fact for a few years we did the pre-production color styling for the Classics Collection.

Overstreet: Where is the market today?

RS: Great animation art remains on the menu, and the selection and quality of the art available is remarkably fine. Prices are rational and reasonable, reflecting the age and importance of the art, and the selection remains astonishingly wide.

Overstreet: Given the age of much of the art, where does restoration fall into the marketplace?

RS: Gone are the days, thankfully, when collectors recognized the authenticity of a cel or drawing by how much dirt or damage it had. Restoration, once the black sheep of animation art, is now accepted and expected.

Overstreet: Any final words about what to look for?

RS: If you understand how much art was created in the production process and compare that amount with how much is available in the marketplace, you begin to realize that nearly anything that is good and reasonably priced is a treasure worth holding. Most importantly, you should ideally be buying because you love this incredible art form. I understand investments and all, but when you look at a *Pinocchio* cel and see the work, the craft, the love in there; when you see the paint so bright against the cel and ultimately see the smile on the puppet's face before you, your heart should soar and melt at the same time.

Snow White's Homecoming

After an encounter with the daughter of a pre-war Disney "Ink and Paint Girl" at his first major auction, Steve Ison turned his nascent interest in animation art into a full-fledged passion for collecting Snow White. In the years that followed, he established himself as the top Snow White collector and as an authority on the subject. He did it not only by seeking out the best pieces for his collection, but by exploring the human elements of information. In many cases he found the former Disney animators and other employees had stories to tell, and he listened. Through these methods over the course of more than two decades, Ison's Snow White collection grew in size and scope to become the stuff dreams are made of.

An interior shot from the gallery Steve Ison built in his home to showcase his collection.

He staged exhibits, put together an impressive book on the subject, and continued to acquire keypieces, all with his personal focus not on the monetary value of the collection but on its historical and social significance. He believed, in his words, that "This stuff is important."

That these items were ever available in the first place illustrates how times have changed since the film was made in 1937. What would now most likely be seen as a distinct company asset was not closely guarded; over the years many of the pieces just "walked out" the door, and a number of pieces were sold to cover expenses associated with making the film in the first place. In recent years, though, under Chief Executive Officer Robert Iger, Disney has conspicuously moved closer to its roots.

This direction marked a change from the tenure of Iger's predecessor, Michael Eisner. While Eisner gave the authorization to build and maintain the Animation Research Library and storage facility, he did not appear to place any sentimental value or historical importance on the vintage artwork.

With so much of the company's history in one place, perhaps the collecting world shouldn't have been surprised, but they were definitely startled in the summer of 2006 when it was announced that Ison had sold his prestigious collection to Disney.

As a child, Steve Ison collected baseball cards, coins, and the like. Nothing more than a fascination with the scene in which the skeleton reaches for a drink would tip his interest in Snow White, but even then, in each area he was active in, he narrowed his focus to collect a specific niche. It was a

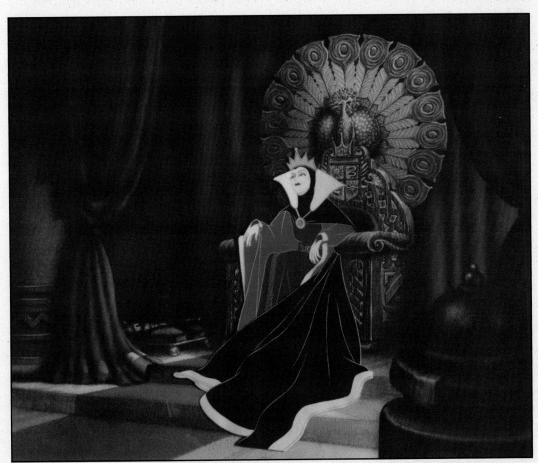

Wicked Queen Grimhilde in her finery—and her element—as depicted in the early scenes of *Snow White and the Seven Dwarfs* (1937). This image and other Snow White cel and story sketch art reprinted here: from the collection of Steve Ison.

habit that would serve him well later in life.

"I couldn't learn it all, or afford to buy it all, so I decided to narrow my collecting strategy," Ison said.

In college, he was in a singing group that had sung at Walt Disney World. There he saw an original vintage Disney cel that was being sold for $50. Being the typical college student, he couldn't afford it at the time, but started to investigate the idea of collecting animation art. He began talking with the few expert dealers and collectors he could find and started networking. He attended an auction at which he met the daughter of a Disney animation department employee. The woman's mother had been an "Ink and Paint Girl" (or "inker" for short), which was a job assigned to women because the studio found women's steady hands could ink the cels in a more fluid and competent manner. She offered him what turned out to be his first real indoctrination in this area of vintage animation art collecting. On a trip to her Michigan home, he purchased an array of pieces from a number of different Disney films.

"After buying the pieces, I instantly had this huge collection; pieces from all of the classic Disney animated features. I have never collected with profit in mind. That idea has never appealed to me. So, what I did when deciding to focus on Snow White was to sell and/or trade the pieces that were non-*Snow White*-related, the *Peter Pan*, *Mickey* and other pieces. I would pool my money into collecting only *Snow White*. My initial goal was to get a cel of every character from *Snow White*. That developed into concept and storyboard art and that eventually evolved into the collecting of the original background paintings," he said. "The only downside to the way I went about narrowing my collection was that I sacrificed some really amazing pieces of early Disney animation to focus on *Snow White*. Throughout the entire time, I've never regretted it! There are some pieces that I wish I still had, but you just can't have it all."

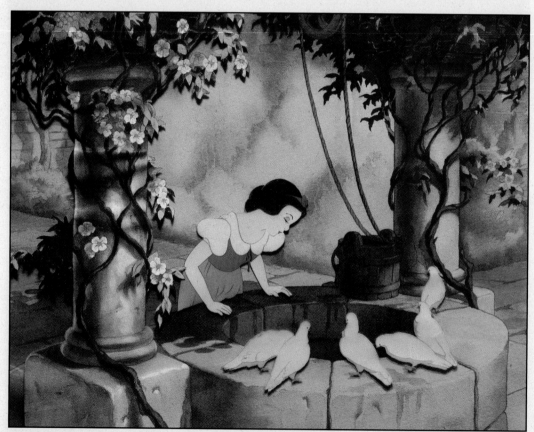

Snow White sings the opening strains of "I'm Wishing," the first of the feature film's numerous hit songs. Voiced by Adriana Caselotti, Disney's first princess warbled to the words and music of Frank Churchill and Leigh Harline.

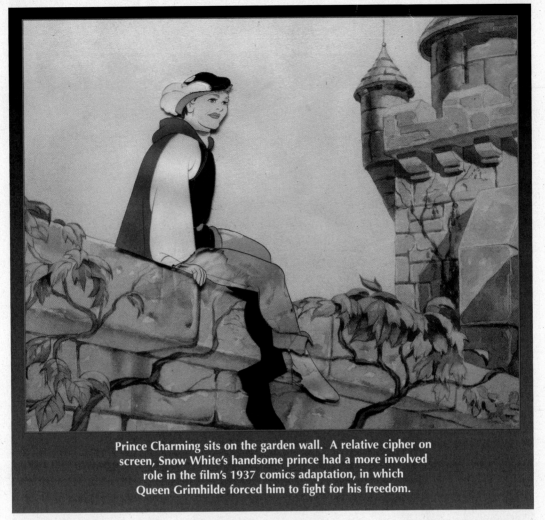

Prince Charming sits on the garden wall. A relative cipher on screen, Snow White's handsome prince had a more involved role in the film's 1937 comics adaptation, in which Queen Grimhilde forced him to fight for his freedom.

His collection continued to grow and as it did, Ison looked for ways to improve the public's perception of the art form.

"I've always tried to get people to understand that this is more than some 'Disney collectible;' I consider it fine art. It has never been about me. It's always been about the art and the incredible artists who created it," he said.

"In 1989, I approached the Indianapolis Museum of Art, and asked one of the directors of the museum about having an exhibit of animation art. After five years of convincing, they agreed to display my collection. By that time, the collection had evolved. It would now be possible, through the viewing of storyboards, backgrounds, drawings, and concept pieces, for even the youngest student to learn the story and production process of *Snow White*." he said.

Early storyboards and organizational story documents allowed Ison to see where there might be gaps in the story of Snow White, particularly if it was to be told in the visual form of actual art. He began filling in all of the holes in his background collection based on the original version of the storyboards, including scenes that were cut from the final version of the film. This allowed him to focus on the missing pieces while keeping his collection intact. Of the approximate 200 backgrounds that were created for *Snow White*, for instance, he ended up with over 60 of them when all was said and done.

The details of this process and the museum's interest in producing a catalog of the exhibit eventually developed into Ison's book, *Walt Disney's Snow White and the Seven Dwarfs: An Art in Its Making*, which was released in 1994 and eventually published in several languages (a miniature version of it accompanied the special edition DVD release of the film).

"Famed is thy beauty, Majesty; but hold, a lovely maid I see. Rags cannot hide her gentle grace; alas, she is more fair than thee." Voiced by Moroni Olsen in Snow White, the Slave in the Mirror later got a new voice – Hans Conried – and a new job as host for many later Disney TV shows.

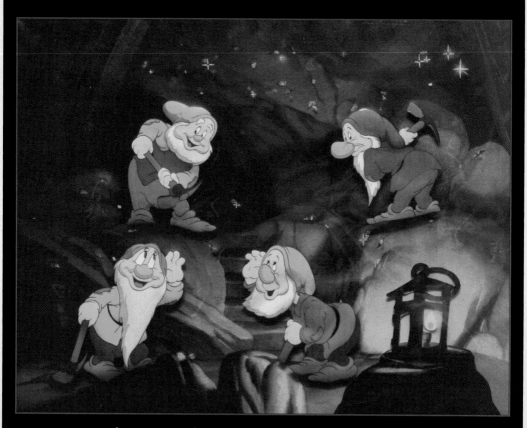

The Seven Dwarfs "work work work work work work work, in [their] mine the whole day through!" Animator Bill Tytla's delineation of Grumpy—whose attitude changed over the course of the film from chauvinist pig to sensitive soul – marked an early character animation milestone.

"It gave me the direction I needed to not only put together an exhibit, but the book, too," he said. "They originally planned to do a pretty straightforward, meat-and-potatoes-type of book, but I said to them, 'Let's make this really more interesting, because animation art, especially at the Disney company, is all about the story, all about personality.' I also wanted to include information on the animators who had put their personalities and talents into making *Snow White*, so I decided to fly myself and my two co-authors out to California, where I had set-up between 15 and 20 interviews that would be included in the book."

Ison's ability to arrange interviews for the book was significantly enhanced by the connections he had made through collecting.

"Over the years, I had become friends with former animators like Mark Davis, Ollie Johnson, Frank Thomas, Jim Grant, Maurice Noble and others, and every time I was in California my old friend Bill Justice would meet me at the Hilton in Burbank with a box of animation art treasures that he would sell for other people that he had worked with. I was always fair in my dealings, out of respect for them and what they had created. Over the years, there were many horror stories where some collector or dealer had cheated many of these people. I would keep the *Snow White* pieces I needed and sell or trade the rest to continue finding pieces for the book and the exhibit," he said. "So I started spending money like it was water to try and fill in the holes in the book. We then contacted The Walt Disney Company to get permission to reproduce the artwork in the book."

The company initially became aware of his collection when he contacted them about the book.

"Our first letter outlined the exhibit itself, which was comprised of my collection. Initially, the request to do the book was rejected, but while we were out in California conducting the interviews for the book, the Disney board made the announcement that the company would be releasing *Snow*

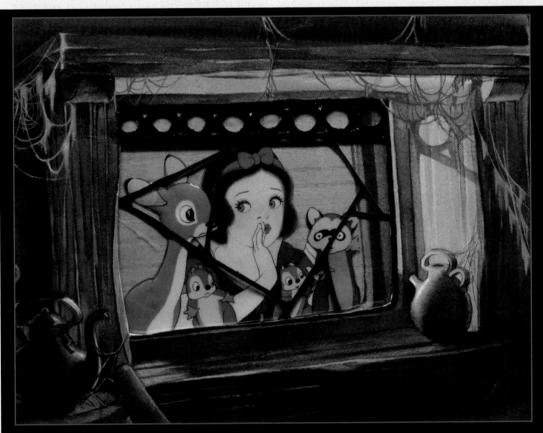

Snow White and her critter friends investigate the
house of the absent Seven Dwarfs.

White on VHS. At that point, Disney was also just starting Hyperion Publishing, and with the release of *Snow White*, we decided to approach Hyperion with the idea of publishing the book," Ison said.

"They immediately seemed interested in the concept and asked for a prospectus, but at that point we were three-quarters of the way done with the book and had completed most of the photography. So rather than just a simple prospectus, we sent them three or four sample chapters and that was it; they immediately went for it. That's how Disney ended up publishing the book, and ultimately finding out about my collection. This ended up being a perfect situation because no one expected *Snow White* to be released on video and all of the sudden a nearly finished book on the film just fell into their laps," he said.

By 1996, Ison's collection had grown to the point where he thought that it was a truly important collection.

"I've always been surprised that The Walt Disney Company had let me, 'Joe Average' from Indiana, compile this massive collection from their first animated feature. This was their history…their legacy! If *Snow White* hadn't succeeded, we would be asking 'Walt who?' right now. I never believed in collecting for the monetary value of the pieces, but as I told my wife, in the early years of collecting, I believed that the art was important, and would someday be recognized as such," he said. At that point his goal was to add two or three key pieces every year, specifically backgrounds and concept art, which is what really caught his eye.

But by the mid- to late-1990s, the animation art market had taken a hit. While key pieces of classic animation art retained large percentages of their value at the time, many of the dealers and collectors of newer material had stopped collecting due to the influx of manufactured collectibles. As many unsuspecting collectors and even dealers discovered, the idea of "limited editions" meant that they were really limited in performance.

At first, such limited editions had attracted a fair amount of attention, but after

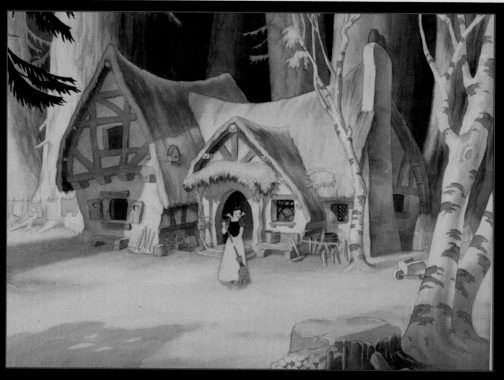

Later, they clean it out in the "Whistle While You Work" musical number, again written and composed by Frank Churchill and Leigh Harline. Hard as it is to believe today, Snow White's animal pals got merchandise of their own in the 1930s – including a cover feature in *Mickey Mouse Magazine* #32 (1938).

they succeeded there were soon too many being produced for the market to handle. As a matter of supply and demand, this impacted the situation negatively to the point where many of the editions sold for below their issue price. Disenchanted collectors, some who never knew the difference between the limited editions and true vintage pieces, sold their collections. There was some reciprocal fallout in the vintage market as well.

Undeterred, Ison said this left him in good position to further his collection.

"I continued buying both backgrounds and concept art. I was able to add many great art pieces to my collection, during those years. It didn't really matter to me what the monetary value was," he said.

There have been some very special moments in collecting for Ison. One night while the exhibit was on display (from 1993-1994), Ison got a phone call from Diane Disney Miller, Walt's daughter, who had said that she read the forward in the book and that it had touched her. She then asked if she could come out and see the exhibit.

"Of course I told her that was definitely okay," Ison laughed. "So she flew out from San Francisco, and I picked her up at the airport. I kept her visit under wraps from both the local media and the museum staff because I felt that she was there because she had a genuine love and appreciation for the art that was a part of her father's first animated feature. After her visit to the museum, we became friends and have stayed so over the years."

While the company and now the Disney family were aware of his collection, things still had not fully clicked into place for what would eventually happen. In the forward to his book, though, he had alluded to the notion that he hoped that one day there would be a place where all of the wonderful pieces could be housed and displayed for everyone to see.

"I've always felt guilty about having all of this great art and never really being able to share it with the world. I've built several home galleries over the years, but never really made them open to the public. I even designed and built one that was a

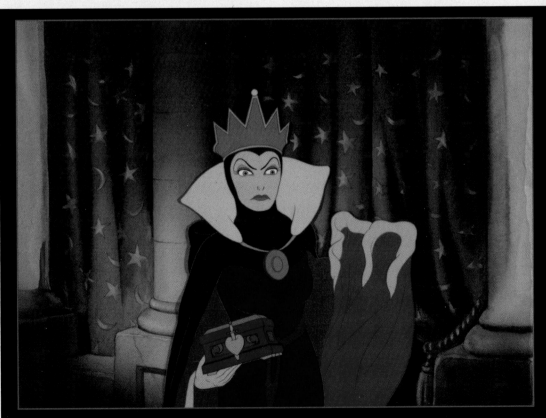

Queen Grimhilde gets the bad news that not only hasn't Snow White been executed – "t'is the heart of a pig" the Queen instead holds in her hands.

Flagons of pulsing chemicals transform Queen Grimhilde into
the infamous Wicked Witch. Norm Ferguson, lead animator
on the Witch, turned a fundamentally comic character design
into a figure at once horrifying and cunning.

Dopey – typically animated by Fred Moore – handles the percussion section in "The Silly Song" production number.

reproduction of the interior of the Dwarfs' cottage, complete with working fireplace; and all to museum specifications. Some of the art is very fragile, and it's your job, as it's steward, to preserve it."

"I've always talked about a public museum, but when Diane contacted me about three years ago about the construction of a Walt Disney Family Museum at the Presidio in San Francisco, we talked about housing my collection there. It was planned to be the upper level of the museum, but in the end the expenses that were involved just became too much. It just broke my heart. At that point, we were building a home in the mountains of North Carolina, and I didn't want to deal with the construction of another home gallery, so I decided I would probably put the artwork into storage to protect it and hoped that maybe something would happen someday. Also, during that time, I had sent artwork to an important exhibit of vin-

tage animation art that the Walt Disney Company was involved with in Paris, France. While there to view the exhibit, I was fortunate enough to meet Bob Iger through Lella Smith, the Executive Director of the Walt Disney Animation Research Library. Iger told me that he had read my book and had heard about my collection for years. It was very kind."

"The next night, at dinner with Lella Smith, we began discussing the possibilities of a Snow White "homecoming", about selling the collection to the company".

"Over the years I've had several people approach me about selling my collection, but I've always turned them down for fear the collection would be broken up," he said, but that wouldn't be the case with Disney purchasing it. "Over the course of the next three or four months, they came to view my collection and they couldn't believe the amount and quality of the material. It's one

The Seven Dwarfs pay their respects at the grave of not-yet-dead Snow White. Animator Frank Thomas captured the Dwarfs' grief in a genuinely touching sequence. Interestingly, the scene as screened marked a slight softening from its first conception: in a short moment that was animated, but didn't make the final cut, a pained, grief-stricken Dopey points directly at Snow White's presumed corpse before (as generally seen) breaking down and sobbing on Doc's shoulder. Luckily for the Dwarfs, of course – not to mention Snow White – we're only minutes away from a happily-ever-after conclusion.

thing to see photos, but quite another to see these amazing pieces in person."

After the inspection, a deal was hammered out and they took possession of the collection in April 2007.

"This really came about because the upper management of Disney was, as I understand it, genuinely excited to have these pieces at the studio once again. They were very, very happy to regain this important part of the history of their company. It seems to be a whole new era at Disney these days. This decision came from the very top," he said.

Though many collectors have tried, it's difficult to go from "full speed ahead" to "stop" simply through the process of selling a collection after decades of work. Ison has already acknowledged this and has no inten-

tions of stopping yet.

"In between the initial discussion and the final sale of my *Snow White* collection, I've begun focusing on collecting vintage *Fantasia* concept art. I chose this because, to me, this was really Walt's attempt at an art film in a medium in which he truly set the standard. I've already found some pieces that would bring a tear to the eye of the harshest art critics. I think I'll always collect in some form or another. Maybe it's a way to hold on to the past; but if it weren't for the collectors of the world, many important works of art and artifacts would be lost forever. I just happen to collect art that has it all…amazing design, beauty, and the wonderful memories it evokes every time I look at it. I miss the collection, but it comforting to know it has a good home."

Ison recreated the interior of the Dwarves' cottage to house elements of his collection. From the working fireplace to the intricately crafted walls and furniture, it was a tribute to the impact of Snow White.

DIRECTORY LISTINGS

(a)	Golden Age Comics	(i)	Gaming Supplies	(q)	Books - New	(x)	Other Toys
(b)	Silver Age Comics	(j)	Manga	(r)	Comic Related Posters	(y)	Records/CDs
(c)	Bronze Age Comics	(k)	Anime	(s)	Movie Posters	(z)	Blu-rays/DVDs/VHS
(d)	New Comics/Magazines	(l)	Underground Comics	(t)	Trading Cards	(1)	Doctor Who Items
(e)	Back Issue Magazines	(m)	Original Comic Art	(u)	Statues/Mini-busts, etc.	(2)	Simpsons Items
(f)	Comic Supplies	(n)	Pulps	(v)	Premiums (Rings,	(3)	Star Trek Items
(g)	Collectible Card Games	(o)	Big Little Books		Decoders, etc.)	(4)	Star Wars Items
(h)	Role Playing Games	(p)	Books - Used	(w)	Action Figures	(5)	HeroClix

All Star Auctions
PH: 201-652-1305
allstar@allstarauctions.net
www.allstarauctions.net

Dr. David J. Anderson, D.D.S.
5192 Dawes Avenue
Seminary Professional Village
Alexandria, VA 22311
PH: 703-671-7422
FAX: 703-578-1222
DJA2@cox.net

ArchAngels
4629 Cass Street #9
Pacific Beach, CA 92109
PH: 310-480-8105
rhughes@archangels.com
www.archangels.com

Batman & Wonder Woman Collectors
P.O. Box 604925
Flushing, NY 11360-4925
batt90@aol.com
wwali@aol.com

Best Comics
1300 Jericho Turnpike
New Hyde Park, NY 11040
PH: 516-328-1900
FAX: 516-328-1909
TommyBest@aol.com
www.bestcomics.com
(a,b,d,f,m,t,u,w,3,4)

Steven M. Bialick
5861 Cedar Lake Road
Minneapolis, MN 55416
PH: 952-542-1927
FAX: 952-542-8389
stevenbialick@att.net
(m)

Cloud 9 Comics
Ken Dyber
P.O. Box 82233
Portland, OR 97282
PH: 503-488-5573
ken@cloudninecomics.com
www.cloudninecomics.com
(a,b,c,d,e,l,m)

Comic Art Appraisal LLC
Joe Mannarino & Nadia Mannarino
PH: 201-652-1305
www.comicartappraisal.com

ComicConnect.com
873 Broadway, Suite 201
New York, NY 10003
PH: 888-779-7377
PH: 212-895-3999
FAX: 212-260-4304
support@comicconnect.com
www.comicconnect.com

ComicLink Auctions & Exchange
PH: 718-246-0300
buysell@ComicLink.com
www.ComicLink.com

Dave and Adam's Card World
55 Oriskany Dr.
Tonawanda, NY 14150
PH: 888-440-9787
service@dacardworld.com
www.dacardworld.com

Diamond Comic Distributors
10150 York Rd.
Suite 300
Hunt Valley, MD 21030
PH: 443-318-8001

Diamond International Galleries
10150 York Rd.
Suite 300
Hunt Valley, MD 21030
PH: 443-318-8422
GalleryQuestions@
 DiamondGalleries.com
www.DiamondGalleries.com

Fandom Advisory Network
www.fandomnetwork.com

Dan Gallo
Westchester, NY
PH: 954-547-9063
DGallo1291@aol.com
eBay ID: DGallo1291
(a,b,c,m)

Stephen A. Geppi
10150 York Rd.
Suite 300
Hunt Valley, MD 21030
PH: 443-318-8203
gsteve@diamondcomics.com

Geppi's Entertainment Museum
301 West Camden Street
Baltimore, MD 21201
PH: 410-625-7089
FAX: 410-625-7090
www.geppismuseum.com

E. Gerber Products
1720 Belmont Ave.; Suite C
Baltimore, MD 21244
PH: 888-79-MYLAR

Hake's Americana
P.O. Box 12001
York, PA 17402
PH: 866-404-9800
www.hakes.com

Heritage Auctions
3500 Maple Avenue
17th Floor
Dallas, TX 75219-3941
PH: 800-872-6467
www.HA.com

Nick Katradis
PH: 917-815-0777
ndde@aol.com
www.NickKatradis.com

Metropolis Collectibles
873 Broadway, Suite 201
New York, NY 10003
PH: 800-229-6387
FAX: 212-260-4304
buying@metropoliscomics.com
www.metropoliscomics.com

Mill Geek Comics
Russ Bright
17928 Bothell-Everett Highway
Unit C
Mill Creek, WA 98012
PH:425-415-6666
MillGeekComics@gmail.com
www.MillGeekComics.com
(a,b,c,d,f,g,h,i,1,3,4)

Romitaman Original Comic Art
Mike Burkey
P.O. Box 455
Ravenna, OH 44266
PH: 330-221-5665
mikeburkey@aol.com
www.romitaman.com

ADVERTISER INDEX

COLLECTOR
BUYING PRE-1965
COMIC BOOKS
AND RELATED COLLECTIBLES

COMIC BOOKS
CLUB KITS · PREMIUMS
OTHER CHARACTER COLLECTIBLES

I am the
most serious collector
you'll ever find...
I LOVE THIS STUFF!

SEND YOUR SALE LIST!

Stephen A. Geppi
10150 York Road, Suite 300
Hunt Valley, MD 21030
443-318-8203
gsteve@diamondcomics.com